Glenn Adamson and
Julia Bryan-Wilson

Art in the Making

Artists and their Materials
from the Studio to Crowdsourcing

With 219 illustrations

Thames & Hudson

First published in the
United Kingdom in 2016 by
Thames & Hudson Ltd, 181A
High Holborn, London
WC1V 7QX

*Art in the Making: Artists and
their Materials from the Studio
to Crowdsourcing* © 2016
Thames & Hudson Ltd, London

Text © 2016 Glenn Adamson
and Julia Bryan-Wilson

The inside pages of this
book have been designed by
Fraser Muggeridge studio

British Library
Cataloguing-in-Publication Data

A catalogue record for this
book is available from the
British Library

ISBN 978-0-500-23933-9

Printed and bound in China
by Everbest Printing Co. Ltd

On the front cover:
Ron Mueck at work (detail), 2009.
Photo Gautier Deblonde.
Courtesy the artist and
Hauser & Wirth

On the back cover:
Anne Wilson, *Local Industry*,
2010. Performance and
production, Knoxville Museum
of Art. Weavers Tommye Scanlin
and Geri Forkner finishing the
Local Industry Cloth.
Courtesy the artist

To find out about all our publications, please visit
www.thamesandhudson.com. There you can
subscribe to our e-newsletter, browse or download our
current catalogue, and buy any titles that are in print.

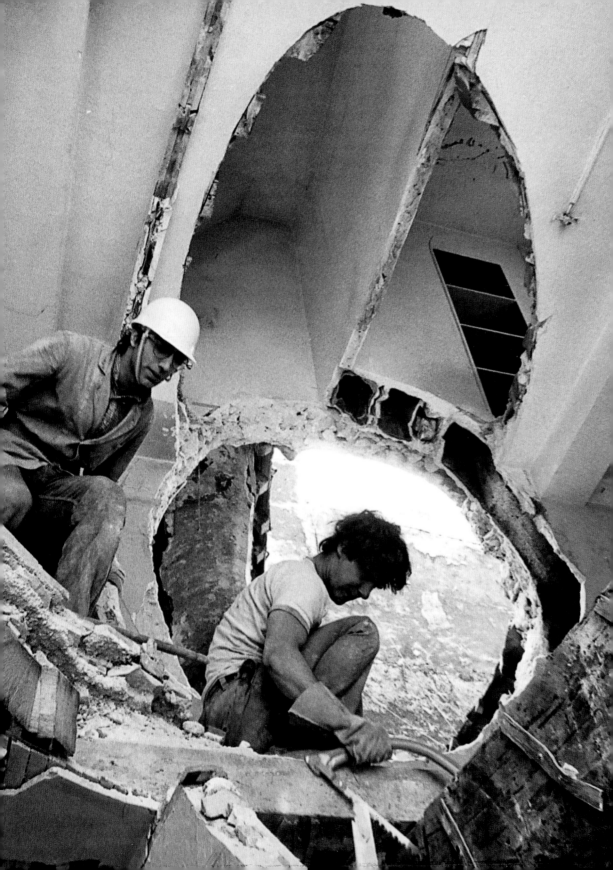

Introduction

When future art historians look back at the present day, it is possible that it will be the sheer proliferation of our art that will strike them most, rather than its content. No era has created so much art, or art of such eclecticism. The profusion of artistic production in all its variety is bewildering, so much so that apart from its apparently unstoppable expansion, it seems impossible to summarize art's tendencies in the past half-century or so. There appear to be no obvious barriers of acceptability left to break through. Ideas such as avant-garde provocation, or "newness," or "originality" have for contemporary artists become timeworn clichés.

Yet there is one arena in which art today is changing dramatically, and departing radically from precedent: the *ways* that it is made. Long gone are the days when art was typified by the atelier model of production, in which one artist makes unique objects in a studio or, in the case of Frida Kahlo, after an accident, from the confines of a bed.[1] This image of an artist so committed

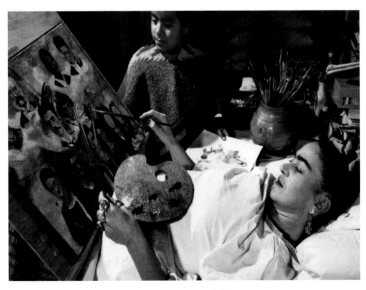

Frida Kahlo painting in bed, 1950. Photograph by Juan Guzman

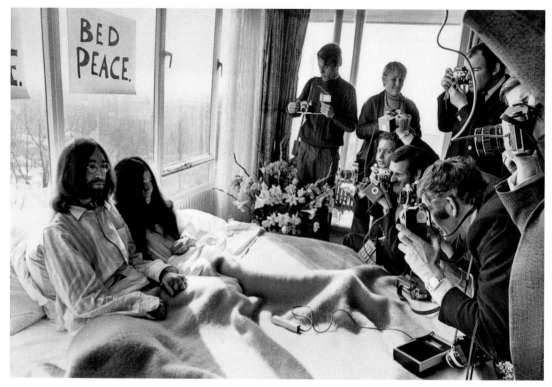

Bed-In for Peace, 1969. John Lennon and Yoko Ono receiving journalists in their bedroom at the Hilton hotel in Amsterdam, during their honeymoon, March 25, 1969

to her practice that she paints even while convalescing from an incident of serious bodily injury marks one particular vision of an artist at work. Kahlo learned to paint while lying down, and this photograph presents not the typical upright, able-bodied maker in a workroom, but rather an alternative space of vibrant artistic activity. It is the full spectrum of sites of production, from artist loft to factory floor to database, that this book considers.

To illuminate how artistic processes have expanded and diversified since this photograph was taken of Kahlo, let us take a quick tour through a small sample of other instances of artists' beds, beds that, like Kahlo's, function as more than just places of heterosexual conception, rest, and imaginative escape. We take this tour of beds (it could also be thought of as a detour) in part because we want to make concrete from the very beginning our overarching point about how multiple artistic making has become. We are also modeling in these opening pages our practice for the entire book, which is to construct an argument insistently driven by and through a series of tangible examples.

Consider Robert Rauschenberg's *Bed* (1955), a "combine"
or assemblage in which the artist incorporated a pillow and
quilt, painting atop them with reckless abandon. In this work,
Rauschenberg uses found objects: what Marcel Duchamp
called readymades. This strategy, in which a pre-existing thing
is appropriated into the situation of art, initially appears to deskill
the act of making. Because Duchamp could simply purchase his
readymades – a urinal, a bottle rack, or a shovel – he did not need
any of the traditional skills of a sculptor.

This strategy has rightly been perceived as a major conceptual
disruption in the pattern of art-making, and one that still resonates
today.[2] Rauschenberg's *Bed*, however, shows that incorporating
found objects is entirely compatible with deeply expressive
gestures. It has been argued that the work is a kind of self-portrait,
which represents his conflicted relationship to same-sex desire.[3]
Without the use of found objects, the poignant psychology
of the work would not be nearly as palpable. The quilt was not
Rauschenberg's, but rather belonged to Dorothea Rockburne,
and some feminist critics have questioned his absorption of this
piece of functional "women's work."[4] Thus his use of the quilt as
a kind of canvas also raises issues about the incorporation of
"low" materials within "high" art.

In the following decade, Yoko Ono and John Lennon
camped out on their honeymoon in hotel suites (in Amsterdam
and Montreal) with banners affixed around them in protest of
the US war in Vietnam, in *Bed-In for Peace* (1969). Rauschenberg
had exploited the intimacy of the bed, normally considered a private
realm, but Ono and Lennon's performance was a choreographed,
political effort that sought to capitalize on their already very
public lives as global superstars, turning mass media attention
into a vehicle for awareness about the anti-war movement. The
"making" here extends out from the couple's bed to the journalists'
photographs as they made their way into newspapers and onto TV.
Those documents and their circulation are as much a part of the
production as the artists "working," that is, sitting in their nuptial
bed talking to visitors about peace.

Next, think of Tracey Emin's *My Bed* (1998), an installation of
the artist's bed and its immediate surroundings in all their messy
disarray, including stained underwear, bedroom slippers, empty
vodka bottles, and condoms. Emin did not produce or manufacture
any of the everyday objects on display, but acquired and arranged
them, apparently to replicate how her bed looked after she lay in it

for days due to depression. What was encoded in the case of Rauschenberg's *Bed* was in this case explicit: this is making as a form of selection and re-enactment, charged with the artist's affective state. For some viewers, it invited a mode of encounter more interactive than mere visual contemplation: two artists, Cai Yuan and Jian Jun Xi (who work together under the moniker Mad for Real), leapt onto Emin's work at Tate Britain, stripped to the waist, and had a pillow fight. They called the piece *Two Artists Jump on Tracey Emin's Bed* (1999).

As these examples suggest, art in the postwar era has charted a tangled path through the overlapping possibilities of making: handmade and readymade, intensely private and mass-mediated.

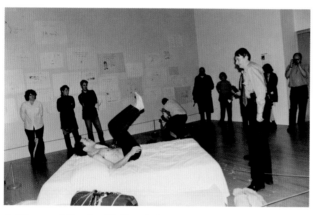

Cai Yuan and Jian Jun Xi, *Two Artists Jump on Tracey Emin's Bed*, 1999. Performance at Tate Britain, London

To make matters even more complex, today's artworks are often not created by the artists who are their nominal authors. Art is just as likely to be produced by a team of carpenters working onsite; in an enormous fabrication facility; by a luxury goods firm; using a computer program; live, by bodies performing in front of an audience; or by the contributions of hundreds, even thousands, of people, as with Aaron Koblin's *The Sheep Market* (2009), in which over 10,000 worker-participants were paid 2 cents to draw a sheep facing left, using Amazon's Mechanical Turk function. (Sheep, of course, tangentially relate to beds, due to their famed slumber-inducing properties when mentally counted; in Koblin's exercise of underpayment, they are also negatively associated with mindless following.)

Despite the turn toward what Rosalind Krauss termed the "post-medium condition," specific processes, such as Mad for Real's bodily performance, or Koblin's hands-off commissioning of an archive, have resurfaced as central to the workings of contemporary art.[5] As these various means of production have been introduced, new questions are prompted. One of the most obvious concerns authorship. If artists do not physically make their own work, has something been lost? What are the implications of a system in

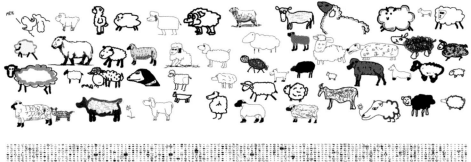

Aaron Koblin, *The Sheep Market*, 2009. Collection of 10,000 sheep made
by workers on Amazon's Mechanical Turk, a crowdsourcing marketplace

which production is distributed across many hands, and artists
are increasingly dependent upon the support of specialists, or
random strangers, to realize their ideas? What are the ethics
involved in such procedures? And what about uniqueness, or
the lack thereof? A dynamic once confined to bronze casts and
print editions, in which the production run of a given image is
calculated based on front-end investment and eventual distribution,
has now become general and widespread. Whether or not viewers
are aware of it, seriality is now the order of the day, and even truly
unique objects can be spun off into derivatives of many kinds,
each of which requires its own production strategy. Some artists
have made multiples integral to their practice, such as Andrea Zittel
with her functional designs, including her *2nd Generation A–Z
Wagon Stations* (2012), which are inhabitable sculptures created
to streamline and downsize many aspects of domestic life,
including sleeping.

Most critically, there is the simple fact of resources. Immense
amounts of money are being pumped into the making of art today,
perhaps more conspicuously than at any time since the Renaissance.
Many artists are now heavily dependent upon the powerful interests
that capitalize their projects. Artists seeking alternatives to these
brokers of the art world might turn to other networks of exchange,

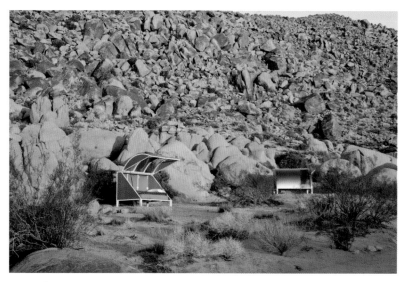

Andrea Zittel, *2nd Generation A–Z Wagon Stations*, 2012.
Installed at AZ West, Joshua Tree, CA

such as micro-patronage fundraising campaigns on social media. Still others look to bartering or to gift economies, or to collective resource-pooling. Even these attempts to spread the wealth are quickly absorbed within a system that rewards a few stars and neglects nearly everyone else. Often the most overlooked are those who actually do the hands-on work of producing this art, that is, the fabricators or studio assistants who have been tasked with realizing an artist's vision. While this book attempts to account for some of the breadth of support provided to artists, it is not a systematic exposé regarding the payment (or non-payment) of assistants, though such a book would be most welcome. Instead, we hone in on a select number of discrete means through which artists make their final objects, including pigments, tools, and human helpers.

When you go to an art gallery or museum, you are told little about such factors as the acquisition of raw materials, wages for the workers, or payments to the artists. Making – and the exchange of capital to which it is inextricably linked – is the proverbial elephant in the room, its effects evident for all to see, but rarely discussed openly. It is obvious that multi-ton sculptures, vast paintings, five-hour films, and performances involving tens or hundreds of performers all place tremendous demands on those who desire to bring them into being, and to all those who help realize those desires. Sometimes artists' projects have to overcome significant bureaucratic and monetary obstacles:

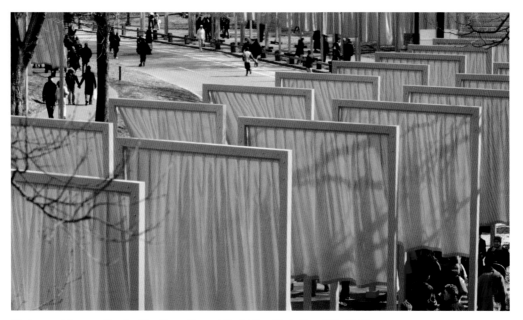

Christo and Jeanne-Claude, *The Gates*, Central Park, New York City, 1979–2005. 7,503 gates, each 16 ft high (4.87 m) with a width varying from 5 ft 6 in. to 18 ft (1.68 m to 5.48 m), lining 23 miles (37 km) of footpaths, free-hanging, saffron-colored fabric panels suspended from the top of each gate and hanging down to 7 ft (2.13 m) above the ground

Christo and Jeanne-Claude's *The Gates*, Central Park, New York City (1979–2005), for instance, required millions of dollars to pay for massive amounts of saffron-colored nylon fabric and over 7,000 vinyl gates, as well as the hours of labor to produce and sew the panels and position the gates. It further required decades of negotiations on the part of the artists with the city of New York to obtain permission to install their work. In many cases, the amount of time that artists expend on making their work far outweighs the time that they (or the audience) spend conceptualizing it. Yet the book you are reading is, to date, the very first to critically consider the *making* of art since 1950, with a focus on both conventional and more recently developed processes. Why?

Part of the reason has to do with the issues just mentioned. Sensitivities about authorship and economics have led to a situation in which narratives of making can be veiled, or hard to establish. Many fabricators are bound by confidentiality agreements; many artists would rather talk about their ideas than their production strategies, perhaps for fear that they will seem prosaic. This relates to another factor, pertinent to art historians like ourselves: making may seem a conservative matter for scholarship. For decades art

15

has been principally valued for its conceptual merits, not
for its physical qualities such as materials, craftsmanship, or
technological sophistication. Indeed, the notion that contemporary
art is principally about ideas underpins one of our most cherished
beliefs: that it is more than just another sort of commodity; that it
matters, deeply and profoundly, in a way that other things that are
made, sold, and owned do not. We are also in an era in which the
reception of art – its networks of circulation, its institutional homes,
and its counter-institutional impulses – dominates critical discourse.
"Studio practices" were the focus of traditional art history, but
there has been a shift away from accounts of art in its moments of
becoming, and toward art as it is curated, taught, and distributed.

Yet the reasons for critically investigating the making of art are
numerous. For the moment we will concentrate on three. First,
production is clearly a determinant factor for artists themselves,
and by ignoring it we risk seriously overrating other matters that
may in fact be secondary or conditional. If someone wants to make
a particular work of art, it is commonly assumed that they will find
a way to do it. In fact, the exact opposite is the case: all artists,
even the most powerful, are limited in what they can make. Their
own skills, what they can afford, and the material constraints of
scale, matter, process, and engineering are always in play. Many
artists concentrate their efforts right at the frontier of the possible,
in order to expand these material constraints. Fireworks explode
in a spectacular sequence; cars suspended from the ceiling dazzle
with lights that extend out from their bodies; an army of replica
wolves leaps through space (each of these are examples of works
by Chinese artist Cai Guo-Qiang). A walk through a contemporary
art fair, biennale, or museum is just as astounding for our time as
the great machines displayed in world fairs were in the nineteenth
century. Such feats of production make it only more important to
be aware of the limits of feasibility that exist for each artist, for
they often provide decisive creative friction.

A second fact about making can be summarized in the phrase
"all production is political." Our attention to process stems from
our commitment to materialist approaches, and this book was
generated out of our shared interest in how art is made. That
concern is inevitably indebted to the theoretical legacy of Karl
Marx, who considered the question of how things come into
being as the products of capitalist wage labor. Marx described
the worker's life of long, twelve-hour days, "weaving, spinning,
drilling, turning, building, shovelling, stone breaking."[6] This book's

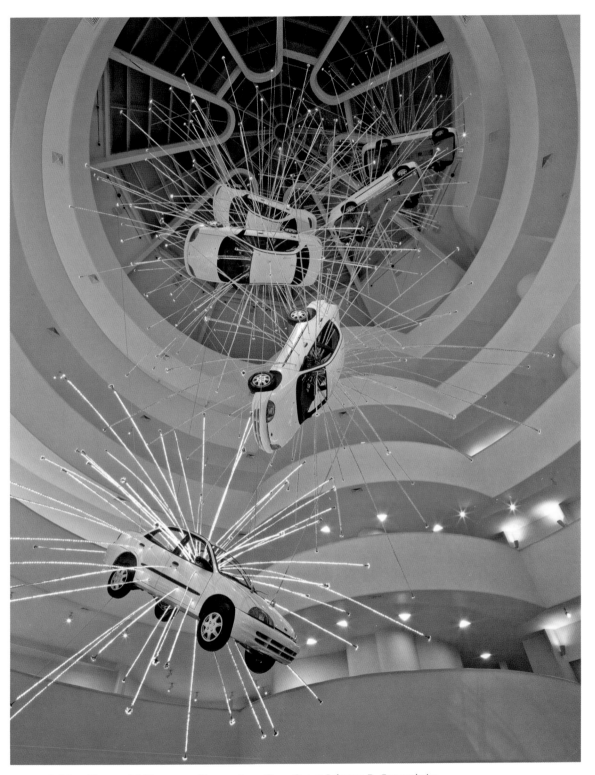

Cai Guo-Qiang, exhibition copy of *Inopportune: Stage One* at Solomon R. Guggenheim Museum, New York, 2008. Nine cars and sequenced multichannel light tubes, variable dimensions

chapters, organized around procedures such as painting, building, and performing, are but a distant echo of that list.

Many artists are acutely aware of the political implications of their own work and, rather than trying to escalate their capacities, are intentionally downsizing their practices, pointedly employing localism, slowness, the miniature, and the handmade. The effect of such modesty often draws heightened attention to the cares and efforts of making, and attempts to rethink the artist's role within market exchanges. Some current artists take great pride in fully engaging in such activities as weaving, but some employ others to perform the kinds of tasks that Marx describes. Marx goes on to comment that for the worker under capitalism who sells their efforts and their time, such labor as drilling or turning is personally meaningless, as instead "life begins for him where this activity ceases, at table, in the public house, in bed."[7]

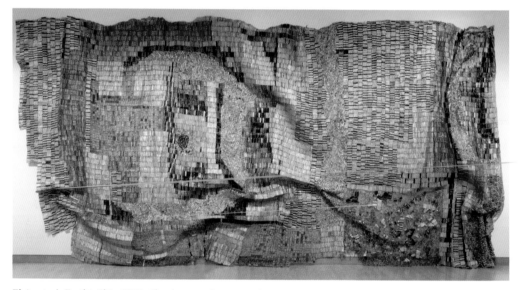

El Anatsui, *Earth's Skin*, 2007. Aluminum and copper wire, approximately 14 ft 10 in. × 32 ft 10 in. (4.5 × 10 m)

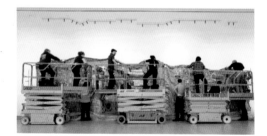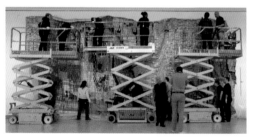

Art handlers installing El Anatsui's *Earth's Skin* at the Brooklyn Museum, 2013

Some art-makers return to traditional domestic craft methods in order to comment on widespread, globalized mass production, like the Ghanaian sculptor El Anatsui, whose shimmering tapestries are created from ordinary bottle caps. What does it mean for artists and activists to adopt such everyday materials in an economy of international sweatshop labor? How are such small gestures tied into community outreach projects, or what has been influentially described as "relational aesthetics"? Works such as those by Anatsui depend upon many types of workers, both seen and unseen, to realize and present them: from those who helped produce the bottle tops at the factory, to the artisans who bind them together, to the art handlers who carefully hang the pieces on the museum wall.

Indeed, one cannot approach the subject of artistic making without an awareness of how it is embedded in class systems and associated inequities of economic imbalance. We also take our cues from feminism, critical race theory, and queer theory when we emphasize throughout our account questions of gender, race, and sexuality. Along with these categorizations, ability, ethnicity, geography, age, and other social identities and divisions routinely enter into narratives about artistic production.

We should not overemphasize the degree to which our investigation of fabrication is purely practical, to be counted up in hours and minutes, dollars and cents; or politically partisan, to be measured on a left-right axis. This leads to our third, and perhaps most important, reason for examining narratives of production in art: making is a form of thinking. For us, this means that the specificities of creation and the conceptual premise are inextricably linked. The structure of this book is intended to convey this: the nine chapters track a general movement from the tangible to the abstract, while showing that these opposing poles of art-making are always contained within one another.

We start in our first chapter with the painter's pigment: seemingly the most raw and emblematic of art materials, freighted with expectations about individual expression. The following two chapters similarly examine concrete art-making processes: woodworking, a basic technique within sculpture; and architectural crafts, which allow artists to achieve large scale. Taken together, these first three chapters show how particular materials are deployed as artists search for new forms and ideas. Paint, wood, and steel girders each have specific properties, which have a determinate role in the way artists think. Alongside these pragmatic considerations, we also demonstrate how artists subvert

expectations about these materials and associated processes, pushing the definition of "painting" to include things like colored gas and body ornamentation; interrogating expressive structure through an emphasis on wooden substructure; and adopting the lexicon of architecture to propose radical ideas about cultural space.

The fourth chapter examines performance: a type of art in which there is sometimes little material apart from the artist's body itself. In this chapter we emphasize issues of dependency. No artists truly work alone, even when they put their own body on the line. We argue that bodily action, while it may seem to be the quintessence of individual expression and commitment, must always be seen within its immediate social and practical context. In the fifth chapter we take an initial step away from direct making processes, looking at artists who create or modify tools, which in turn determine the form of an artwork. Here we are still largely concerned with individual, atelier-based production, but a crucial variable has been introduced, in that the invented or adapted tool has an automatic role within the process.[8] This chapter on tooling introduces a dynamic that is sustained through the rest of the book, as we examine various systems by which art is not so much made, as made to happen. The underlying goal here is to show the complexity of artistic authorship today. Every artist stands at a nexus within an extensive social matrix, and their simplest acts of creation are affected by the forces present in that matrix.

In Chapter 6, "Cashing In," we confront that dynamic head-on by discussing the extrinsic force that is applied to artists by the market. Considerations of materiality return here, as we look at precious substances like diamonds and gold. But our interest is not so much in the physical handling of these materials as the economic dimension of art production in general: the money and power that surround artists, and the way they navigate that reality (and let us not forget the collective labors of unpaid interns, art handlers at auction houses, guest-workers building art museums in Dubai, and other members of the art world precariat: what Gregory Sholette calls the "dark matter" of artistic production[9]).

Chapter 7, on fabrication, retains this focus on economic underpinnings. We turn our attention to some of the backstage or off-screen aspects of current art production. This is one area where we consciously build on existing secondary literature, such as Michael Petry's *The Art of Not Making: The New Artist/Artisan Relationship* (2011), which considers outsourced fabrication and contains illuminating interviews with fabricators themselves.[10]

Our contribution to this developing scholarship emphasizes the artist's decision-making process in working with outside producers. Turning to a fabricator is not an abdication of responsibility, but rather the initiation of a different and more complex form of authorship. We insist on the qualitative aspect of the relations between artists and their fabricators: one can outsource with greater or less intelligence, just as one can paint thoughtfully or not.

In the last two chapters we turn to two related phenomena within contemporary art practice: digitization and crowdsourcing. By these means, art-making is becoming increasingly abstract, and disconnected from the frictional dictates of materials. For this reason, digital media and crowdsourcing seem to bring newfound freedom to art. This can make them seem very contemporary – the leading edge of art – but in both chapters we examine how current patterns of thinking have roots in postwar art history. We also show that, even in the exciting discovery of these new frontiers for art-making, certain sociopolitical and practical issues remain constant.

With these final chapters, we complete our survey of progressively more distributed models of production. A journey that began with the artist's brush culminates in practices involving online technology and large masses of participant-authors. Yet these seemingly polar opposite methods of making – single, "expressive" authorship versus anonymous, or computer-generated work – have much in common. Throughout this book, we seek to overturn easy oppositions in art-making: machine-made versus handcrafted, the digital versus the analogue, the individual versus the crowd.

It is an admittedly selective and eccentric course we are charting. We have no ambition to be encyclopedic about the methods of making we interrogate, and opt for a thematic, argument-driven approach rather than a straightforward timeline. Our chapters do not conform to a strictly chronological narration, but this is not because we believe recent art to be ahistorical, unmoored from time and place; quite the contrary. Rather, we intentionally cluster examples from different decades together to highlight how old and new procedures of making art *coexist*. Just because a method has been recently invented or embraced does not mean that previous ways are abandoned.

We start, roughly, in the 1950s and move up to the present day, with special focus on the 1960s, a decade that was marked

by a widespread interest in issues of process. Though we touch on a wide range of cultural production, including fashion, street interventions, community-based organizing, and social media, the list of processes we do not consider in any depth is far longer than the one of those we do write about: drawing, printmaking, graffiti, ceramics, photography, art-magazine insertions, conceptual thought-experiments, and so on. Throughout, we focus on practices that are hybrid, intermedial, and cross-disciplinary.

Many of our examples are drawn from the two national contexts in which we are personally embedded, the United States and the United Kingdom, but as art travels, so does our book, and we do look at artistic methods located around the world. We have given significant space to emerging and lesser-known artists, while also interrogating those who might be considered "usual suspects," inspecting canonical figures with a new lens to give fresh insight into normative histories of art. Some artists appear in multiple chapters, examined in depth from different angles; others make relatively brief appearances. Our hope is not only to productively examine the realities of art-making today, but also to give artists themselves a set of tools, which may help them think through what they are doing now and might do in the future.

Let us conclude by returning to the motif of the artist's bed that opened our introduction (see also our discussion of Janine Antoni's *Slumber* of 1993–94, p. 127). In 2013, Tilda Swinton, for an iteration of Cornelia Parker's piece *The Maybe* at New York's Museum of Modern Art, napped inside a glass vitrine. The box was outfitted with cushions and a carafe of water, and brought to mind a specimen captured for inspection. Why should we care about this slumbering white woman, aside from her beauty and her fame? *The Maybe* keys into fascinations with celebrity and showcases museum forays into popular entertainment. It resembles, but only superficially, an earlier work by Native American artist James Luna, who put his body on display in San Diego's Museum of Man for *Artifact Piece* (1986), complete with information cards about each of his scars. The presence of this breathing Luiseño man shook assumptions about racial othering and ethnographic objectification, not least the corrosive myth that Native peoples are consigned to the past.[11]

The Maybe and *Artifact Piece* both seem to be about the act of not-making. Yet in their different ways, they do perform "work." As Swinton and Luna lie flat, the institutional frame around them is simultaneously celebrated (in the case of *The Maybe*) or challenged

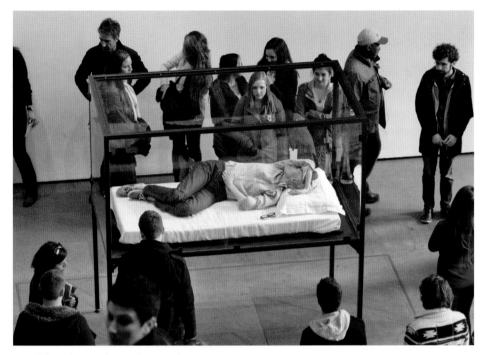

Tilda Swinton, *The Maybe*, March 23, 2013.
Installation at the Museum of Modern Art, New York

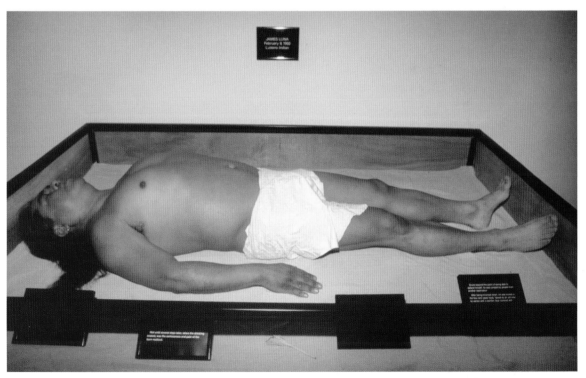

James Luna, *Artifact Piece*, 1986.
Performance piece, Museum of Man, San Diego

and critiqued (in the case of *Artifact Piece*). The very stillness
of the performer, the absence of evident labor, invites variable
responses from the audience. It is as if the task of completing the
work has been implicitly handed over. It is our collective job, as
witnesses to contemporary art in all its forms, to think about how
we, too, are implicated as producers. If art is an ongoing circuit
of meaning, perpetually in the making, then let us consider how
we might be alert to its conditions rather than be content to
remain, as if dreaming, in the dark.

Painting

Chapter 1

In 1994, a group of prominent art historians fell into an argument about the definition of painting. The dispute concerned the conceptual artist Robert Barry. Best known for works that were invisible and undetectable, such as a release of colorless, odorless gases into the desert atmosphere of the US West – his *Inert Gas* series (1969) – or radiation emitted in a gallery, Barry was called a "painter" by Thierry de Duve. "That's a textbook example of

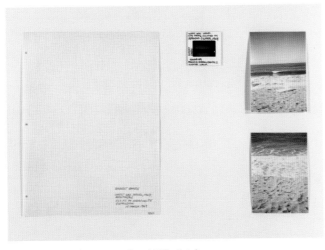

Robert Barry, *Inert Gas* series, 1969. Catalog page, photographs and color slide, 19 ¹¹/₁₆ × 19 ¹¹/₁₆ in. (50 × 50 cm)

a painter dematerializing painting but always remaining a painter in the end," de Duve said.[1] Others in the conversation, which was published in the journal *October*, variously agreed – or strenuously disagreed – with this assertion.

Their lack of consensus points to the ever-shifting borders around painting, as it has become an increasingly slippery term in recent decades. Our relatively straightforward assumption that to paint is to apply pigment to a surface has been somewhat unmoored. At the same time, the status long afforded to painting as the most emblematic of art-making practices has become eroded,

and even erased. What, we might ask, is the "work" of painting today? Does the manipulation of pigment on a flat surface still have a privileged role to play in contemporary art? Or has it become just another process, no more (or less) special than any other?

Further questions arise when we begin to consider the boundaries of painting as a physical practice. What about the support: is a painting a painting because it was made with paint on canvas? (Museum curators in departments known as "works on paper," who look after drawings, prints, watercolors, and sometimes photographs, might see the logic in this distinction.) What about images made of blood, mud, jam, or string? Is a painting any optical, physical object that brings together a more-or-less flat structure, surface, and support? Or, following de Duve, can something like an imperceptible, amorphous gas also be included in the medium's fold? These questions are not merely semantic. They cut right to the heart of the way that art is understood either as a disciplinary matter, with clear rules and limits, or, alternatively, as a free zone of exploration, in which traditional genres like painting are only optional affinities, historical points of reference. In this chapter, we will look at various cases in which these issues of definition are at stake. In combination, they suggest that painting's very centrality to art in the past is exactly what makes it a useful exploratory tool in our own trans-disciplinary present.

Paint, seemingly the "rawest" of art materials, is in fact highly processed stuff. It is composed of two principal ingredients: the pigment (historically, crushed minerals like lapis lazuli for blue, cadmium for red, and lead or titanium for white); and a binder, most commonly oil or acrylic, though egg white and other natural and artificial substances can be used as well. Until the nineteenth century, artists either made up their own paints, or bought them from "colormen," artisans who sourced and mixed the ingredients to order. In the mid-nineteenth century paint became an industrial product, made in factories. It became a mass-produced commodity. Just like any other mass-produced commodity, it can be appropriated as a found object or "readymade," in the manner initiated by Marcel Duchamp. This possibility was famously voiced in the 1960s by the artist Frank Stella, who claimed that he wanted to keep his paint "as good as it was in the can."[2]

The understanding of paint as a readymade remains key today. Thierry de Duve's liberal definition of painting, including his assertion about Barry "remaining a painter," rests on this idea; as he has argued in an essay entitled "The Readymade and the

Tube of Paint," all artistic materials are in some respects "assisted" (or manipulated) found objects.[3] None of us can create matter out of nothing. All artists are, at least to some degree, reacting to a pre-existing set of conditions, rearranging as well as making. Painters are no exception.

So how do artists keep the paint "as good as it was in the can," that is, engage with the broader possibilities of art-making that were inaugurated with the readymade? This does not necessarily mean thinking about painting as a purely theoretical,

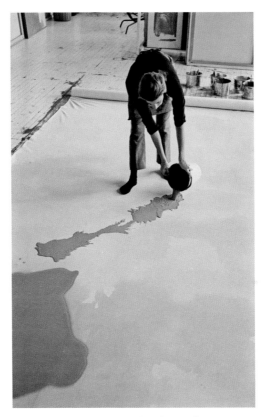

Helen Frankenthaler, at work in her studio, 1969

dematerialized, or poetic activity. On the contrary, the main tendencies in late twentieth-century abstraction involved a dialectic, in which paint's status as a readymade existed in a dynamic relationship to its identity as an expressive medium. This is one of the many ideas that artists took from Jackson Pollock. Each splash of paint that lies atop or soaks into his canvases, each dribble and drip, is legible as a gesture, but also as a simple deposit of the unmixed industrial paint onto the canvas.

This doubling, in which paint is handled by the artist even as it is left intact and "pure," was particularly important for a subsequent generation of artists known as Color Field painters, such as Helen Frankenthaler, Morris Louis, Jules Olitski, and Sam Gilliam. Before the 1950s, whether working on panel, canvas, or some other material, painters had typically laid down a base (a "primer") before applying the pigment. Abstract Expressionists and then Color Field artists skipped this step, working directly on the cotton cloth. In Frankenthaler's early work, in which she poured and rubbed her paints by hand, one can often see a halo of oil as it leaches into the fibers of the canvas. Later on, artists switched to quick-drying acrylic resin or Magna (a paint invented in 1947 in which mineral spirits are used in combination with acrylic). Artists were just as associated with particular techniques as they were with their pictorial vocabularies: Olitski with his use of the spray gun; Louis with his virtuosic controlled pours, which extended a great distance along the canvas. Gilliam, perhaps more than any other Color Field painter, explored a wide repertoire of physical

Sam Gilliam, *Along*, 1969. Acrylic on canvas, 111 × 144 × 2 in. (281.9 × 365.8 × 5.1 cm)

acts of mark-making: masking, splashing, and particularly folding of the canvas, which yielded symmetrical, Rorschach-blot forms. He sometimes eschewed stretchers, preferring to drape his works, producing parallels between the canvas and the house-painter's drop cloth, and thereby making associations between his practice and the skilled trades. Gilliam would sometimes set his paint can directly on the surface of the work, imprinting a neat circle amidst the surrounding chaos of pigment.

The emphasis that American Color Field artists laid on the materiality and tools of painting has carried on to the present. The best-known example is Gerhard Richter's use of a squeegee (a long, flat, hard rubber blade) to push wet paint across the surface of his works. This technique depersonalizes and randomizes his initial gestures, creating a vertiginous confusion between that

Gerhard Richter at work. Still from Corinna Belz's film *Gerhard Richter Painting*, 2011

which is meant and that which is purely chance. Though the overall impression imparted by Richter's abstract works is one of control – each has a distinctive look and emotional tenor, created by the palette and a specific vocabulary of mark-making – any given individual detail might or might not be intentional. This is Richter's contribution to the tradition of paint-as-readymade: in his paintings, craftsmanship and chance operations coincide and merge, so that they are indistinguishable from one another.

Much earlier than Richter, and even before the Color Field artists, a more aggressive and embodied articulation at the intersection of chance and intention was staged by the Japanese avant-garde group known as the Gutai Art Association, particularly

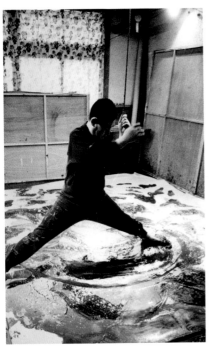

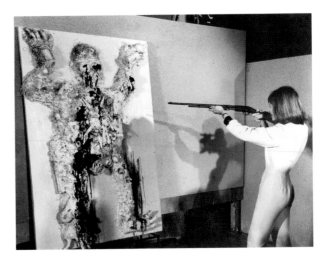

Niki de Saint Phalle, *Tir Gambrinus*,
at Galerie Becker, Munich, 1963

Kazuo Shiraga painting in his studio, 1963

the artist Kazuo Shiraga. Beginning in the late 1950s, he quite
literally began to wrestle with the idea of paint, adopting a whole-
body process method of application. In pieces like his *Untitled*
(1959), large thick strokes of black and blood-red radiate out from
a clotted, dark center. Made by the artist's feet as he swiped his
legs across the canvas, such works evince a profound interest in
painting as an evidentiary trace of often aggressive bodily motions.
Much gestural effort is apparent in the large swathes of paint
as they arc across the surface. In other works, he continued his
abandonment of the brush, rather using his own body by hanging
from ropes as he twisted and turned over the surface of the canvas.

Though Shiraga's work has often been likened to Abstract
Expressionism – a comparison prompted by Hans Namuth's famous
photographs of Jackson Pollock at work – he, and the Gutai group
more generally, were also deeply concerned with an issue particular
to post-World War II Japan: the mass destruction of the corporeal
body. For them, oil paint was one element among many others that
might be utilized to raise questions about the value of residues,
aftermaths, and remains. In another series of "paintings," Shiraga
wrestled with mud wearing nothing but a loincloth, an event that
was, as art historian Namiko Kunimoto puts it, "distinctive [for] its

investment in violence."[4] Painting, in its specifically material form, as well as in its more capacious expansions, became a vehicle for wider political questions about power and war.

In her discussion of Shiraga, Kunimoto also describes the complex masculinist ideologies embedded in the artist's practice. A striking contrast, in which gender is addressed from a contrary perspective, can be found in the work of French artist Niki de Saint Phalle, who was associated with the Nouveau Réalisme movement. In Saint Phalle's *Shoot Paintings* of the early 1960s, the artist and other participants, including the audience, aimed a .22 caliber gun at canvases covered with polythene bags of paint and other materials enclosed in plaster that, when pierced, released their bright colors in explosive bursts. Enthusiastic groups of fellow artists eagerly shot the gun proffered by Saint Phalle, including Robert Rauschenberg and Jasper Johns, whose firing resulted in thick rivulets dripping down the canvas, pooling amid the textured

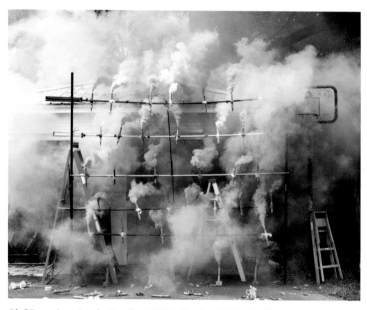

Olaf Breuning, *Smoke Bombs 2*, 2011. C-print, 47 1/4 × 59 1/16 in. (120 × 150 cm)

plaster and seeping from the bullet holes. Saint Phalle recalled, "No one ever got hurt. But after a shoot-out we always felt emptied, exhausted, like after a bull-fight."[5] She ceased this series in 1963, concerned that she had become somewhat addicted to the process.

Along with these tactile encounters, artists who push at the boundaries of painting also work with more intangible substances.

Swiss-born Olaf Breuning has taken up some aspects of Saint Phalle's painting-as-peril legacy in his *Smoke Bombs* (2008–12). For this series, Breuning places gridded scaffolding in the street, detonating colorful smoke bombs that pour vivid blues, yellows, and pinks into the air. In some respects, this is an updated response to Robert Barry's gas releases; yet Breuning turns the undetectable into the hypervisible, all the while asserting the physical means of their realization. He makes no effort to conceal his process, attaching the smoke bombs to the poles with prosaic duct tape and allowing detritus to collect underneath. A further flamboyant, even theatrical, touch is provided by his assistants, who mount ladders to ignite the fuses in full view of the public.

Shiraga and Saint Phalle were departing from paint as a way to voice a pervasive postwar anxiety about violence. One can ask whether Breuning's undeniably beautiful and ephemeral works follow suit: do they sufficiently address the real-world contexts in which smoke bombs might be encountered, such as riots and military occupations? However one answers this question, his works (along with theirs) point once again to the way that painting can be used against itself. Violence done to painting, as a foundational art medium, very easily reads as violence done to the settled narratives and pleasures of art in general.

Such gestures imply a more focused hostility, too, against the orthodoxy of "medium-specificity" that was championed by the critic Clement Greenberg in the mid-twentieth century, which he described as "the use of characteristic methods of a discipline to criticize the discipline itself, not in order to subvert it but in order to entrench it more firmly in its area of competence."[6] For Greenberg, painting's primary job was to establish itself firmly *as painting*. First and foremost, this meant an emphasis on flatness, which he saw as the "pre-eminent characteristic method of the discipline." Greenberg saw the picture plane as a field held in tension, which the successful painter had to disrupt and control, creating a "strong" image that avoided collapse into the condition of the decorative. Such a view, which is grounded in a masculinist imperative toward dominance, has long since been critiqued, if not totally abandoned.[7] The "characteristic methods" of painting may still be valuable, but if so that is precisely because of their potential to "subvert."

To what end, though? Is the assault on the boundaries of painting simply an in-house maneuver, still playing out an endgame in which art addresses its own condition? This is where an emphasis on particular materials and making practices becomes

Derek Jarman, *Blue*, 1993. Still from film

Yves Klein, *Blue Monochrome*, 1961. Dry pigment in synthetic polymer medium on cotton over plywood, 76 ⅞ × 55 ⅛ in. (195.1 × 140 cm)

crucial. To escape the logic set in train by Greenberg and perpetuated by his detractors, it helps to look not just at "painting" in its generic sense, but in its detailed procedures. Take, for example, the manufacture of pigment. Since the Italian Renaissance, when ultramarine made from ground lapis lazuli was so precious that patrons often drew up contracts specifying how much blue they expected artists to use on the paintings they were commissioning, pigment has been understood as conveying value (this topic of luxury materials used in art will be more extensively taken up later in this book, see Chapter 6).[8] French artist Yves Klein patented his "International Klein Blue" in 1961, making monochromes as well as featuring this color prominently in sculptures and performances, including ones with nude women functioning as living brushes. At the opening for his show *The Specialization of Sensibility in the Raw Material State of Stabilized Pictorial Sensibility*, most commonly known as *The Void*, at Iris Clert Gallery in Paris in 1958, Klein served blue cocktails to an audience who queued under a blue canopy, waiting to enter a room that consisted of nothing except a cabinet painted white. Art historical legend holds that this libation turned their urine blue. Like Coca-Cola's globally standardized "Coke Red," Klein's act demonstrates

a keen understanding of color choice as a facet of branding. IKB, as it is known, was developed not in the artist's studio but by the pharmaceutical company Rhône Poulenc in consultation with chemists, who helped Klein achieve his desired density of color by suspending the powdered pigment in a synthetic resin manufactured by the company. Klein's project thus marks a notable and early collaboration between painting and industry.

Blue monochrome is not the exclusive purview of Klein's brand, as is demonstrated in examples as varied as works by British avant-garde filmmaker Derek Jarman and German artist Rosemarie Trockel. In Jarman's film *Blue* (1993), an unchanging screen is a jumping-off point for interweaving voices and sounds that reflect upon the AIDS crisis. In one of Trockel's knitted paintings, *Patient Observation* (2014), the artist uses acrylic yarn to create a cobalt blue, all-over surface that is riven by slender white lines that thread down the upper edge of the frame. One would hardly call Jarman's *Blue* a painting, and Trockel's series of knitted paintings, its title notwithstanding, is arguably more akin to textiles such as tapestries. But to think about the film and the yarn piece through the lens of pigment (broadly defined) indicates that it might be a connective tissue among and through divergent media. You might say that both of these works update, translate, or politicize Klein: Jarman queers the blue with his intimate soundtrack, and Trockel speaks back to Klein's objectification of women, as her yarn falls within the realm of women's work and is in an oblique dialogue with feminism.

Artists who treat the valuation of pure color differently than did Klein, as an indicator of individual differentiation, include the Brazilian Neo-Concretist Lygia Pape, who reduced painting to a series of hues in her *Wheel of Delights* (1967). In this piece, porcelain bowls arranged in a ring are filled with colored liquids, and audience members are invited to use small pipettes to imbibe the different tones, thereby dying their tongues. Pape distills and incorporates painting, suggesting it might be an internal procedure as well as a distributed or participatory one, where the solo artist in the studio is displaced by an ever-shifting viewership. What is more, in contrast to many advocates of conventional painting, she suggests that the eye is only one – no longer the primary – organ of perception.

Another artist who considers pigment in this broader, more experiential sense is the German Wolfgang Laib, who meticulously gathers the pollens of plants and then lays them out in vibrant

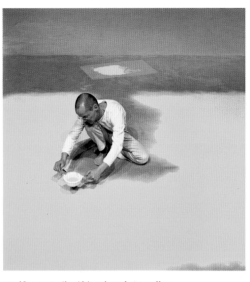

Rosemarie Trockel, *Patient Observation*, 2014.
Acrylic yarn, 23 5/8 × 23 5/8 × 1 in. (60×60×2.5 cm),
24 7/16 × 24 7/16 × 2 1/4 in. (62×62×5.6 cm) (framed)

Wolfgang Laib sifting hazelnut pollen.
Installation at Centre Pompidou, Paris, 1992

yellow geometries on gallery floors. In *Pollen from Hazelnut*, on view at the Museum of Modern Art in New York in 2013 as a radiant, room-sized installation of pollen gathered by the artist since the mid-1990s, pigment functions as a transmitter of energies (as the kernel of nascent life), as well as a conduit for meditative thought. Not everyone is enchanted by Laib's monastic approach, or the simple forms he creates with his painstakingly harvested pollen. In a review in the *New York Times*, Ken Johnson wrote, "No amount of just looking will reveal the truth of the material, how it got where it is and what it means." Tellingly, Johnson was more compelled by the short video that documented Laib in fields of flowers than by the art itself, concluding, "If the artist is more interesting than the art he or she makes, it's a problem."[9]

Johnson's claim is hardly self-evident, however. What the anthropologist Alfred Gell once called "the art cult" is arguably focused above all on the artist's persona, with the works actually made by the artist only the proof or trace of that character.[10] Even if one rejects such hagiography, there is good reason to think first about labor, and only second about results. Laib's sifted pollen squares may be beautiful, but they are primarily meant to signify the intensity of his preparation, and the life he leads through this activity. Seen from this perspective, pigment is interesting because it is *not* always a readymade; it can also be an unstable signifier of

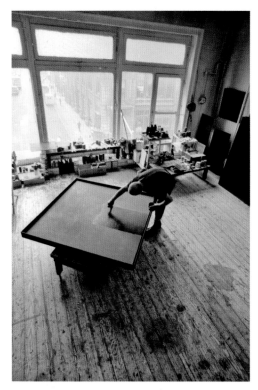

Ad Reinhardt at work in his studio,
New York, July 1966

artistic effort. For some artists, using paint squeezed from a tube or fresh from a can is akin to a massive cop-out, relying on cheap, deskilled commercial production.

Even in the 1950s and 1960s, when the likes of Pollock and Stella were using commercial, off-the-shelf paints, there were others who took this more artisanal view. The American painter Ad Reinhardt was famously picky about the materials he used for his *Black Paintings* (1953–67), whose subtle monochromes reveal themselves slowly, after a period of close looking, as gridded variations on the color black. Reinhardt claimed that he devised his black paintings to make them impossible to photograph: given the camera and printing technology of the time, his nuanced tonal compositions reproduced as solid black rectangles in an average art magazine. This devious poke against the commercial logic of the art market has proven to be even more substantial than he imagined, for Reinhardt's canvases are notoriously difficult to conserve due to the saturation and uniformity of his color.[11] Any small scratch or interruption of their velvety matte surfaces cannot be easily retouched, as his blacks are nearly impossible to recreate or seamlessly match. He achieved this effect through a multi-step process in which he mixed oil paint with turpentine, letting the turpentine separate the paint film from the oil binder and then draining off the resultant liquid, so that what was left was primarily dried pigment. It is a fine irony: though his paintings appear to erase the touch of the artist's hand, they are so carefully made that they are virtually impossible to replicate.

A rejoinder to Reinhardt's abstract approach is taken up by Kerry James Marshall, an African-American artist keenly interested in blackness not only as a chromatic value but also as a loaded

racialized designation. In his *Black Painting* (2003), Marshall gives us a canvas made entirely of shades of black, though his work, unlike Reinhardt's, is figurative, gradually revealing a murky, just-legible bedroom scene. Along with a redirection of Reinhardt, Marshall's use of all-black pigment, in which the darkness of the figures dissolves into the shadowy background, threatening to eclipse them, functions as a comment on Ralph Ellison's novel *Invisible Man* (1952).[12] Its title is also a clever play on words: Marshall is a black, painting. Throughout his oeuvre, Marshall has deployed velvety blacks that might look uniform, but, when examined closely, reveal colored undertones that have been carefully mixed. As such, these paintings are not only formally commanding artworks, but also lessons in looking carefully and in the politics of paying attention.

If Laib, Reinhardt, and Marshall infuse pigment with meaning through strategies of refinement, others have taken a more pragmatic approach. Self-taught American artist James Castle, for instance, worked with what he had on-hand, including making his medium out of a mixture of stove soot and his own spit. Castle was born deaf, and it is unknown to what extent he was able to

Kerry James Marshall, *Black Painting*, 2003. Acrylic on fiberglass, 72×108 in. (183×274 cm)

Of all the high–low collisions staged by Muniz, perhaps the most poignant is a series entitled *The Sugar Children* (1996), in which photographic portraits of black boys and girls are rendered through a negative drawing technique (highlights and white background are executed in sugar, while black skin is the uncovered paper). The fragile sugar drawing is rephotographed. The resulting pictures come across as rather sweet (both literally and figuratively), but there is an underlying bitterness in the fact that the particular children featured are from plantation families in the Caribbean. Many black workers have died over the centuries in the region's sugar trade – first as slaves, more recently as underpaid laborers – and though Muniz's portraits depict contemporary children, one inevitably thinks of the many generations who preceded them, and the brutal working conditions they endured. Nor is it incidental that sugar is naturally dark, becoming white only through refinement. (Kara Walker similarly addressed this process in her project *A Subtlety, or The Marvelous Sugar Baby*, organized by Creative Time at an abandoned Domino Sugar Factory in Brooklyn in 2014.)

Vik Muniz, *Valentina, the Fastest*, from *The Sugar Children* series, 1996. Gelatin silver print, 14×11 in. (35.6×27.9 cm)

Byron Kim, *Synecdoche*, 1991–present. Oil and wax on wood, each panel 10×8 in. (25.4×20.3 cm). Overall installed 10 ft ¼ in. × 29 ft 2 ¼ in. (3.05×8.9 m)

Muniz is just one of many artists who use pigments as a surrogate for skin tones, highlighting the ideological construction of whiteness, blackness, brownness, and yellowness. A well-known work by Korean-American Byron Kim, *Synecdoche* (1991–present), is an ongoing investigation into how skin tone does and does not map onto categories of identity. In this work, Kim paints monochromatic 10×8 inch (25.4×20.3 centimeter) panels as "portraits" of different people who have sat for him, including colleagues, friends, family, and museum employees. Arranged as a wall-based grid, the hues look vaguely like paint chips for a generic office color scheme, ranging from pinkish beige to deep brown. None are "black," none are "white," none are "yellow." Nearby, a label identifies the subjects, but as the viewer correlates the names with the panels, it becomes clear that literal color is no indication of ethnicity.

As with Marshall and Kim in the US, many other artists, including Berni Searle of South Africa and Adriana Varejão of Brazil, tap into the racialized properties of pigment and their freighted cultural associations. Searle's *Colour Me* series (1998–2000) provides a postcolonial rejoinder to Yves Klein's use of

43

Berni Searle, *Untitled (red)*, from the *Colour Me* series, 1998.
Handprinted color photograph, 16 ⁹⁄₁₆ × 18 ¹¹⁄₁₆ in. (42 × 50 cm)

women as living paintbrushes. To create these works, the
artist covered herself with spices like paprika and turmeric and
photographed herself lying face-up. Her nude, female, highly
colored body refers to the colonial history of her hometown,
Cape Town, which served as a stop along the Indonesian route
of the Dutch East India Company's spice trade. The photographs
– which portray the artist's body broken into twelve sections –
are topped with jars of spice, and her thickly coated skin, vividly
red or orange, is a hyperbolic reference to her mixed-race status
in South Africa, known under the apartheid regime as "coloured."

Brazil is another place where skin color (and gradations of color)
has had a potent social dimension. Varejão's investigation of this
theme began when she started buying tubes of "flesh colored"
oil paint from around the world, only to find that all were pinkish
white. This discovery prompted her to create a new collection of
paints, which relate to a census taken by the Brazilian government
in 1976. Individual respondents were asked to list, among other

identifying features, the color of their skin. The result was linguistic cacophony. As Margherita Dessanay writes, "the census produced a list of 136 names and locutions that, far from having scientific virtue, bear witness to how the Brazilian Portuguese language has developed imaginatively poetic words to define different color-complexions."[14] The artist chose thirty-three descriptors that seemed particularly evocative to her (including "snow white," "sun kissed," "sweet mulatto miss," and "the color of a runaway donkey") and then invented new skin tone paints to match, summoning up a utopian scenario in which each and every individual is treated as equally normative. Finally, she asked a professional painter to render her own portrait eleven times. Each of these images is identical except for the skin colors, which were chosen from the palette she had created. Varejão presents herself as both multiple and unified, a single entity composed of heterogeneous materials: like Brazil itself, or indeed any nation.

It has long been claimed that painting requires a unique set of skills, ones that have been highly prized within the fine arts. Even after the advent of relatively deskilled Modernist forms, which no longer necessarily required extensive knowledge of chiaroscuro, for instance, or foreshortening, painting has held a privileged status within the hierarchy of arts. In the contemporary art landscape, there are some who turn to painting because it is productively laden with multiple historical references. There are others who turn away from brushwork to mobilize pigment in all its many

Adriana Varejão, *Polvo Oil Colours*, 2013. Wooden box with acrylic cover, containing 33 aluminum oil paint tubes, 14 1/8 × 20 1/8 × 3 1/8 in. (36 × 51 × 8 cm)

forms – whether from a can, or smoke, or soot, or spices –
for a range of effects. Some artists have stretched the edges
of painting so far that they have almost disappeared, and still
others have addressed the latent ideology that is present in the
paint manufacturing sector, inserting themselves into the cycle
of production while the material is still in its "raw" state. What
seems clear, taking this range of investigation into account,
is that the work of painting – as a flexible medium and as
a political horizon – remains unfinished.

Adriana Varejão, *Polvo Portraits III (Seascape Series)*, 2014.
Oil on canvas, 28 ⅜ × 21 ¼ in. (72 × 54 cm) each

Woodworking

Chapter 2

In the previous chapter, we concentrated on pigments on the front of paintings, where most people think to look. But paintings have sides and backs too, and if you were to walk through an art museum storage facility, past racks of paintings packed as close as safety allows, it might strike you as quite an impressive sight. Since the mid-twentieth century, it has become customary not to frame paintings (frames seeming an unnecessary embellishment), so you can see the sides of most modern canvases. Some artists finish this exposed surface cleanly, either by painting right round the corner or, more commonly, stopping right at the edge of the front picture plane. Others are more casual, allowing drips, fingerprints, and stains to remain visible. One can learn a great deal about the attitude of artists from such details: are they careful or careless? Are the corners of the canvas tucked away neatly, like a well-made bed? Or do they overlap irregularly in conspicuous folds? It would be revealing to curate an exhibition of well-known paintings so that they could be seen only from the side. Jay DeFeo's masterful *The Rose* (1958–66), which the artist worked on laboriously for many years, is arguably as visually compelling

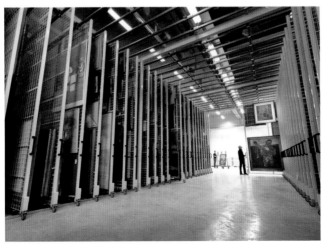

Katoen Natie Art depot for the Royal Museum of Fine Arts, Antwerp

Jay DeFeo, *The Rose*, 1958–66. Oil with wood
and mica on canvas, 10 ft 8 ⅞ in. × 7 ft 8 ¼ in.
× 11 in. (327.3 × 234.3 × 27.9 cm)

from the side, its thickly encrusted surface bulging out like a belly, as it is from the front.

Of greater interest still, because they are even more neglected, are the backs of paintings. In most cases, if you turn a canvas over you will find a stretcher: a joined framework across which the material is pulled taut. Typically, this is a simple structure made of wood, though other materials are popular too (aluminum has become a common choice owing to its lightness, strength, and flexibility). Assuming the painting is square or rectangular, the stretcher will have four sides, perhaps one or more internal braces to add strength, and simple joints: in the case of a wooden stretcher, typically interlocking miters with additional fixing hardware. More unusually shaped works are much more demanding from the point of view of construction. Getting the canvas tight across an eccentric shape is a demanding craft skill, somewhat comparable to furniture upholstery. But even a typical rectangular stretcher must be well made, otherwise the painting will warp, sag, or wrinkle. (Some artists, such as Sam Gilliam [see p. 30] and Richard Tuttle, forgo stretchers altogether and utilize the drooping and tugging of free-form cloth.)

In addition to the functional consideration of durability, a stretcher imparts to a painting a "feel," which is hard to put into words. This is dictated principally by the tension of the canvas, but also varies with the thickness of the stretcher bars, the choice of material, the presence or absence of medial braces, the method of joining the corners, and so on. The stretcher establishes a set of spatial dynamics too. It determines not only the width and height of the work, but also its depth, the degree to which the painting stands off the wall. The stretcher can even be the bearer of authorship.

Front and back views of Pamela Jorden's *Foxfire*, 2015. Oil and bleach on linen, 48×40 in. (121.9×101.6 cm). Stretchers by Craig Stratton of Beagle Easel, Los Angeles

Most painters these days do not like to sign their work on the front, because a signature is such a strong pictorial element in its own right. Therefore, they often sign the stretcher instead, though in most cases, they have not made it themselves.

A stretcher, then, is an apt symbol of the general dependence of art on underlying, unseen craft. It is where most paintings begin: before there is an image, often before there is even an idea. The stretcher determines much about the final result, but it is only if the making goes wrong that you will notice it at all. Perhaps for this reason, few painters dwell on the design and execution of the stretchers. They are thought to be incidental to artistic intention. But there are exceptions. Frank Stella, for example, has employed unusually deep stretchers to make his works project more emphatically into space, as much wall-hung sculptures as paintings. He also used the width of his stretcher bars as the unit of measure for the stripes in his early Minimalist paintings, turning a somewhat arbitrary measurement into a guiding principle. The physical construction is echoed in the painting, like a ripple in the water.

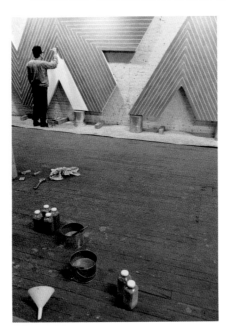

Frank Stella working, New York, 1964. Photograph by Ugo Mulas

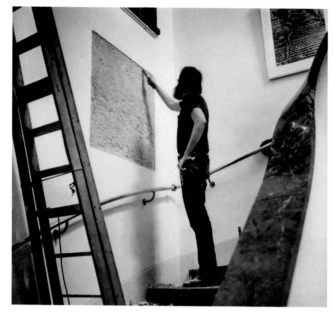

Lawrence Weiner, *A 36"× 36" REMOVAL TO THE LATHING OR SUPPORT WALL OF PLASTER OR WALLBOARD FROM A WALL*, 1968. Lawrence Weiner constructing the work for *When Attitudes Become Form: Works–Concepts–Processes–Situations–Information*, Kunsthalle Bern, Switzerland, 1969

The conceptual artist Lawrence Weiner went one better than Stella in a work entitled *A 36"× 36" REMOVAL TO THE LATHING OR SUPPORT WALL OF PLASTER OR WALLBOARD FROM A WALL* (1968). In its scale and shape, the square hole is reminiscent of an abstract painting, but the image consists only of wooden studs that are revealed by the act of cutting. The logic of the stretcher is hereby reversed, from unseen support to main event.

As works like those by Stella and Weiner demonstrate, the front and the back of art – the image and its underlying construction – do not have to be treated as if they are separate realms. They are, in fact, contiguous and mutually supporting. Stretchers are only one example of this important but under-recognized role of construction in art history. Woodworking is perhaps the most commonly encountered example and it is easy to guess why. Many artists have wood, nails, and glue on-hand, because no matter what object they create, they eventually need to ship it in a crate, and put it on a wall, base, or pedestal. Often carpentry materials are readily available. This recommends them for artistic use, as do the facts that they are relatively cheap and can be worked at different levels of skill and tooling, from the rudimentary to the masterful. When

the first Dada and Cubist collages were made by Kurt Schwitters, Pablo Picasso, and Georges Braque in the 1910s, off-cut bits of wood were a commonplace ingredient. Though such inclusions can be read aesthetically or symbolically, they were also a matter of practicality: the *collagistes* were simply using what lay ready to hand. The same is true of more recent art. Louise Nevelson, for instance, used found scraps of wood in her intricate wood assemblages, painting them in monochromatic hues, usually black or white, to unify their textured surfaces. In the photograph below of Nevelson in her studio, a kerchiefed assistant (Diana MacKown) works alongside her, with the tools of her work – a pile of nails and a can of spray paint – at the ready.

Ever since the first students arrived at Johannes Itten's *Vorkurs* at the Bauhaus or Alexander Rodchenko's classes at the VKhUTEMAS (the Moscow school that was, for a time, a center for Constructivist experimentation), an artist's initial experience of sculpture has likely been in wood. Through a simple set of craft procedures, art students can begin to explore the world of 3D form. Carpentry is ideal for aspiring artists for the same reason that it is taught to school kids: it is cheap, available, and relatively easy to manage. Indeed, some students might already have acquired woodworking skills when they were younger. (While in some national contexts woodworking has been taught to all children, in others it has historically been gendered as a primarily male pursuit.)

Of course, artists who wish to employ higher production values have many other craft idioms from which to choose. In the domain of woodworking alone, rather than borrow from basic vocational joinery, they may instead turn to carving, cabinetry, shipbuilding, coopering, and marquetry. One of the best-known carpenter-sculptors of the 1960s was Mark di Suvero, whose baroque language of form was taken from the vocabulary of house building.

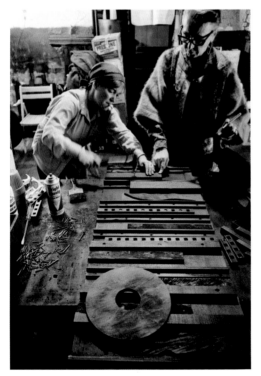

Louise Nevelson working with Diana MacKown, New York, 1964. Photograph by Ugo Mulas

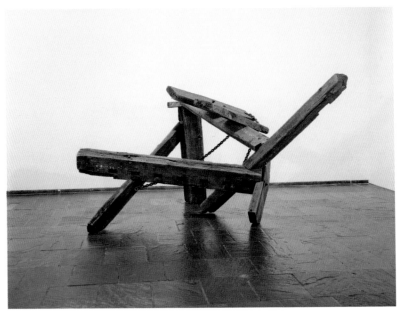

Mark di Suvero, *Hankchampion*, 1960. Wood, steel hardware, and chains, overall 6 ft 5 ½ in. × 12 ft 8 in. × 9 ft 1 ³/₁₆ in. (1.97 × 3.86 × 2.77 m)

Despite their clear indebtedness to the gestures of Abstract Expressionist painting, his early sculptures speak most powerfully of the means of their own production. *Hankchampion* (1960), for example, was made out of timbers from recently destroyed buildings that di Suvero salvaged from his neighborhood in New York City. Angled lap joints and wooden pegs, like those one might find in a trussed roof, hold the sculpture together. The timbers are found objects from a junk pile, but they seem to have been carefully selected, as they feature a number of striking compositional incidents. (A linear row of rectangular mortises, for example, could be read as an allusion to the seriality of contemporaneous Minimalist sculpture.) Even the title speaks directly of the work's fabrication: Hank, the artist's brother, helped build the sculpture, and the chains used in the work were manufactured by the Champion Company.

Di Suvero has expressed his admiration for the traditional trades, noting that "structure is something that every house builder, boat builder, and carpenter knows," and in works like *Hankchampion* he shows himself to be a keen student of these vernacular crafts.[1] Yet the sculpture is also an abstract composition. It sprawls across the gallery floor, masses held taut in a muscular dance of cantilevers and cross-forces. The constituent parts of the work may be everyday, but the overall choreography is clearly meant to be extraordinary.

This contrast, between quotidian carpentry and spectacular form, is the key dynamic in *Hankchampion*. The visual impact of the work transcends its humble origins in woodworking even as it depends upon them, as surely as a painting stands apart from but also relies upon its stretcher. Di Suvero has turned the unpromising detritus of a demolition site into compelling artistic form.

Hankchampion could also be seen as an act of hubris. Everyday means of making, not to mention the disruptions of urban change (a neighborhood dismantled), are transmuted into inappropriately heroic form. Over the course of the 1960s, just that sort of suspicion against grand gestures increasingly held sway within New York art circles: part of a more general reaction against the macho swagger of Abstract Expressionism. Effectively, this impulse meant turning away from the "front side" of art and attending to its underlying conditions. An emphatic statement of this new position, which contrasts sharply with di Suvero's exuberant personalism, is Robert Morris's *Box with the Sound of its Own Making* (1961). The work is just as advertised in the title: a walnut cube built using basic joinery techniques, inside of which is a tape recording of that process, playing on a loop. Some years later, Morris wrote:

> I believe there are "forms" to be found within the activity of making as much as within the end products. These are forms of behavior, aimed at testing the limits and possibilities involved in that particular interaction between one's actions and the materials of the environment. This amounts to the submerged side of the art iceberg.[2]

We see (or rather, hear) this "submerged" workmanship in the *Box*. It constantly plays and replays the record of its own making, without providing any further edifying information. As we hear the sounds of sawing and hammering, we perhaps have a generalized experience of being in a woodshop. But the sights and smells are missing, and it would be an attentive gallery visitor indeed who could reconstruct the sequential process of the box's making on the basis of the sound alone.

Though the *Box* is typically taken as a perfect union of form and process, the one explicating the other, it could just as easily be read as an object haunted by disjuncture. Standing in front of it, one is struck by the disparity between its visual stillness and the aural cacophony of its making, which issues forth in spectral form. We might even think of Morris's work as a comment on the "black box"

technology ascendant in the 1960s – such as radios, tape recorders, and televisions – whose exterior shell gives little or no insight into its interior workings. *Box* demonstrates just how difficult it is for an object to act as its own how-to guide.

It is notable that Morris chose walnut for the *Box* in this early construction, a wood long associated with furniture-making and known for its durability. By contrast, he also experimented in this period with structures made from plywood, a manufactured composite material that gained traction in the twentieth century for construction projects and artists alike. The art history of plywood has been traced by John Welchman, who comments that though artists like Morris and fellow Minimalists turned to it precisely for its industrial properties – its standardized look and its off-the-shelf uniformity – it was far from a neutral choice. Claiming that plywood is at once a technology as well as a material, Welchman asks, "In what, precisely, we might ask, does the honesty of plywood consist?"[3] Like the industrial paints we considered in

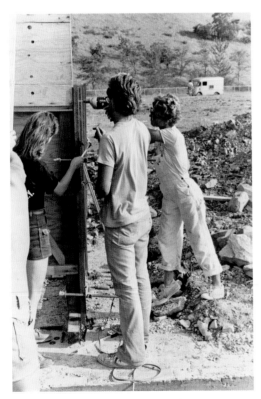

Alice Aycock at Artpark, working on '*The Beginnings of a Complex...*': *Excerpt Shaft #4/Five Walls*, 1977. Wood, 28×8 ft (8.53×2.44 m)

Chapter 1 (see p. 28), this material has a history before it ever reaches the art studio, ranging from the development of big commercial shipping to military research in World War II.[4]

Over the succeeding decade Morris would create a series of process-based works. He continually set the "limits and possibilities" of making into relief, exploring the partial gaps and connections that exist between intention, physical facture, and final form. It was a lesson that was not lost on one of his most brilliant students, Alice Aycock, who studied with Morris at Hunter College in New York. As a woman setting out into the New York avant-garde, a boys' club that was yet to reckon with feminist critique, Aycock was well aware that the deck was stacked against her. But she also had an ace up her sleeve. Her family owned a construction company, and

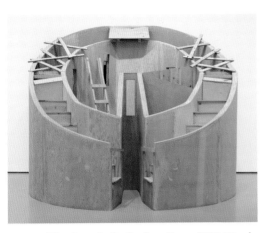

Alice Aycock, *Studies for a Town*, 1977. Wood, 3 to 10 ft high (0.91 to 3.05 m), diameter varies from 11 to 12 ½ ft (3.35 to 3.81 m)

Alice Aycock, detail of *Studies for a Town*, 1977. Wood, 3 to 10 ft (0.91 to 3.05 m) high, diameter varies from 11 to 12 ½ ft (3.35 to 3.81 m)

she had grown up in that milieu, surrounded by power tools. Aycock put this knowledge to effective use in her work. Though she drew on the building arts in general – including cinderblock and earthen construction, fiberglass, and welding – wood was her most important medium. This was, again, a matter of convenience; she was often working on site in museums and sculpture parks, and could rapidly and inexpensively draw on the resources of a local lumber yard.

Aycock rejected subtractive carving techniques, finding them too traditional: "sculpture with quotation marks around it." She oriented herself instead to the Constructivist way of working, in which abstraction is derived from simple processes like cutting and joining. She soon hit upon a middle way between di Suvero's Expressionism and Morris's recursive self-referentiality; as she put it, "structure can be a model/metaphor for the world while at the same time remaining a thing in the world."[5] Works like *Studies for a Town* (1977) exemplify this approach. Neither a grand gesture nor a closed circuit, the sculpture comes across as a prototype, or perhaps a stage set awaiting further action. This provisional quality is explored through the composition, which admits only partial views of the interior, and implies physical access without actually granting it (two stairs curve up into the structure, but they are barred at waist height). In its seemingly incomplete state, *Studies for a Town* communicates Aycock's view that fully resolved artistic forms failed to reflect the reality of experience: "the world is a mess. The moment you make your garden, the weeds come. The moment you make your house, the bomb comes."[6]

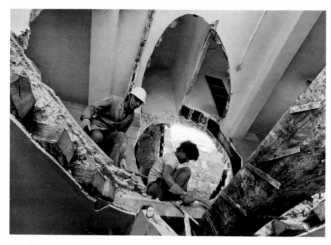

Gordon Matta-Clark, *Conical Intersect*, 1975. Still from film

Aycock was not the only artist active in New York in the 1970s who sought to replace structure with substructure. Her close friend Gordon Matta-Clark famously cut slices and conical voids into buildings, so as to illuminate the porousness between inside and outside, or private and public. Another colleague, Mary Miss, created sculptures that looked as if they had had their skins peeled off to reveal the framework within.[7] It has been said of Miss's work that "it often resembles architecture, particularly in the nascent stages of building, which can be the most appealing phase in the architectural process."[8] This generation of artists wanted, on the one hand, to be more forthright about the artistic process than their Expressionist predecessors, and on the other to indicate openness to the wide world, in all its rough and tumble disorder. They at once stripped sculpture back to its raw state and infused it with the protean energy of a building site.

This formula has proved an enduring one in contemporary art, not least because of its practicality. In the 1980s, the scale of sculpture and installation art began to increase dramatically, a tendency to

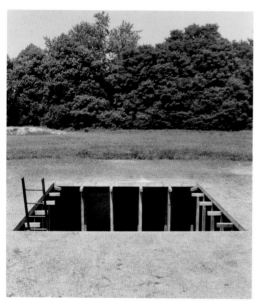

Mary Miss, *Perimeters/Pavilions/Decoys*, Nassau County Museum, Roslyn, New York, 1977–78. Earthwork

gigantism that has continued since. At the same time, the art world became more globally interconnected. For many artists, this has meant a life of itinerant, ambitious projects in which local resources have had to be quickly marshaled and deployed. Woodworking is a perfect solution. Most towns have a lumber yard and skilled carpenters, and large structures can be realized quickly, especially if they are left in a state of rough construction.

The Japanese artist Tadashi Kawamata has been particularly ambitious and effective in exploiting this method. It was famously said of Marcel Duchamp's painting *Nude Descending a Staircase* (1912) that it resembled "an explosion in a shingle factory," but the line would be more accurately applied to Kawamata's work. His projects consist of timber elements (either new or reclaimed) that are arranged into unpredictable spirals, swerving ramps, and spiky excrescences. Typically they are built in relation to existing architecture, as if a contractor's scaffolding had taken on a life of its own. Like Aycock, Kawamata sees his impressive anti-monuments as continuous with the transient urban environment:

> Building sites are always in the midst of demolition and construction. The processes are temporary and ongoing. The fact that there are such sites in every town and every large city means that there is one large cycle... I feel I am able to express the endless cycle of demolition and construction.[9]

Kawamata here voices his understanding of architecture as an ongoing process, of buildings rising into and falling out of existence. Some see a view with strong roots in Japanese culture, notably the Shinto tradition of remaking temple structures at periodic intervals. As one critic has commented:

> In his work primitive constructions meet sophisticated technology, simple craftsmanship confronts the large-scale complexity of modern civilization. In another way we could say that the organic pure wood, the archaic ground material of Japanese housing, challenges the soulless, lofty forms of Western architecture, as a "poor" counter-image to its heterogeneous hodgepodge surface.[10]

But if Kawamata's work represents an Eastern conception of the built environment, it also registers the global system of art production. Though he employs a consistent style of

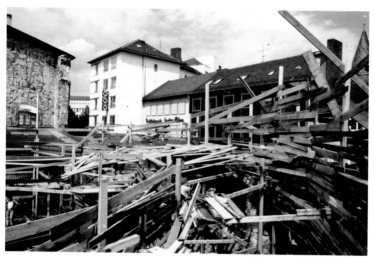

Tadashi Kawamata, *Destroyed Church*, March–September 1987. Wood. Installation view, Documenta 8, Kassel

deconstructivism in all his projects, each also has a flavor born of its locale, the materials prevalent in that particular place, and the team of assistants involved. At Documenta in Kassel, Germany, he has achieved an effect of woodsy charm; at the Serpentine Gallery, in London, an upright severity; in France, vertiginous towers of salvaged chairs that could be the deposit of a particularly concentrated tornado.

In a piece for Art Basel in 2013, Kawamata attempted to transplant one local idiom to another, with disruptive results.

Tadashi Kawamata, *Favela Café*, 2013. Mixed media installation, Art Basel, 2013, variable dimensions

Favela Café consisted of a set of catering shacks whose ad hoc construction was inspired by the urban slums of Brazil. Fair visitors could buy their morning coffee or lunchtime falafel at the café. For the artist and his team, the goal of the project was to draw attention to dire social conditions elsewhere in the world. A group of young protestors, however, found this

Doris Salcedo working. Still from "Compassion," an episode from *Art in the Twenty-First Century*, 2009

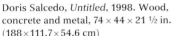

Doris Salcedo, *Untitled*, 1998. Wood, concrete and metal, 74 × 44 × 21 ½ in. (188×111.7×54.6 cm)

combination deeply upsetting. How could Kawamata think it was appropriate to create a poverty-inspired backdrop for a snack bar catering to well-heeled art professionals? They occupied the café, at first peaceably, and even built their own shacks. But eventually they were expelled by the police, a process that turned violent, involving the use of tear gas.[11]

Were the protestors right to regard Kawamata's project as offensive, or was it misunderstood? Did the conflict actually constitute a sort of artistic success, given that it transported to the settled precincts of a Swiss art fair something of the unrest of a Brazilian slum? Whatever one thinks of the incident, it certainly brought an unaccustomed degree of debate to Art Basel. Art fairs are environments in which transgressive political content is ever-present but safely contained. Perhaps it is not a coincidence that a roughly made wooden structure could precipitate such a rupture. Kawamata's café was not just a representation of the *favela*; it was a physical index of that place, a reconstruction. The clash between police and protestors was directly engendered by that materiality. As so often in the construction of art, the framework affects the result, in ways that even the artist may not be able to foresee.[12]

The aim of this chapter has been to show how carpentry can both constitute the underlying conditions of art-making, and in turn be used to address those conditions. From a painting's

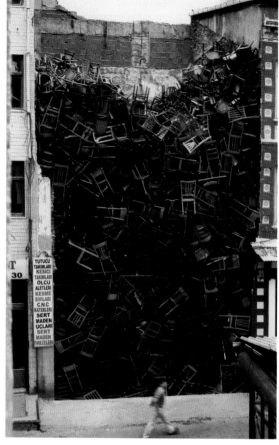

Doris Salcedo, *1550 Chairs Stacked between Two City Buildings*, Istanbul, 2003. Installation for the 8th International Istanbul Biennial

stretcher to Kawamata's sprawling installations, this trajectory has taken us from the conventional studio environment out into the broader landscape, and from the purposeful to the inadvertent. Colombian artist Doris Salcedo works at this exact intersection, making abstracted sculptures out of chairs, armoires, bedframes, tables, and other familiar household items in a way that is simultaneously composed and arbitrary, personal and generic. Sometimes she embeds these hybridized forms with hair, shoes, or other human mementoes, a visual reminder that furniture, because we live with it, has profound capacities to hold memory. Some of her works merge objects that might appear in the same house but are not usually conjoined – bed frame with wardrobe, table with bed – producing unnatural hybrids and couplings. In urban installations like the one she created for the 2003 Istanbul Biennial, with its monumental stacking of 1,550 chairs jammed between two

buildings, she evokes displaced persons (in this case, she spoke of migrants who underpin the workings of a global economy) or disappeared bodies, their material traces hauntingly left behind.

Salcedo employs a team of skilled carpenters, architects, model-builders, and fabricators who assist her in the meticulous process of creating, from scratch, "impossible objects" out of what seem to be original antique pieces.[13] Together they pay careful attention to each seam and surface, as well as to the structural and engineering problems that arise as Salcedo seeks to hammer out a new language for memorialization in Colombia and elsewhere.

A completely different aesthetic, which nonetheless shares Salcedo's roots in the everyday, can be found in the work of Martin Puryear. He has a claim to being the most skilled artisan among contemporary American sculptors, and this has been a contentious issue for him: until very recently, artists who ply their own hands with consummate skill have often found themselves accused of being mere craftsmen. Early works like the serene *Some Tales* (1975–78), which comes across as the half-dreamt reminiscence of a wall of farm tools, may have further encouraged this attitude in Puryear's case. Against this, one must place his extraordinary gifts as a form-finder. In works made principally of wood, but also sometimes involving tar, wire mesh, woven rattan, and other simple materials, he has shown how techniques usually devoted to support

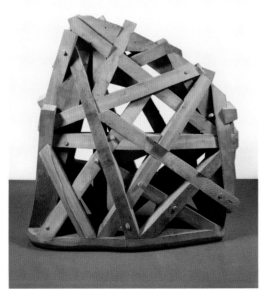

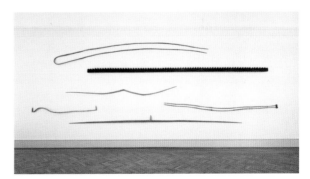

Martin Puryear, *Some Tales*, 1975–78. Ash and yellow pine, approximately 30 ft (9 m) long

Martin Puryear, *Thicket*, 1990.
Basswood and cypress, 67×62×17 in.
(170.2×157.5×43.2 cm)

can become the main event. Unlike Mark di Suvero, whose *Hankchampion* raids the toolbox of architectural joinery to dramatic effect but does not actually employ the skills of that craft, Puryear attends very carefully to professional carpentry and infuses his work with the compositional intelligence of that trade. The results have imposing monumentality, though they exist mainly at the scale of the body. *Thicket* (1990) is a good example: a sculpture of almost Flintstone-like simplicity, with large dowels protruding from each joint. Yet its overall form – a leaning fin, like that of a plane or a fish – is achieved only through rigorous attention to detail. No two of the work's many joints are identical.

It is intriguing to see how woodwork, whether it is an arrangement of slats, a basic chair, or a full-scale inhabitable building, sets the terms for artistic engagement with the outside world. A final example may serve to show the depth that artists can find in construction: the works of Cuban artists Los Carpinteros

(Spanish for "The Carpenters"), consisting of Marco Castillo and Dagoberto Rodríguez, and until his departure from the group in June 2003, Alexandre Arrechea. As their name implies, Los Carpinteros adopt an artisanal, guild-like approach to the making of art. They are themselves skilled woodworkers, and much like Aycock, Miss, Salcedo, or Kawamata, their objects tend to occupy a middle ground between furniture, architecture, and sculpture. They have pulled off various feats of craftsmanship in the course of their careers, from a living room seemingly suspended in mid-explosion to a full-scale lighthouse lying on its side. They also make furniture in the shapes of particular buildings with political importance in Cuba: a way of domesticating them, perhaps,

Los Carpinteros, *Someca*, 2002. Watercolor and pencil on paper, 94 1/8 × 60 in. (239 × 152 cm)

Los Carpinteros, *Globe*, from the *Sala de Lectura* series, 2015. 3D rendering

or knocking them down to size.[14] Like many carpenters past and present, they make lovingly detailed drawings of the objects they envision. A great deal of labor is necessary to execute each design, which may or may not be realized.

The works that have gained Los Carpinteros most attention in recent years are open cages made of timber, which recall oversized architectural models, or perhaps library shelves. The artists refer to the structures as *Salas de Lectura* (1997–present), or "reading rooms." They are large enough to inhabit, and in fact Los Carpinteros have made one for Art Basel Miami, the Florida spinoff of the fair that commissioned Kawamata's controversial *Favela Café*. It served as a bar, and though in this case no protestors took offense, it was a similarly pointed juxtaposition of art world conviviality and sociopolitical content. Other similar structures have been made for temporary gallery displays. The *Salas de Lectura* are inspired by the Presidio Modelo, a prison on the Isla de la Juventud near Havana. This massive jail is thickly overlaid with history. Though it was built in the 1920s, its design was inspired by the Panopticon prison famously imagined by

65

Jeremy Bentham in 1785. Bentham's idea is both ingenious and disturbing: a building centered on a single guardpost, from which one warden is able to see many hundreds of prisoners. Though he can only survey a few cells at a time, each prisoner must behave as if he is under surveillance at all times. As the theorist Michel Foucault has written, the prisoners internalize this sense of being watched, effectively disciplining themselves.[15] The Panopticon was not realized according to Bentham's plans in his own lifetime, but the Presidio Modelo is a direct application of the concept. During his revolutionary youth, Fidel Castro was imprisoned there; now the building is a museum, used by the Communist government as the damning evidence of Cuba's oppressive colonial past.

In 2015 Los Carpinteros created a permanent *Sala de Lectura* as a commission for the Victoria and Albert Museum (V&A) in London. It is installed at the center of a series of displays devoted to European art and design, and more specifically, in a gallery on the topic of the Enlightenment. This was the time of Bentham, when omniscience was a goal animating not just prison design, but many scientific disciplines as well. The dream of the Enlightenment – one that is still with us – was of complete comprehension, in which all people, all objects, all facts are gradually revealed to knowledge. That impulse was at once democratic and domineering. On the one hand, the Enlightenment impulse was to create equivalence between cultures and a secular understanding of society; on the other, it suggested that closely held secrets (like those of religions, or indeed craft guilds) were obstructive mystifications.

Los Carpinteros' wooden structure reminds us of both the power and the limits of the Enlightenment's attempt to grasp the world.[16] The simple fact that the artists are from Cuba, a nation that was on the receiving end of imperialism, emphasizes that the Enlightenment's pretense to universality disguised its fundamentally Eurocentric character. Standing in the middle of this great half-globe, you are struck by the way it organizes itself around your body. Each carefully finished joint angles toward you, a single, central point of reference. Metaphorically, it puts you right in the place of that Enlightenment observer, or the warden of the Panopticon. But you are imprisoned too. This wooden framework, a piece of quasi-architecture, is a gentle rebuke to those who would claim dominance, or even understanding, of global conditions. Like the stretcher behind a painting, or any sound artistic construction, it provides a platform from which thoughts may take flight.

Building

Architecture is often called "the mother of the arts," because it incorporates so many different trades. Painting, bricklaying, sculpture, ceramics, wood- and metalworking, concrete forming, glazing, lighting, and plastics are all part of it. It is appropriate that our word for this discipline derives from the Greek words *arche*, "master," and *techne*, "craft." Both the historic roots and present practice of architecture are dependent on the work of numerous skilled artisans.

These days, when we think of a professional architect, we usually imagine someone at a drafting table, or more likely a computer screen. Only one technical skill is typically taught in architecture schools – drawing – and it is meant to be used legislatively, to direct all the constructive processes that might go into a structure. As in other branches of design, particular means of drawing tend to result in particular types of buildings. Traditional academic draftsmanship is an ideal way in which to render classical architecture, with its long-established systems of articulation and ornament, while contemporary computer-aided drawing (CAD) systems and associated engineering software enable architects like Zaha Hadid to abandon straight lines altogether. Drawing is also important because it communicates across the conventional divide between "architecture," as a branch of design, and "building," as a repertoire of practical techniques. Architects draw, builders make. Traditionally they are different people with different skill sets, and, often, from different social classes.

In the past thirty years, some writers and practitioners sought to break down this distinction, arguing that the lasting value of a building is to a large extent determined by how it is made.[1] This represents a turn back to the foundational roots of architecture as a "master craft," and away from the view of the discipline, particularly common in the 1970s and 1980s, that the most important aspect of a building was its ability to communicate to the public through imagery, ornament, and functional program.[2] Since the 1990s, increasing stress has instead been laid on questions of technology,

Zaha Hadid Architects, digital render of Abu Dhabi Performing Arts Centre, 2008

sustainability, and workmanship. These factors had been
central to Modernists in the early twentieth century, too. But
their re-emergence today does not presume a core "truth" in
building, which often marked Modernist practice. In short,
craft has returned to the center of architectural discourse, but
it is now seen in expressive, rather than fundamentalist, terms.

Bricks, steel, and concrete – all traditional materials of the
building trades – have also been employed by artists, and for much
the same reasons that they are used in architecture. All are strong
and durable, suitable to monumental construction. Each has its
own particular compositional role to play: bricks are identical units,
so they introduce modularity into a structure, and can be arranged
in patterns across a substantial area; steel I-beams (named for their
shape in cross section) provide great strength across a lateral span
or in the vertical axis, and are ideal for the creation of armatures
on which other materials can be mounted; concrete can be cast into
any form and is incredibly obdurate, particularly when reinforced
with internal metal rebar. All three materials allow sculptors to
achieve large scale, so that their work can indeed compare in size
with buildings. In this chapter we will survey the applications of
these materials by artists, showing how they think in ways that
are sometimes akin to their colleagues in architecture and the
building trades, and at other times distinctly different.

One starting place for this discussion is the work of Carl Andre, which refers explicitly to the trade of bricklaying. There are conspicuous and important differences between Andre's sculptures and the low walls or sections of flooring that they superficially resemble. Firstly, they are unjoined – no mortar holds them together – so they can be taken apart and rearranged at will. Secondly, they lack any decorative pattern (herringbone or the like) or structural interlocking. They are not a displacement of the mason's craft into a sculptural context, but rather a simplification or abstraction of that craft.[3] As Andre put it in 1972, "I don't want the detail of a structure to be interesting, you know, beautiful effects and so forth. This doesn't interest me at all. I want the material in its clearest form."[4]

Andre's brick works constitute a baseline position for building-as-sculpture. They involve certain key elements of architecture – composition, materials, and site – but present these with a minimum of elaboration. The only compositional given is gravity, a force that Andre acknowledges through simple decisions like laying the bricks face down, instead of on edge. Yet this direct approach, so typical of 1960s art and architecture alike, was not necessarily incompatible with a more expressive attitude to form. In Chapter 2, we discussed the work of Mark di Suvero, whose dynamic compositions draw on the vocabulary of house carpentry (see p. 53).

A roughly contemporaneous figure in Britain, Anthony Caro, pursued a similar sculptural syntax using architectural steel.

One of Caro's earliest abstract works, *Midday* (1960), typifies his breakthrough style. From some directions *Midday* appears to be a random jumble of sectioned I-beams; from others a clear, almost representational, pictorial image. (Its stance vaguely echoes that of a rearing equestrian sculpture.) Unity is provided by an overall coating of sunshine-yellow paint. This cancels out the specific history and purpose of each metal part; as Caro puts it,

Anthony Caro, *Midday*, 1960. Painted steel, 7 ft 8 ¾ in. × 37 ⅞ in. × 12 ft 9 in. (235.6 × 96.2 × 388.6 cm)

"I take anonymous units and try to make them cohere in an open way into a sculptural whole."[5]

Caro had arrived at the point of making *Midday* following an encounter with the work of David Smith, a major American sculptor who incorporated architectural materials in his work. Though (like Caro) he began with traditional bronze casting, in the 1950s he began to weld together existing pieces of metal: scrap, tools, mesh, boiler lids, and rebar. Gradually he incorporated monumental elements, including I-beams. Even as Smith adopted the repertoire of a builder, however, he voiced a certain ambivalence: "by choice I identify myself with working men and still belong to Local 2054 United Steelworkers of America. I belong by craft – yet the subject of aesthetics introduces a breach."[6] Here he voices a theme that we will encounter again and again in this chapter: the tension between the artist's practical affinity with construction workers and other professional artisans, and the self-conscious feeling of difference that derives from the class issues introduced by artists' cultural capital.

Throughout Caro's career he tried to downplay references to architectural construction, insisting that his interest was in pure form. But *Midday* is festooned with rivets, which hold it together in a manner that seems in excess of requirements. It is as if the forces present in the skeleton frame of a towering skyscraper have been imported into the sculpture, which is not that much taller than a person (about 8 feet high by 12 feet long [2.4×3.7 meters]). Caro made it in a garage, but he was plying a trade that is practiced by construction workers many stories above ground, which seems appropriate, given his intention both to master and transcend the materials at his disposal.

In the 1960s, Postmodernist theorists within the field of architecture began to argue for a less masterful, more contextualist approach, in which multiple factors embedded in and surrounding the work were fully acknowledged. In architecture this led to an emphasis on the façade of the building: the way it addressed its environment. Contextualism meant recognizing the existing neighborhood, rather than interrupting it. This in turn led to an understanding of the built environment as an ongoing compromise, in which multiple forces are constantly in play: zoning laws, economic imperatives, conflicting interests, and layered histories. Buildings inhabit a complex and contradictory fabric, and architects were increasingly alive to this.[7] Postmodern thinking in fine art paralleled these ideas, often focusing on institutional or commercial contexts for display. This might involve emphasizing issues of class,

gender, or race, or prevailing political conditions rather than purely formal issues.

It was at this moment (1979, to be exact) that the art historian and theorist Rosalind Krauss published her celebrated essay "Sculpture in the Expanded Field," which sought to establish a theoretical continuum between artistic and architectural thinking. Krauss argued that sculpture had lost its traditional monumental role of marking an important spot, like an urban square or a battlefield, and had entered a condition of "sitelessness, of homelessness, of absolute loss of place."[8] (Indeed, ambitious art and architectural projects often result in the displacement of local residents, and hence cause actual, rather than metaphoric, homelessness.) Krauss further posited that, in this Postmodern condition, artists were maneuvering between three previously distinct categories – sculpture, architecture, and contextual landscape – arriving at new categories of form such as the "marked site" and the "axiomatic structure." Krauss's careful parsing and labeling of the options seems overly systematic in retrospect, an ambitious but ultimately quixotic attempt to bring taxonomic order to the wild variety of contemporary art. What has proved more lasting is a simpler idea: her framing of the problem summed up in the phrase "expanded field." She had captured the sense that art was now loose in the world, contingent within the broader environment.

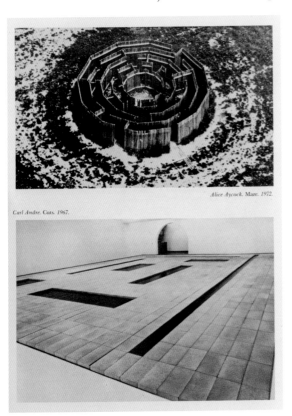

Alice Aycock, Maze, 1972, and Carl Andre, Cuts, 1967, as illustrated in Rosalind Krauss, "Sculpture in the Expanded Field," 1979, p. 40

Krauss's essay is not usually considered in relation to construction techniques, but the building trades were an important backdrop for her discussion. The images that illustrate "Sculpture in the Expanded Field" include some of the carpentry-based work discussed in our previous

chapter – Robert Morris, Mary Miss, and Alice Aycock (see p. 55–58) – as well as a brick floor piece by Andre, earthworks and installations of plate glass by Robert Smithson, and an installation by Joel Shapiro captioned as *Untitled (Cast Iron and Plaster Houses)* (1975). To her, these works seemed to attest to an "infinitely malleable" condition for sculpture. But in terms of their physical makeup, nearly all had in common the repertoire of the building trades: brick floors, timber frames, and glass windows. Even Smithson's fabulously complex *Spiral Jetty* (1970), which he buttressed with a pseudo-documentary film and a densely theoretical explanatory text, was at the most basic level a deployment of equipment normally used to clear a lot and lay a foundation.

The point of this observation is not to diminish Krauss's contribution in defining new conditions of sculpture, but rather to note the consequences that artists faced as their productive means expanded. For Andre, it was an imaginative leap just to see that bricklaying could be a valid means of making art. For the next generation, the possibilities afforded by materials and process cracked wide open. Art entered an unprecedented period of formal experimentation. From the point of view of making, however, there is no such thing as "infinite malleability." Operating in the "expanded field" requires a concrete involvement with, and dependence on, long-established trades.

Theaster Gates, *Dorchester Projects*, 2013: *Archive House Past* (2009) and *Present* (2013)

In the years since Krauss wrote her essay, artists have developed an increasing respect for building as a practice. Many have come to see that materials are not just conduits for ideas; they are imbued with their own particular narratives and lifecycles. Artists of the 1960s had certainly been concerned with the aesthetic possibilities of masonry, wood, and iron, and, to a lesser extent, the social connotations of such materials. But this register of their work was generalized and implicit. Bricks and girders were used without reference to particular historical circumstance. This has changed in recent years, as artists have sought to bring sculpture closer to the condition of traditional crafts – such as pottery and weaving – and try to highlight how those materials have their own stories to tell.

Theaster Gates, who began his career as a potter, is an outstanding example of such an artist. In his celebrated initiative *Dorchester Projects*, he has transformed a small district of abandoned buildings in Chicago into a multipurpose community center. Almost everything in the project is recycled. There are libraries of books, magazines, and slides that had been deaccessioned by other institutions, and an archive of used vinyl LPs, secured from a closed-down record shop called Dr Wax. The architecture of *Dorchester Projects* is similarly composed of salvaged materials, from derelict sites all over Chicago – wood slats from an ex-bowling alley, terracotta slabs from a former bank – which are either used in construction or to make salable artworks. The *New York Times* has noted that Gates's strategy is "a kind of circular economy whereby his urban interventions were being financed by the sale of artworks created from the materials salvaged from the interventions."[9]

The building as a site of further interaction, performance, and use is of particular importance in this work. *Dorchester Projects* includes a cinema, a kitchen, and plenty of other places in which to gather. For Documenta 13 – the international art exhibition in Kassel, Germany – Gates created a similar environment for occupation. Working closely with his longtime collaborator and lead fabricator, John Preus, and a crew of assistants, he transported scavenged materials from Chicago and used them to reimagine a ruined nineteenth-century hotel in Kassel, called Huguenot House. The project draws a poetic analogy between the Huguenots (Protestants who fled religious persecution in France in the seventeenth century) and African-American migrants who came to Chicago in the decades following the Civil War (1861–65). While the converted hotel is rich in layered history, it came alive when activated by music, discussion, and video projection.

Theaster Gates, *12 Ballads for Huguenot House*, 2012. Installation view, Documenta 13, Kassel, Germany

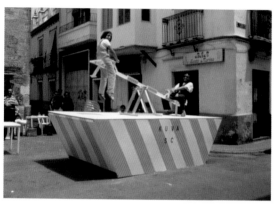

Santiago Cirugeda, *Skips*, *S.C.*, 1997. Occupation license, steel beams and sheets, wooden boards, paint, variable dimensions

A question that is perennially asked about Gates's practice is whether it counts as sculpture, performance art, architecture, design, or urban planning. The answer is that he is exploiting the edges and overlaps between all these categories, leveraging the financial possibilities afforded by the art world and applying them to the problems normally faced by planners. This is just one example of how the disciplinary transgressions probed by Krauss in her "Expanded Field" essay continue to be relevant today.

Worldwide, other difficult-to-classify practitioners are carving out possibilities in the interstices of practice. Santiago Cirugeda, for example, has gained notoriety for a series of unauthorized projects in Spain. One initiative began when he applied for an extension to his own apartment and was refused planning permission. His response was to construct (legal) scaffolding outside his building, supposedly to remove graffiti, and then secretly build the desired extension inside the scaffold's structure. He went on to exploit the same loophole to create aboveground homeless shelters, which huddle against buildings, in public space yet hidden from view. In another project, Cirugeda obtained permission to locate a dumpster in a poor neighborhood, ostensibly for waste removal, and then turned it into a playground for local children. In theory his proposals for a more progressive urban landscape are "open source," in the sense that anyone is invited to apply them to their own environment. Cirugeda's projects probe at the boundary between the legal and the unauthorized, but his own professional status as an artist/architect is critical to his practice. Like Gates, he takes advantage of the creative license afforded to artists – in his case, to push at the boundaries of

regulatory regimes – and uses it to draw attention to the
unattended needs of his own community.

Teddy Cruz also works at the borderline of art and architecture,
as well as at another border: the Mexico/USA line, south of San
Diego and north of Tijuana. This landscape is shaped by dramatic
social asymmetry, with people living in poverty only a few miles
from manicured suburbs. Waste materials such as used tires and
dismantled old bungalows find their way south across the border,
where they are adapted into impromptu housing. While much is
made of the disappearance of manufacturing from the US, this
region is heavily developed with factories because of the abundance
of cheap labor. Cruz's architectural propositions respond to these
conditions. "As factories get cheap labor from slums around them,
they should contribute with micro-infrastructures for housing,"
he notes. "The site of design intervention is the factory, infiltrating
existing systems of production."[10] His projects therefore mimic
the collaged and recycled structures of Tijuana, or are made up
principally of industrial products intended for other purposes.

Another artist who has been inspired by Mexican building
practices is Abraham Cruzvillegas, who grew up in an area of

Teddy Cruz, rendering for *Manufactured Sites*, 2008

have found its way to a kitchen countertop or ornamental frieze, is beautifully carved on the basis of innumerable data points tracking the earth's topology. Lin has noted the importance of the work's artisanal character: "It's a process that balances scientific data with the handmade. If the end form looks only like the idea of the information, then it fails."[13] Made in the immediate aftermath of Hurricane Sandy, which devastated New York City, and motivated by Lin's environmentalism, the piece is an effort to direct our attention to the world that lies beneath our feet.

Cast concrete affords another, still more sobering, example of construction materials as the bearer of social narrative. Many artists have adopted concrete because it so effectively indexes a history of urban decay. It was a commonplace in the 1980s, observed in film (the dystopian milieu of Ridley Scott's *Blade Runner*, 1982), design (Ron Arad's bashed-up *Concrete Stereo*, 1983), and in architecture itself (the work of Arata Isozaki, for instance). It was also embraced by many artists in the period, such as the German sculptor Isa Genzken. While Genzken is prolific and varied in her choice of materials, she produced an unusually focused group of works in the late 1980s and early 1990s: arrangements of rough concrete slabs atop metal armatures. Though they mimic the proportions of sculptural busts set on plinths, they also look like architectural ruins in miniature, "their pockmarked walls," as one critic notes, "often suggesting buildings on the verge of collapse."[14] Given the artist's nationality, it is not difficult to read into these works a whole range of historical associations: the military bunkers and bombed-out cities of World War II; the Berlin Wall, still standing when Genzken began the series; or perhaps the derelict social housing of East Germany.

Standing in front of the sculptures, which face an adult viewer at eye height, one feels

Isa Genzken, *Marcel*, 1987. Concrete, steel, 79 ½ × 21 ¼ × 18 ⅛ in. (202 × 54 × 46 cm)

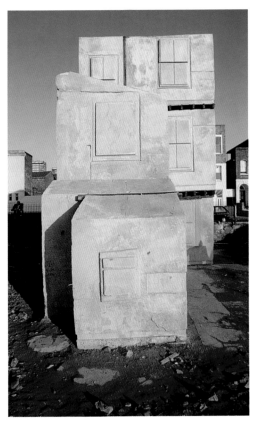

Rachel Whiteread, *House*, 1993. Mixed media

confronted by this history.[15] Crucial to the effect is the surface quality of the works. As builders know well, concrete picks up every detail of the means used to cast it. The mold's interior can be read in reverse: its joints, injection points, and if timber or plywood planks are used, even its wood grain. It is also easy to tell how carefully the cast has been made. Air pockets and other surface imperfections are created when it is poured rapidly, or allowed to dry too quickly. On all these counts, and like the historic built structures they reference, Genzken's sculptures are conspicuously shoddy. They look like battered remnants, survivors of difficult history. The act of casting itself, in which an absence is made present, serves as a metaphor for this engagement with memory.

A similar dynamic is present in the work of the British artist Rachel Whiteread, who also uses concrete and other materials to give substance to negative space. In the artist's best-known early project, *House* (1993), she cast the entire interior of a Victorian

residential building in East London that had been scheduled for demolition. Though the sculpture quickly achieved art world acclaim, the local council considered it an eyesore, and it was itself demolished a short time after it was completed. In making *House*, Whiteread took advantage of two simple facts about the casting process. First, the mold used to make a cast is discarded after use. Its shape hovers, a ghostly negative version, around the finished object. In Whiteread's project the original house is the mold, and its absence is used as a metonym for the disappearance of those who had lived there.

Second, when making a cast, the mold's interior contours are exactly replicated in the finished sculpture's exterior, but in reverse. Just as printmakers must plan for their images to flip 180 degrees, a caster must be able to think inside out. The psychological effect of Whiteread's *House* depended on this inversion. It is possible to look at a photograph of the sculpture for a long moment before realizing that you are seeing the inside contours of the front door, walls, and windows. These are the surfaces that the inhabitants would have seen and touched. Whiteread turned a private space into a public monument, at the same time rendering it absolutely still, tomblike.

A further obvious but little-mentioned fact about *House* is that it is not cast from a single volume. Rather, it is made up of multiple casts of the building's separate rooms, stacked on top of one another. Instead of leaving gaps where the walls and floors had been, Whiteread opted to compress the house's interior voids together into a single negative-made-positive space. This decision, reminiscent of the gravitational imperative in Andre's brick works, emphasizes the weight of the concrete imposed on the site.

This same dramatization of mass, as well as Whiteread's reversal of concrete's usual constructive role, has been explored by Oscar Tuazon. His major installations might be described not as site-specific but rather site-aggressive. In *Bend It Till It Breaks* (2009), Tuazon suspended a set of concrete beams from a wooden truss using a set of pulleys. The construction was elaborate but purposeless: as Sonia Campagnola has written, "these elements are combined with no other mission than to sustain each other in a dysfunctional, implicitly critical way."[16] In *My Mistake* (2010) he created a framework of enormous beams (in timber rather than concrete) that literally burst through the walls of the Institute of Contemporary Arts, London, over-filling the volume and penetrating the permanent architecture.

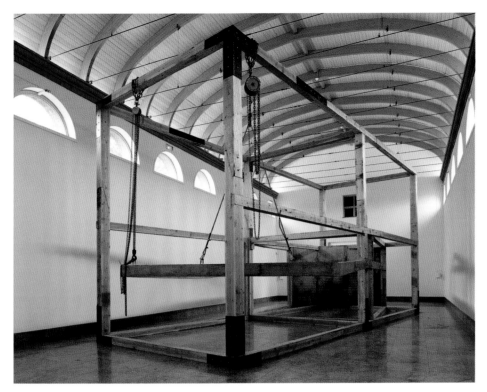

Oscar Tuazon, *Bend It Till It Breaks*, 2009. Wood, steel, and concrete

Rather than prioritizing conception over execution, like Anthony Caro, or seeking an ideal minimum state for the expression of materiality, like Carl Andre, Tuazon hurls himself bodily into the making of sculpture. He has even provided a manifesto to this effect

Oscar Tuazon, *I use my body for something, I use it to make something, I make something with my body, whatever that is. I make something and I pay for it and I get paid for it*, 2010. Concrete, reinforcing bar, mesh, approximately 30 $^5/_{16}$ × 177 $^3/_{16}$ × 161 $^7/_{16}$ in. (77 × 450 × 410 cm)

in the lengthy title of one of his works: *I use my body for something, I use it to make something, I make something with my body, whatever that is. I make something and I pay for it and I get paid for it* (2010). The sculpture is a simple, low, concrete table, which the artist has knocked into semi-destruction using a sledgehammer. The nod to Minimalism is clear, as is Tuazon's intention to depart from any sense of that movement's confident control or formal mastery. He

83

prioritizes his own labor over any other consideration, presenting himself in the guise of a DIY demolition man, a hired hand, rather than as an architect with a drafting board and a site plan.

At the logical extreme of this orientation toward brute labor stands the provocative figure of Santiago Sierra. In *Cubes of 100 cm On Each Side Moved 700 cm*, staged in Switzerland in 2002, he hired six Albanian refugees without work permits to move three heavy concrete cubes from one wall of a gallery to the other. Their struggle to shift the weight was a Sisyphean plight, painful to behold, as a visual enactment of the uneven legalities of migrant labor. It was reminiscent of the everyday tasks of warehouse workers, or indeed preparators shoving heavy display plinths around an art gallery. A particularly ambitious and frightening project of Sierra's involved loading concrete blocks into the Kunsthaus in Bregenz, Austria, until it was near its stated load-bearing limit of 300 tons. Up to a hundred gallery visitors were allowed in at a time, a weight that theoretically brought the building to the very brink of collapse. Here the casual bravado of Minimalist work returns with unapologetic force.

In Sierra's work, we encounter the building materials of architecture not in the guise of functionality, but rather as something potentially terrifying and deathly. Concrete and steel

Santiago Sierra, *Cubes of 100 cm On Each Side Moved 700 cm*, 2002.
Performance at Kunsthalle Sankt Gallen, Switzerland, April 2002

Shinique Smith, *No dust, no stain*, 2006. Mixed-media installation

structures can, when bombed or shaken by earthquakes, turn from housing or office buildings into mass graves. In much recent sculpture, there has been a broader tendency to fixate on themes of collapse and detritus: a sense that no edifice is truly built to last. The exhibit *Unmonumental*, which opened at The New Museum in 2007, defined the moment by tapping into a deep well of sculptural indeterminacy. As critic Lane Relyea wrote in his review of the exhibition, "An outfit that is entirely makeshift, that is nothing but fragments and temporary solutions, is surprisingly well suited to negotiate today's entrepreneurial and communicational mandates."[17]

One of the participants in *Unmonumental* was Shinique Smith, who began her career as a graffiti artist and then moved on to making complete architectural interiors. In these spaces Smith applied the coloristic, gestural sensibility she had acquired while creating graffiti, but incorporated a diversity of other materials, particularly textiles. This material would become increasingly important for her as she developed a series of sculptures using

Shinique Smith, *Bale Variant No.0020*, 2011. Clothing, fabric, twine, and wood, 72 × 28 × 28 in. (182.9 × 71.1 × 71.1 cm)

bundled and wrapped cloth and garments. These "bales" recall unwanted materials that are gathered in the USA and then sent to recycling centers abroad: often to Africa, Latin America, or Asia. Smith's sculptures emulate hard-built Minimal forms, but are composed of provisional materials saturated with transcultural associations. By constructing her work from soft, degraded materials, rather than unyielding materials like metal and concrete, she mounts a critique of the culturally narrow, heroic mode that has often typified abstract art. In this way she pushes against the remaining boundaries that still delimit the "expanded field" of sculpture.

Smith, like many of the artists shown in *Unmonumental*, came of age when the events of September 11, 2001 loomed large for the US, and the New York City art world in particular. It is unsurprising that images of breakdown and ruination have such prominence in art made since. The physical traces of 9/11, relics of the World Trade Center, are themselves reminders of that day, and have been widely exhibited: chunks of concrete, twisted steel, scorched fire

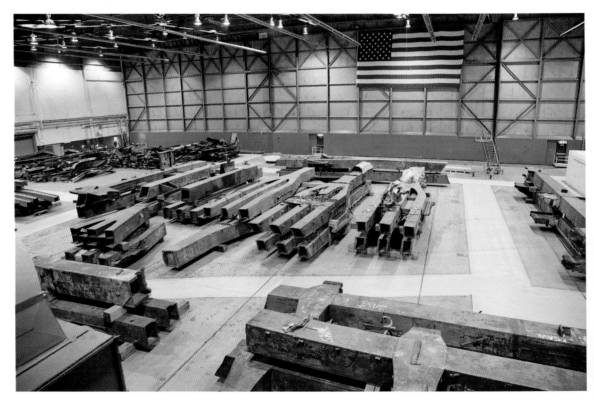

Artifacts chosen by curators out of the wreckage from the World Trade Center, stored temporarily within an 80,000 sq. ft (7,432 sq. m) hangar at JFK airport. Some of the artifacts are now displayed in the National September 11 Memorial Museum, which opened in 2014

Miya Ando, *After 9/11*, 2011. One piece of World Trade Center steel, 28×10 ft (8.53×3.05 m)

Isa Genzken, *Hospital (Ground Zero)*, 2008. Artificial flowers, plastic, metal, glass, acrylic paint, fabric, spray paint, mirror foil, fiberboard, casters, 122 7/8 × 24 3/4 × 29 7/8 in. (312×63×76 cm)

engine parts. These remnants are already too fraught as manifestations of memory. How can art provide an adequate response? The work of American sculptor Miya Ando offers a cautionary tale. When she turned detritus that had been found in the wreckage into a memorial on the tenth anniversary, reactions were decidedly mixed. Originally intended for a London park, the sculpture attracted criticism, lost its original site, and ended up being stored on a farm under a blue tarpaulin. At the time of writing it is unclear whether it will have a permanent home.[18]

Isa Genzken, whose concrete works of the late 1980s were so determinedly downbeat, has provided an artistic response to 9/11 that is unexpectedly affirming. In a series of fictional proposals for rebuilding Ground Zero, she eschewed architectural materials; nor do the objects even really look like buildings, apart from their generally vertical orientation. Instead, they are made up of everyday items: trolleys, ribbons, bins, etc. One piece is crowned with a bouquet of plastic flowers, an echo of the impromptu memorials set up on streets all over New York in the aftermath of the attacks.

These sculptures have been described as "ungainly, chaotic things," but also "ludicrously optimistic designs... in their belief in alternatives that could be made possible."[19] This optimism is a goal that architecture itself, for all of its utopian schemes, has always struggled to achieve, trapped as it is by the constraints of funding, regulation, and authority. How can architecture practically and imaginatively account for the varied bodies, and lives, of those who might inhabit its structures? Genzken's assemblages of found objects allude to the act of building, but they are unfettered by such realistic constraints. All the same, they provide us with a conceptual tool for engaging with the aftermath of a crisis. With Genzken's works we reach one possible end of the brick road first laid by Carl Andre: a path that winds in and out of architecture, and permits us to see this "master" discipline anew.

Performing

Chapter 4

On September 30, 1978, Taiwanese-born artist Tehching (Sam) Hsieh commenced the first of a series of extreme durational performance pieces by locking himself in a cage and committing to remain there, with no exceptions, for an entire year. A cliché about performance art is that it involves artists enacting strenuous tasks, like Oscar Tuazon's sledgehammer work discussed in the previous chapter (see p. 82). *One Year Performance 1978–1979*, which is commonly referred to as *Cage Piece*, however, gives us a model of performance not as hard labor, but rather a state of what could be called hard *languor*. Hsieh built himself a cage out of pine dowels in the corner of his New York City apartment, and outfitted it with the barest of furnishings: a bed, a pail, and a sink. For his year-long confinement, he brought with him no reading material to pass the time, no radio to listen to, no television to watch, and no notebooks in which to scribble his thoughts. According to the rules of his own vow of silence, he also did not speak. After

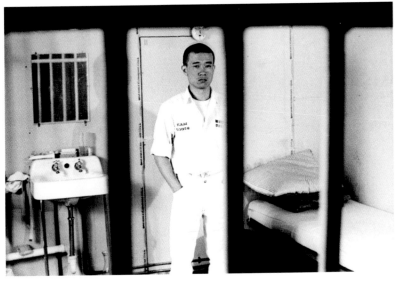

Tehching Hsieh, *One Year Performance 1978–1979*, 1978–79. Life image

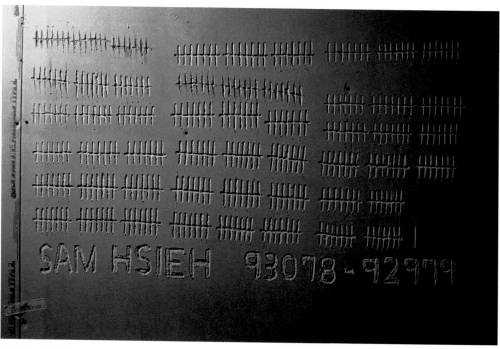

Tehching Hsieh, *One Year Performance 1978–1979*, 1978–79. 365 daily scratches

the year had run its course, the artist's lawyer, Robert Projansky, certified that Hsieh had not broken any of the seals installed around his cage.

What happens when the artwork, as in Hsieh's piece, consists of a body doing what any living body does: breathing and being? How can we approach such performance, or "lifework," to use Adrian Heathfield's helpful term, as a physical kind of making, even as the bodies in question produce no permanent objects, and offer no services?[1] Where, we might ask, lies the *matter* of performance? Is it in the flesh and bone of the performer, the filmic records or other documents generated around the performance, or in the intangible memories of witnesses? The answer is certainly some hybrid of these things. In the case of *Cage Piece*, the material residue generated was both significant and memorable: Hsieh created paperwork testifying to his intentions and made a poster announcing his public hours; photographs were taken daily of him in his cage, recording his hair as it grew to his shoulders; and he scratched off each day with a hash mark using his fingernail on the wall by his bed.

Performance art, insofar as it does not result in a saleable object as its primary outcome, might seem a strange choice

for a book about the material making of art. Yet performance is *produced* in a way that aligns it with other artistic genres, not least because of what happens before and after the performance itself (preparation for the event, and subsequent documentation in the forms of photographs or moving images). Theorist Pierre Bourdieu used the term "cultural production" to redefine the realms of literature and the arts as concrete economic practices, subject to questions of valuation, circulation, marketing, and consumption.[2] In a colloquial sense, a "production" is that which is exaggerated, as when someone makes an unnecessarily big deal out of something with relatively small importance. Within the realm of contemporary art, redefining performance as

September 30, 1978

STATEMENT

I, Sam Hsieh, plan to do a one year performance piece, to begin on September 30, 1978.

I shall seal myself in my studio, in solitary confinement inside a cell-room measuring 11'6" X 9' X 8'.

I shall NOT converse, read, write, listen to the radio or watch television, until I unseal myself on September 29, 1979.

I shall have food every day.

My friend, Cheng Wei Kuong, will facilitate this piece by taking charge of my food, clothing and refuse.

Sam Hsieh

Sam Hsieh

111 Hudson Street, 2nd/Fl. New York 10013

Tehching Hsieh, *One Year Performance 1978–1979*, 1978–79. Statement

"production" serves to complicate narratives that focus exclusively on authorial intent, and instead situate performance within wider cultural matters.

 Some theorists of performance art hold that its central concern is an encounter with the body as a physical thing; in this sense is a medium in its own right, standing alongside paint, wood, digital information, and the other materials we explore in this book. In this view the body is taken as another type of readymade object, one that, when inserted into institutional contexts of display, challenges conventions of the static commodity.[3] Other interpretations, less physical in emphasis, focus primarily on autobiography, providing a personal glimpse into the thoughts and emotions of the performer. However, as Frazer Ward observes in an argument regarding Hsieh's work vis-à-vis his status as an undocumented immigrant living in violation of US law, a performance can also hold viewers at bay. Hsieh's *Cage Piece* does little to reveal what the artist might be like as a person, apart from his force of will.

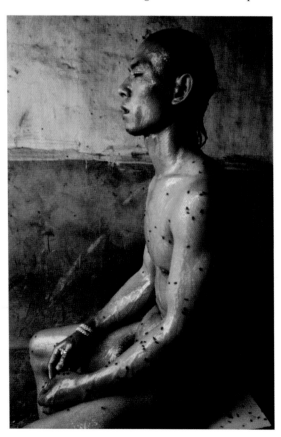

Zhang Huan, *12m²*, 1994. Performance, Beijing

Zhang Huan, *My New York*, 2002. Performance, Whitney Museum of American Art, New York

For those who have not had a similar experience, it is difficult to even imagine what his day-to-day experience might have been like. As Ward puts it, the work "resists subjectivity as a central problematic."[4] Every three weeks during the run of the performance, Hsieh held visiting hours in which viewers could come to his unlocked apartment from 11 a.m. to 5 p.m., though what there was to see there was somewhat limited: a man living in a state of self-imposed "solitary confinement," as Hsieh put it. He offered his visitors the experience of radical withholding: much less than normal life has in it, rather than more.

Yet even in a case as extreme as this one, it helps to think about the practical execution of the work. Often overlooked in accounts of Hsieh's *Cage Piece* is the importance of dependency, and the use of others as "social tools," for he did not, in fact, work alone.[5] According to his artist's statement, he never meant to stage an exercise of absolute deprivation. Basic necessities would be taken care of: "I shall have food every day. My friend Cheng Wei Kuong will facilitate this piece by taking care of my food, clothing, and refuse." Physical needs, economic realities: someone still had to put food on the table, take away his urine and feces, and pay for his laundry detergent, not to mention his rent (his parents pitched in with financial support).[6] *Cage Piece* is thus also about the performance of care and trust, friendship and family. As Shannon Jackson has cogently argued, "support" is a crucial element in much recent performance.[7] If we take Hsieh's work as emblematic of one strain of "supportive" performance art, we might say that the genre can be a matter of bodily tendings, underscoring human systems of intake and emission that fundamentally challenge ideas of self-sufficiency and thrust them into the realm of production.

Few artists have pushed the tendency to think of bodies as a substance to be sculpted, shaped, and challenged as far as Chinese artist Zhang Huan, whose works are much shorter in duration than those of Hsieh but no less intense in their psychological commitment. In *12m²* (1994), Huan covered himself with a mixture of honey and fish oil and sat in a public restroom, immobile, as flies began to cover his naked form. His stoic face does nothing to reflect the squeamishness most people feel regarding contamination, bodily excretions, and insects. Yet this seemingly monkish experience was at the same time a social production, as the piece frames bodily functions within the infrastructure of human waste-management. What is more, though the piece was not staged to be observed live by a wider public, video and photographic documentation

demonstrates that in addition to one unwitting participant (a man who came to use the facilities), there were other bodies in the space: the people shooting the footage, whose presence authorized, enabled, and made visible Huan's efforts, and who similarly had to endure the uncomfortable circumstances of the performance.

Critics have commented that some of Huan's pieces are "sensationally masochistic."[8] Yet his works also comment on questions of inequity, exchange, and value. In *My New York* (2002) he wore a suit made from meat, whose bulging contours made him resemble a flayed, beefed-up bodybuilder. Performed at the Whitney Museum of American Art, *My New York* began with a group of men walking into the forecourt of the museum, their forms obscured by a white sheet; the sheet was pulled off to reveal that they were carrying Huan on a tray. He gradually stood and then led visitors out of the museum and onto the street where caged white doves were released, a Buddhist gesture of compassion. As the artist has written,

> Something may appear to be formidable, but I will question whether or not it truly is so powerful. Sometimes such things may be extremely fragile, like body builders who take drugs and push themselves beyond the limits of their training on a long term basis, until their heart cannot possibly bear such enormous stress. In this work I combine three symbols: migrant workers, doves, and body building.[9]

The reference here to migrant workers is crucial to the overall meaning of the piece. Someone had to butcher those animals and fasten that suit together, facilitating Huan's transformation into a hulking mass. Again we see here the importance of *assistance* within the making of performance, as well as the body as a production site.

One of the most insistent ways that bodies get "produced" is through systems of race and gender. Steeped in conceptual art and phenomenological questions about the relationship of the self to the world, artist Adrian Piper undertook a private performance in 1971, *Food for the Spirit*, in which she photographed herself in the mirror as she pursued a rigorous study of philosopher Immanuel Kant. During this period, she was simultaneously undertaking a juice-and-water fast. The piece appears to be in conversation with the stereotype of the self-denying ascetic,

Adrian Piper, *Food for the Spirit*, 1971 (photographic reprints 1997). Detail,
photograph number 1 of 14. 14 silver gelatin prints and original book pages
of a paperback edition of Immanuel Kant's *Critique of Pure Reason*, torn out
and annotated by Adrian Piper, 15 × 14 ½ in. (38.1 × 36.8 cm)

known from innumerable paintings and texts, but frequently
exemplified as a man. In the grainy haze of the black-and-white
photography, Piper's body registers as a disappearing trace,
suggesting that the absorption of the Western canon might
also be regarded as a process of abnegation.

Piper's work implies that the body, if it is a readymade, is
nonetheless anything but neutral: it is necessarily shaped by
social forces. *Food for the Spirit* might be a different work if it
were executed by some other (differently gendered, differently
raced, differently abled, differently aged) body.

This awareness has prompted many performance artists,
particularly those associated with the women's liberation

movements of the 1960s, to use their own bodies as a way to emphasize the politics of shape and flesh. Other feminist artists have put in long stretches of time and effort to transform their bodies as a part of their performance practices. In Eleanor Antin's *Carving: A Traditional Sculpture* (1972), for example, the artist spent thirty-seven days pursuing a dieting regimen and documented, in a series of black-and-white photographs, her overall 10 pound (4.5 kilogram) weight loss. Antin's piece is a critique of the pressure imposed by conventional standards of beauty, but also refers to classical, reductive modes of making sculpture by chiseling away matter.

Transgender artist Heather Cassils produced a queer/trans update of Antin's work in the piece *Cuts: A Traditional Sculpture* (2011), undertaking a twenty-three-week program of body modification that questioned the limits of the gender binary. Expending a tremendous amount of energy – and material resources in the form of very high daily caloric intakes and a disciplined work-out schedule – Cassils's body was gradually reshaped from

Eleanor Antin, *The Last Seven Days* from *Carving: A Traditional Sculpture*, 1972. 28 black-and-white photographs, each 7×5 in. (17.8×12.7 cm), seven date labels, 148 black-and-white photographs in the complete piece

Heather Cassils, *Day 1 of Time Lapse (Front)*, 2011, and *Day 161 of Time Lapse (Front)*, 2011. Archival pigment prints

recognizably "female" to one that conforms more comfortably with ideals of masculinity, though the body that resulted from this regime is emphatically one in a state of constant flux and transition. The artist's dedicated hard work culminated in photographs and a video that portrayed Cassils's weight gain and growing muscle mass. Unlike Antin, who dieted alone, Cassils had a team of helpers – or "social tools" – including a trainer, a nutritionist, and a doctor to administer steroids.

Similarly questioning what it means to "work on your body," for her project *Bodywork* (2002–10), artist Liz Cohen simultaneously partnered with a personal trainer and with a body shop. In this eight-year-long process of diet and exercise, she winnowed her figure into the conventional shape of a bikini model while also working alongside an all-male cadre of auto mechanics in Arizona to hybridize two used cars, merging a lowly 1987 Trabant (widely driven in East Germany before the fall of the Berlin Wall) with a Chevrolet El Camino, prized within Latino lowrider car culture. Doing the detail work on the car herself to trick it out and install hydraulics to make it bounce, Cohen effectively reskilled as a manual laborer as she enacted the piece.

Cohen's project gained acclaim within the art world: many galleries and art fairs showed full-color photographs of the artist

Liz Cohen, *Air Gun*, 2005. C-print, 50×60 in. (127×152 cm)

Liz Cohen, *Bodywork Hood*, 2006. C-print, 50×60 in. (127×152 cm)

posing alluringly on top of her "Trabantimino," displaying both body and car as products of intense work. She also achieved recognition within car culture, taking first prize in the category of "Compact Radical" at the "Main Street Showdown Supershow" in Española, Mexico, which has declared itself the lowrider capital of the world. Rarely does contemporary art that seeks to fuse the fine art market and subcultural formations actually make ripples in both. Yet *Bodywork* also stands as proof of the complex politics surrounding the performing body. The art historian Amelia Jones accused Cohen of reproducing "resolutely normative" ideals of desirability, which in her view outweighed any critical potential the project might have. Others defended the artist's "messy, border-fuzzing... non-normative business of immigration," and pointed to the deep relationships that the artist had cultivated with the workers in the body shop. Significantly, Jones's assumption that the artist was white, when in fact she is a "Colombian-American of Syro-Lebanese Jewish heritage," played a role in the dispute about her work.[10]

Despite the political disputes arising from performances like those of Cohen, these bodily manipulations rest on very basic material facts: when you eat less, you lose weight, and when you pump iron, you get bigger. Such works emphasize the body as an often predictable laboratory of ever-shifting actions and reactions. Hsieh's *Cage Piece* offers a different model, one of radical passivity, but even here the everyday material reality of eating and excreting is brought to the fore. An even more fundamental fact about the body is that it can be treated as an *object*, one that can be in the way. This was effectively the subject of *The Loneliness of the Immigrant* (1979), by Guillermo Gómez-Peña, a Mexican-American artist whose

Guillermo Gómez-Peña, *The Loneliness of the Immigrant*, 1979.
Color print, 11×14 in. (27.9×35.6 cm)

Regina José Galindo, *We Don't Lose Anything By Being Born*, 2000. Performance at the municipal landfill, Guatemala. Lambda print on Forex, 70 7/8 × 45 11/16 in. (180×116 cm)

work has explored questions of borderlands and translation. In this performance, Gómez-Peña lay still in an elevator in a downtown Los Angeles office building, uninvited, for twenty-four hours. An elevator, continuously traveling between floors, is a space of constant motion that has no destination, and a site where moments of isolation are punctuated by forced proximity to others, producing unspoken codes of behavior.[11] Wrapped in a batik cloth secured with ropes, Gómez-Peña presented himself as an abject object, an interruption in the ordinary urban fabric. His piece draws attention to various stages of preparation: Who drew the cloth tight against his body? Who tied the ropes? Many hands were required to create such a deceptively uncomplicated act. During his day-long experiment, his passivity catalyzed diverse reactions: he was kicked, ignored, and interrogated. A dog urinated on him. Eventually the building's security guards threw him in a garbage can, thus activating a broader network of labor (in this case, those employed in the realm of surveillance and safety) in aggressive response to his lack of action. As with much performance art, Gómez-Peña's work places its inadvertent viewers squarely within the arena of the act, as their responses are as much "the piece" as is the artist's cloth-wrapped body.

This work – and its exploration of the body as a site of vulnerability that might trigger abuse – has echoes in a more recent piece by Guatemalan artist Regina José Galindo, who in

2000 had herself wrapped, naked, in a transparent plastic bag, and thrown into a municipal dump in Guatemala City. Entitled *We Don't Lose Anything by Being Born*, it speaks to the "disposability" of women in a country rife with human rights violations: Guatemala has one of the highest rates of murder of women in the world. It is also another example of how passivity directs our attention to surrounding systems of labor: the assistants who helped enclose the artist in the plastic bag, and the city's ongoing regimen of maintenance and garbage-collecting. Again, the performance helps to underscore the stakes of the body as raw matter.

Galindo often risks personal harm in order to literalize what happens when bodies are treated as objects or things. As she has stated, "In performance art, everything is real action: the energy explodes, reaches unexpected boundaries."[12] Though her works are "real actions" taking place in the uncontrollable realm of the so-called "real world," they are also intended for art audiences (*We Don't Lose Anything by Being Born* is shown as a condensed four-minute video and a series of color photographs that are available for purchase). Julian Stallabrass has inquired, regarding the apparent dissonance between these violent depictions of a body in pain and the world of art galleries: "What are the wealthy buying in their materialized portions of light? Insofar as [Galindo's] work is not merely about Guatemala but about the neoliberal system as a whole, they buy a fragmentary reminder of their own place in that system and the structural conditions of exploitation that maintains them there."[13] Through the circulation of photographic documentation in particular, Stallabrass argues, Galindo indicts viewers for their eagerness to see violated bodies and their complicity with various forms of injustice.

One cannot mention the intertwining networks of performance art, bodily valuation, and commerce without including the most visible and controversial figure in recent decades: Spanish artist Santiago Sierra, who has already been discussed in the previous chapter vis-à-vis his relationship to architecture (see p. 84). Throughout his career Sierra has thematized issues of the material conditions of performance and menial labor

Regina José Galindo, *We Don't Lose Anything By Being Born*, 2000, shown at La Caja Blanca, Palma de Mallorca, 2012

under capitalism, paying working-class laborers or indigent people to carry out a series of tasks or undergo some procedure: standing motionless in lines for hours; having their hair dyed; being tattooed. Unlike Gómez-Peña or Galindo, who place their own bodies in potential harm's way, Sierra uses others – veterans, addicts, and workers – to enact his instructions, treating living human beings as "assisted readymades." Like Liz Cohen, he has come under fire for replicating rather than critiquing inequalities regarding power, class, and status, but it is undeniable that his work has sparked conversations about what it means to visualize wildly disparate levels of compensation within the frame of the art institution (the artist, of course, makes exponentially more than those who are performing).

As the title suggests, Sierra's *An American Veteran of the Wars in Iraq and Afghanistan Facing the Wall* (performed for the exhibit *The Workers* at the Massachusetts Museum of Contemporary Art in 2011) featured a solitary veteran wearing his US military uniform, facing a corner of a white-cube gallery for hours. He was paid minimum wage and was instructed not to move or to speak if spoken to: a further instance of stillness as work. Though one critic called this a "provocative tableau of humiliation,"[14] it is possible to read this piece not as yet another iteration of Sierra's trademark sado-Marxism, but rather as a quiet tribute, a recognition of resilience. For at least one of the veterans who was employed during the course of *The Workers*, it represented a decent, and welcome, temporary job in a climate of economic scarcity.[15]

As Sierra's work makes clear, performance art, as a form that traffics in the human body, is an arena where questions of objectification and social power are brought to the fore. Because there is no art object to buy and sell (aside from documentation), bodies themselves merge, sometimes uneasily, with the system of commodity exchange. Some artists employ the language of selling themselves to directly provoke the art market, making subtle critiques regarding the marketability of identity. This is the case with African-American artist damali ayo, who from 2003 to 2012 offered herself up under the rubric of her satiric website art piece *rent-a-negro.com*. The website states: "The presence of black people in your life can add currency to your business and social reputation. As our country strives to incorporate the faces of African Americans, you have to keep up." She listed different rates for corporations and individuals, with prices of $350 and $200 per hour respectively. ayo has noted that the project stemmed from exhaustion arising from often being the token black person in social situations and being

damali ayo, *rent-a-negro.com*, 2003–12. Website

treated as a curiosity or asked invasive questions, being compelled to "perform" her blackness. "I have a certain number of white people in my life for whom I'm willing to do that for free," ayo drily notes, "but everyone else needs to go on a fee-for-services basis."[16]

The *rent-a-negro.com* website included a form one could fill out to request ayo's presence at parties or public occasions, and she initially intended to show up to events if invited and paid. But after the artist received vicious threats and hate mail in response to her project, she turned the work from a potential performance into a conceptual art piece, and she did not in the end actually take any money or attend any events as a "Negro-for-hire." Given the hostilities directed toward her as a woman of color, she felt that putting her physical body into circulation ultimately presented far too extreme a risk.[17] The purely gestural (unperformed) nature of ayo's work is shared by recent inquiries into the transactional nature of racial identity, including Keith Townsend Obadike, who in 2001 attempted to sell his blackness on eBay, an obviously impossible proposal that was nonetheless taken seriously enough to warrant censorship. eBay flagged the auction and removed it due to "inappropriateness" only four days after the bidding began. Some genealogies of performance art hold that it emerged defiantly in resistance to the buying-and-selling character of art, and provides

Keith Obadike's Blackness
Item #1176601036

Black Americana

Fine Art

Currently	$152.50		First bid	$10.00
Quantity	1		# of bids	12 (bid history) (with emails)
Time left	6 days, 0 hours +		Location	Conceptual Landscape
			Country	USA/Hartford
Started	Aug-8-01 16:08:53 PDT		(mail this auction to a friend)	
Ends	Aug-18-01 16:08:53 PDT		(request a gift alert)	
Seller (Rating)	Obadike			
	(view comments in seller's Feedback Profile) (view seller's other auctions) (ask seller a question)			
High bid	**itsfuntobid**			
Payment	Money Order/Cashiers Checks, COD (collect on delivery), Personal Checks			
Shipping	Buyer pays actual shipping charges, Will ship to United States and the following regions: Canada			
Update item	**Seller:** If this item has received no bids, you may revise it.			
	Seller revised this item before first bid.			

Watch this item

Seller assumes all responsibility for listing this item. You should contact the seller to resolve any questions before bidding. Auction currency is U.S. dollars ($) unless otherwise noted.

Description

This heirloom has been in the possession of the seller for twenty-eight years. Mr. Obadike's Blackness has been used primarily in the United States and its functionality outside of the US cannot be guaranteed. Buyer will receive a certificate of authenticity. Benefits and Warnings Benefits: 1. This Blackness may be used for creating black art. 2. This Blackness may be used for writing critical essays or scholarship about other blacks. 3. This Blackness may be used for making jokes about black people and/or laughing at black humor comfortably. (Option#3 may overlap with option#2) 4. This Blackness may be used for accessing some affirmative action benefits. (Limited time offer. May already be prohibited in some areas.) 5. This Blackness may be used for dating a black person without fear of public scrutiny. 6. This Blackness may be used for gaining access to exclusive, "high risk" neighborhoods. 7. This Blackness may be used for securing the right to use the terms 'sista', 'brotha', or 'nigga' in reference to black people. (Be sure to have certificate of authenticity on hand when using option 7). 8. This Blackness may be used for instilling fear. 9. This Blackness may be used to augment the blackness of those already black, especially for purposes of playing 'blacker-than-thou'. 10. This Blackness may be used by blacks as a spare (in case your original Blackness is whupped off you.) Warnings: 1. The Seller does not recommend that this Blackness be used during legal proceedings of any sort. 2. The Seller does not recommend that this Blackness be used while seeking employment. 3. The Seller does not recommend that this Blackness be used in the process of making or selling 'serious' art. 4. The Seller does not recommend that this Blackness be used while shopping or writing a personal check. 5. The Seller does not recommend that this Blackness be used while making intellectual claims. 6. The Seller does not recommend that this Blackness be used while voting in the United States or Florida. 7. The Seller does not recommend that this Blackness be used while demanding fairness. 8. The Seller does not recommend that this Blackness be used while demanding. 9. The Seller does not recommend that this Blackness be used in Hollywood. 10. The Seller does not recommend that this Blackness be used by whites looking for a wild weekend. ©Keith Townsend Obadike ###

Keith Townsend Obadike, *Keith Obadike's Blackness for Sale*, 2001. Website

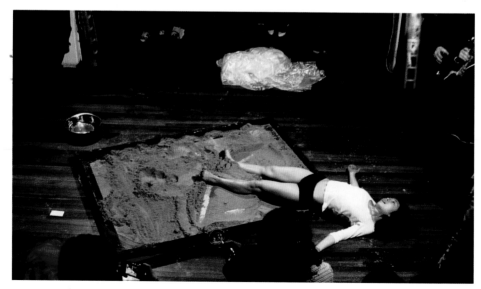

Nunu Kong, *Crowds of Clouds*, 2010. Performance

an alternative option outside of those systems. However, works like those of ayo and Obadike demonstrate that negotiations about material production and valuation cannot be escaped, but rather are part and parcel of having a (gendered and racially particular) body.

Though performance art has taken shape as a discrete category only relatively recently, questions about the value of the live body have long been asked within related realms, including dance. In her 2010 work *Crowds of Clouds*, choreographer/dancer Nunu Kong, based in Shanghai, built a shallow sand box inside a frame on the floor of the Island6 Arts Center. Surrounded by visual art and a small audience, Kong lay down in the sand, shifting her body to make gestures and shapes in the sand, aggressively pulling herself out of the frame or writhing within it, her exertions clearly visible. Kong writes: "For a short time I was able to distract their attention from the original purpose of the exhibition: to look at the art for sale hanging on the walls. Why can't a living artwork be more valuable than the mostly static objects in the gallery?"[18] Next to the frame, and her moving body, was a label that listed the price for her piece as "to be negotiated."

Further demonstration of the inevitability of the valuation of bodies is provided by Tino Sehgal, whose works are all the more sought after, discussed, and collected because of his stated resistance to the commodity nature of his art. Sehgal, who began as a dancer and has moved into the fine arts through the conceit that his pieces are "living sculptures" rather than choreography, has refused to employ photography, written instructions, and all other forms of documentation as part of his performance practice. In *This is So Contemporary* (presented at the Venice Biennale in 2005), trained, paid interpreters dressed as museum guards broke into a song-and-dance number that repeated the title phrase. His "constructed situations" attempt to thwart the intense focus on mediated accounts of live events, but given the ubiquity of cell phones, he is less and less able to control their circulation, as the many covert shots of his *The Kiss* taken by visitors at the Solomon R. Guggenheim Museum, New York, in 2010 demonstrate.

Sehgal has been energetically criticized for commodifying practices that were long established in the dance world (or elsewhere in performance art). As Catherine Wood points out in a nuanced discussion of commodification in his work, Sehgal "operates according to conventional art-world principles of surplus value. His interpreters are paid by the hour, while he owns the work and sells it for art-world prices."[19] The issue is in

Marina Abramović, *The Artist is Present*, 2012. Performance

part logistical: if nothing is available for purchase, not even theater tickets, how does the artist's production justify itself in the market? The answer is that it is only through the action of institutions – more or less centralized and powerful – as seen in the disparity between the fame and financial success of Sehgal and an artist like Galindo, whose actions often happen in spaces distant from the art world.

In recent years, perhaps the most emphatic statement about institutional centrality by any contemporary artist is Marina Abramović's work *The Artist is Present* (2012), for which she sat motionless in the central atrium of the Museum of Modern Art in New York. It would be difficult to imagine a setting more replete with the trappings of art world power, or a work that was so completely transparent about its own myth-making objectives. Abramović staged a highly controlled situation in which visitors sat opposite the artist, who was dressed in a flowing gown, and stared into each other's eyes. The distasteful celebrity-worshipping aspect of this performance has been widely discussed,

not least the premium the work places on physical immediacy to the
unique aura of the performer. Carrie Lambert-Beatty noted the
"quasi-religious" aspect of the work and its resemblance to other
rituals of visitation, such as the "grandiose (the pope) or absurd
(shopping-mall Santa)."[20] At the same time, some moments had
an affective, if stagey, charge, as when Abramović's former partner
Ulay (they split many years previously) arrived and sat in front of
her. Emphasizing the theatricality of this production, when the
artist broke her own protocol and reached across the table to grasp
her former lover's hands, onlookers broke into applause. Within
the media frenzy that attended this extended exercise – Abramović
sat for over 730 hours in total, and thousands came to see her –
questions of production loomed large. Who made the dresses she
wore? There were three, identical but for their colors. (The answer:
costume designer Stina Gunnarsson.) How did she urinate during
the long days she sat at her station without breaks? (Answer: she
held it.) Some visitors were hustled out of the chair for violating
protocol by museum guards who had been directed to keep the
chaos at bay, including a woman who stripped naked. But who
decided the rules in the first place?

More than any other performance artist, Abramović has
sought to impose strict standards, including a licensing process,
for those who wish to re-perform her works. But this desire for
regulation raises critical points about precisely the questions
we have sought to ask in this chapter. What makes a performance
"matter," and how is it infused with value? Such work can be hard
to pin down, especially that which has become solidified as a few
iconic instants known to us in widely reproduced photographs.
If someone wants to do a rendition of a previous performance,
why is that different from a band covering another band's song?
Surely performance could take its cues from the world of music
or function according to the permissive logic of the open-exchange
creative commons as material that should be properly acknowledged,
but that also remains open to be adapted, remixed, and updated.

Abramović's retrospective at MoMA helped signal a new
direction for the history of performance art in terms of mainstream
institutional acceptance. Interestingly, the inaugural installation
in MoMA's series dedicated to rethinking performance was a solo
show featuring Tehching Hsieh (2009), including *Cage Piece*. With
its many photographs and reconstructed cage in a corner of the
museum gallery, complete with spartan cot and daily hash marks,
the installation showed how performance can also be conveyed

via relics or architectural remains. This has been a frequently used method for the historicization of performance, as in the groundbreaking *Out of Actions: Between Performance and the Object, 1949–1979*, at the Los Angeles Museum of Contemporary Art in 1998.[21] Yet the show also revealed the limits of such presentations. The original focal point of the piece – the person in the cage – was absent. So, too, was his loft-mate who dutifully kept the artist alive with all his invisible but vital labors, Cheng Wei Kuong.

Tehching Hsieh, *Performance 1: Tehching Hsieh*, Museum of Modern Art, New York, 2009

Tooling Up

Chapter 5

Imagine that you are an artist with an idea to execute. Do you – or your team – have the skills, time, and resources needed to complete all the steps that might be required? How will you purchase, scavenge, or gather the necessary supplies? Will your bodies physically withstand the efforts involved? Can you hire others to do the work for you? Would you ask volunteers to assist you? As we have emphasized throughout this book, an artist's ability to complete a project, whether as an individual or as part of a collaborative group, is always limited by materials and means. Artists must constantly negotiate this realm of necessity in order to achieve their goals.

Whether you are an assistant or an artist yourself, one thing is inescapable: you will likely need tools. Many of these are obvious, things you can buy in the art supply store: colored pencils, felt-tipped markers, a set of chisels. Other more complex devices, not so specific to art-making, may nonetheless be ready at hand: a photocopier, a computer, a piano. Then there is specialized equipment that requires real investment: a ceramic kiln, a 3D printer, a knitting machine. Given the right context and/or budget, artists can lay their hands on any or all of these tools, but let us assume you hit a roadblock. The exact instrument you want – the one that will make the special line, produce the right sound, or enact the material transformation you have in mind – does not actually exist. You have to either modify or invent it. Before you can make the art, you have to make the tool. Though it might be a novel and surprising item in itself, this tinkered-with or newly devised tool is not necessarily an artwork, but rather is a crucial motor or process *toward* art as it is made. We call this intermediate step of instrumental adaptation "tooling up."

The first thing to say about tooling up is that its transformative potential is not always a matter of technical complexity. Think of Shigeko Kubota attaching a paintbrush to her underwear for her *Vagina Painting* (1965). In this proto-feminist performance, the artist cleverly changed understandings of productive, mark-making

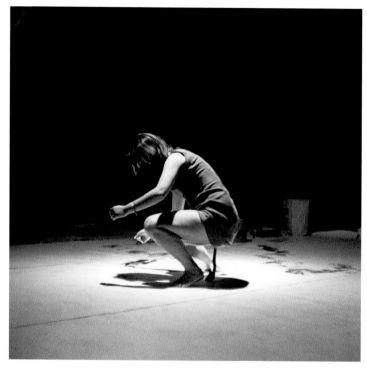

Shigeko Kubota, *Vagina Painting*, 1965. Performed during the
Perpetual Fluxus Festival, New York

female bodies by virtue of a modified painting implement,
which she used by squatting over paper and moving around to
create brushstrokes. Her method was as direct as her message:
a good lesson that rethinking a tool does not necessarily involve
elaborate design work.

Even so, it is worth remembering that the history of art is
inseparable from the history of technology. The advance of tooling
has had a profound impact on how artists think and create. This
is true whether the innovations happen within art practice, or are
imported into it from some other field; either way, working in a
new medium with new tools is an important method for opening
up artistic terrain. Our own times are no exception. The twentieth
century was a veritable explosion of instrumental innovation, with
a vast diversity of tools introduced into art: paintbrushes with
synthetic bristles, gas-powered chainsaws, handheld electric drills,
silicon casting molds, digital cameras, CNC carving machines, and
so on. This spirit of ongoing technical experimentation continues
today, often in a deliberately offbeat or eccentric manner. By
inventing new ways of making, modifying tools, or appropriating

techniques from outside the realm of art, artists displace much of their authorial decision-making into the process itself, producing results that are all the more prized for being unexpected.

Take the case of artist Lee Bontecou, who in the late 1960s and early 1970s worked with a homemade vacuum-forming machine and was invited by a friend to make a series of remarkable objects depicting plant and marine life. The transparent plastic she used mimicked the delicate fish skin and flower petals, and it would not have been possible to achieve this uncanny effect without this new technique. In *Untitled (Fish)* (1970), the creature's scales and bones are rendered not as anatomical facts but as sculptural patterns that conform to Bontecou's typical color palette. In these works, Bontecou has adopted an apparatus not intended originally for artistic production in order to make her work; along the way, she broke down gendered assumptions about ostensibly "male" industrial procedures.[1]

Tooling up is an inherently cross-disciplinary practice, because each discipline is defined largely by its tooling system. When tools are borrowed across different creative fields, are introduced for the first time, or are applied in unaccustomed ways, we feel the ground of the discipline shift. A good example can be seen in the way that tinkering with instrumentation has blurred the boundaries between visual art and experimental music. In the twentieth century, one of the best-known figures to create and utilize customized instruments was composer John Cage, who in 1940 began working with what he called "prepared pianos," that is, pianos that had been altered by inserting objects between the strings to create different qualities of tone and resonance. Cage recalled that his first experiment with a prepared piano came out of necessity. He had been asked to compose the music for Syvilla Fort's dance of *Bacchanale*, and had in mind a percussion ensemble piece, but the theater where the dance was to be performed had no space for the instruments Cage was hoping to use, just a piano in the wings. When he tried to write a piece on the piano that fit with his vision, he recounts: "I had no luck. I decided that what was wrong was not me but the piano. I decided to change it."[2]

Having to use the piano forced him to reconsider it for what it is, a percussion instrument, and he "made do" with objects that were on hand:

> I went to the kitchen, got a pie plate, brought it back into the living room, and placed it on the piano strings. I played a few

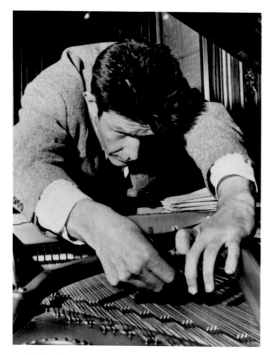

John Cage preparing a piano, *ca.* 1960

John Cage, *Table of Preparations*, from *Sonatas and Interludes*, 1946–48. Printed page, 9 × 12 in. (22.9 × 30.5 cm)

keys. The piano sounds had been changed, but the pie plate bounced around due to the vibrations, and, after a while, some of the sounds that had been changed no longer were. I tried something smaller, nails between the strings. They slipped down between and lengthwise along the strings. It dawned on me that screws or bolts would stay in position. They did.[3]

This moment of ingenuity led to Cage's decades-long exploration of altering pianos, often to accompany the dance performances by his life partner, choreographer Merce Cunningham. One expediency of the prepared piano meant that Cage could reliably generate a new range of sounds when Cunningham's dance troupe went on tour, without having to travel with many delicate, and space-hogging, musical instruments. Instead, he might only have to carry a bag of nails or rubber bands to modify whatever piano came to hand. More recently, artist duo Jennifer Allora and Guillermo Calzadilla have extended Cage's notion of preparation to modify a piano more radically. In their *Stop, Repair, Prepare: Variations on "Ode to Joy" for a Prepared Piano* (2008), they cut a hole in the center of a grand piano. The player then stands literally in the piano

as he or she plays Beethoven's piece, forcing the relationship between body, hand, and keyboard into a different orientation.

Alongside composing and performing music, Cage also created instructions or scores for preparing pianos, such as a table for *Sonatas and Interludes*, which shows the position of various bits of plastic, bolts, screws, and rubber (1946–48). Graphically, it resembles a piece of concrete poetry, with Cage's neatly hand-lettered serif script repeating words that are set off against blocks of empty white page. Cage became increasingly interested in indeterminacy, and he emphasized that no piano, however rigidly prepared according to his scores, would ever sound the same twice. Within the realm of tooling up, control versus chance is an important dynamic: does the new, converted, or transformed tool assure repeatability for its user, or does it rather ensure that no results can ever be repeated, especially when the tools utilized mean that authorship becomes more distributed and dispersed?

Cage's methods result in a strong visual aesthetic; his motivation was to produce new sounds, but his prepared

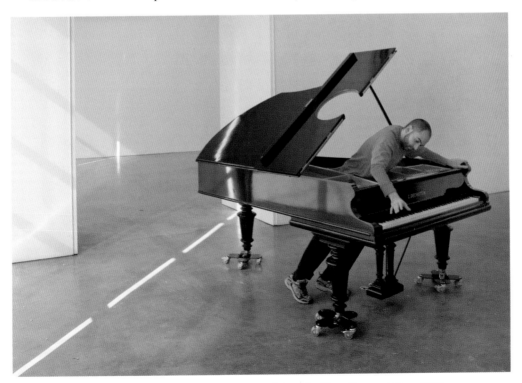

Allora & Calzadilla, *Stop, Repair, Prepare: Variations on "Ode to Joy" for a Prepared Piano*, 2008. Prepared Bechstein piano, pianist (Amir Khosrowpour, depicted), 40 × 67 × 84 in. (101.5 × 107.2 × 213.4 cm)

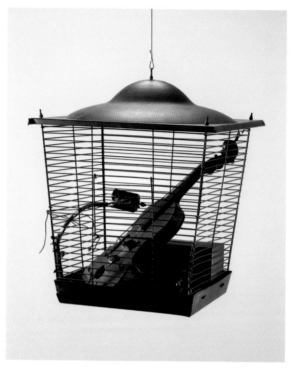

Joe Jones, *Cage Music*, ca. 1965. Metal birdcage containing
painted plastic violin and battery-powered motor with striker,
15 ¾ × 13 × 13 in. (40 × 33 × 33 cm)

pianos also feel like sculptures, and his scores like drawings.
Many other musicians in Cage's general orbit, including Robert
Rauschenberg, David Tudor (who made musical circuits and
electrical instruments) and Alvin Lucier (who used voice recorders
and other devices), worked at the interface between sculpture and
performance. A particularly interesting case is that of Joe Jones,
one of Cage's students who became affiliated with Fluxus. In the
1960s, Jones made a series of fantastical machines by cobbling
together found, sometimes broken and cast-off instruments,
resulting in kinetic sculptures that played distinctive musical
compositions. Around 1965, he created a visual pun acknowledging
the influence of his teacher when he embedded a violin inside
a birdcage along with a battery-operated striker – literally,
Cage Music. Jones was a pioneer in several regards. Some of his
automata-like contraptions were solar-powered, and would rattle
and clang to life when exposed to the sun. Though the artist put
in the work to build these machines, the sounds they emitted were
self-generating. When displayed in a museum, lamps were used
to power the machine's levers, but for Jones part of the interest

in using solar energy lay in the room this choice left to chance.
He welcomed variables such as clouds passing, the turning of the
earth, or wind gently moving the gears as part of an ever-changing
soundscape: the shift "from complete density of sound in a cloudless
sky at mid-day to silence in a heavy sky or total silence at sun
down."[4] Jones resolutely embraced tooling up as a conduit to
indeterminacy and chance, relinquishing the authorship, as
well as the performance, of any given musical piece to the sun.

Another artist loosely affiliated with the international network
of Fluxus, Nam June Paik – a consummately inventive tool-maker
to whom we will return in Chapter 8 (see p. 186) – created hybrid
music/video instruments built especially for cellist Charlotte
Moorman to play, such as *TV Cello Premiere* (1971). The piece
incorporates three monitors of different sizes, stacked with the
smallest in the middle to echo the general hourglass shape of a
cello. Paik intended the televisions to play three separate programs:
a live stream from the performance as Moorman played, a collage
of different cellists from the past, and current broadcast television.
Moorman used a regular bow against the cello's central string
to make electronic sounds, and often performed wearing Paik's
TV Glasses (1971), small monitors fixed up as eyeglasses. Paik was
interested in "humanizing" technology through wearable pieces
like *TV Glasses* and *TV Bra for Living Sculpture* (1969), which was
worn by Moorman strapped to her chest as she played the cello,
two small televisions held in place directly over her breasts with

Nam June Paik and Jud Yalkut, *TV Cello Premiere*, 1971. 7:25 minutes,
color, silent, 16 mm film on video

Rebecca Horn, *Finger Gloves*, 1972. Performance, fabric, balsa wood, length 35 ½ in. (90 cm), at Tate, London, with the help of the Tate Members, 2002

clear vinyl straps. However, one consequence of Paik having a woman bear the burden of wearing such a gendered object is that it flirts with the uncomfortable terrain of instrumentalization, as if the female body is yet another tool to spectacularize and manipulate. Media historian Marita Sturkin has observed that Paik's was "a rather sexist gesture that tended to considerably reduce the notion of humanism."[5]

In the early 1970s, German artist Rebecca Horn satirized the then-current conception of tools as "extensions of Man" by making gloves with fingers several feet long, a bondage-type mask mounted with pencils (a type of drawing machine), a harness topped with a spindly dunce cap, and absurdly large wings that inhibited movement. In each case, Horn employed tools that constricted rather than enhanced her normal body movement, a commentary on the way that dress is typically used to constrain and distort a woman's experience. In one film, Horn simply cuts her hair with two pairs of scissors simultaneously. The result is awkward, verging on self-directed violence: one of the simplest examples of how using a familiar tool unexpectedly can carry psychological weight.

Throughout her career, artist and musician Laurie Anderson has explored the less-than-celebratory conjunction of technology and the body through a feminist lens. In her 1981 crossover hit, *O Superman*, she sings "So hold me, Mom in your long arms. Your automatic arms. Your electronic arms. ... Your petrochemical arms. Your military arms," evoking a Cold War milieu of surveillance, technocracy, an escalating arms race, and the cold comforts of the "nuclear family." Anderson has invented a variety of experimental instruments, including her signature tape-bow violin. Though she has updated and reworked this many times since its first appearance in 1977, in its initial incarnation she replaced the usual horsehair of the bow with audio tape, and put a magnetic tape head on the bridge of the violin that "read" the tape as she drew the bow across it. With these modifications, Anderson can play, warp, accelerate, and decelerate pre-recorded tape samples to create a distinctive sound that she integrates into her recordings and live performances. In Anderson's *Song for Juanita* (1977), the squawks of the tape-bow violin sound variously like bird songs, distorted voices speaking phrases, and sometimes simply noise.

Laurie Anderson, *Tape-bow violin diagram*, 1977

Laurie Anderson, *Talking Stick* used in *Moby-Dick*, 1999. Performance

Anderson's other forays into apparatus-building include the *Talking Stick*, used during her *Moby-Dick* tour in 1999–2000: a tall, wireless musical instrument digital interface that she designed with Bob Bielecki and a team from the technology think-tank Interval Research.

A final example of tooling from the expansive realm of music is David Byrne's *Playing the Building*, installed in four different cities (Stockholm, London, New York, and Minneapolis) between 2005 and 2012. For this piece, Byrne used the infrastructure of large buildings – plumbing pipes, beams, girders, pillars, and heating vents – as wind and percussion elements to create an interactive sonic environment.

David Byrne, *Playing the Building*, 2005–12. Installation view,
Battery Maritime Building, New York, 2008

He attached devices such as simple motors and hammers to these
structural components, causing them to rattle, vibrate, or oscillate,
and drilled holes in pipes to make them chirp like flutes when puffs
of air moved over them, effectively turning the entire architecture
into a massive instrument. The devices themselves are activated by
the keys of an old organ set in the middle of the space, a mess of
cables and wires streaming from its back, with instructions for
visitors to "please play." Byrne left the back of the organ exposed
so that its workings were visible, what he calls its "Victorian steam-
punk technology," though part of the piece's appeal was the sense
of not really knowing where in the building the sounds were coming
from or how, exactly, they had been made.[6] Though *Playing the
Building* was deliberately low-tech, with no electronic amplification,
a long list of credits on the website, including systems engineers,
heads of fabrication, and production managers, indicates what
a project of this scope requires in terms of on-the-ground labor.

Like musical instrumentation, drawing machines have been
a persistent site of inquiry throughout the twentieth and twenty-
first centuries. During the 1950s, in the heyday of Abstract
Expressionism, the Swiss artist Jean Tinguely created a series

of *Méta-matics*, that is, kinetic machines with motorized arms into which the viewer places all manner of implements (markers, pencils, crayons) to produce abstract drawings. The machines could spit out many drawings a day, each one unique, in a stark comment on the overvaluation of artistic intention, as well as a satiric take on gesture as a route to the artist's unconscious thoughts or emotions. There is no denying that with their circular gears and elegant moving parts, Tinguely's *Méta-matics* steal the show from the bland drawings they generate. They are aesthetically compelling sculptures, finely observed in terms of balance and proportion. Yet the machines make sense only when understood simultaneously as vividly assembled three-dimensional objects, as devices for drawing, and as critical instruments that introduce chance and impose distance from the control of the artist. A 1974 drawing of short, vertical, multicolored lines, made with felt-tipped pens, is boldly signed by Tinguely as if to declare full authorship, though he added a stamp on the back to state that this drawing was not wholly of his hand, but rather made "in collaboration with Méta-matic no. 8."

As if to extend Tinguely's work, Tim Hawkinson has used an adapted machine to satirize the value of an artist's signature as a guarantor of authenticity and worth. In his *Signature Chair* (1993), a

Jean Tinguely, *Méta-matic no. 8*, 1974.
Felt-tip pen drawing on light board,
11 ⁷/₈ × 7 ³/₈ in. (30.1×18.8 cm)

Tim Hawkinson, *Signature Chair*, 1993. School
desk, paper, wood, metal, motorized,
37 × 28 × 24 in. (94×71.1×61 cm)

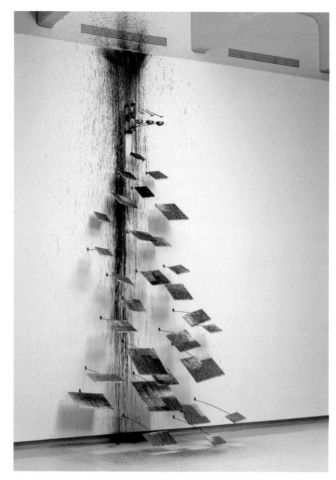

Rebecca Horn, *The Little Painting School Performs a Waterfall*, 1988.
Metal rods, aluminum, sable brushes, electric motor, acrylic on
canvas, 19 ft × 11 ft 11 in. × 7 ft 11 in. (5.79 × 3.63 × 2.41 m)

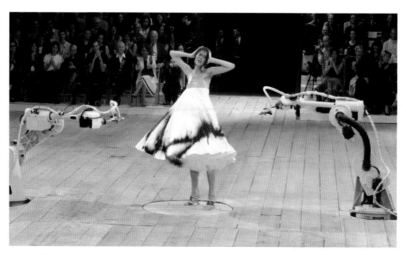

Model Shalom Harlow in a fashion performance staged by Alexander McQueen, 1999

wooden school desk, metal motorized gear, and a repurposed record player have been crudely rigged to sign the artist's name over and over. An ordinary binder clip firmly grasps a pen as a roll of paper is fed onto the small writing platform; once signed, the paper slips are chopped off, dropping down to accumulate in a heap at the base of the chair. Hawkinson's chair mimics the autopen, or automatic signing machine, that has been employed by executives on payday (for issuing checks) and during holiday seasons (for "personally" embellishing greeting cards), though such "hand-drawn" signatures are increasingly becoming relics of a bygone era, replaced by direct deposit and e-cards.

Art is one of the few realms in which an actual pen-to-paper or brush-to-canvas signature can still claim to mean something – *this person* has touched *this thing* – though Hawkinson, and Tinguely before him, suggest how that presumption can be manipulated. In both of these cases, the brute mechanisms of the machines' own making are evident: they are not sleek counterfeit operations but have their guts and screws exposed. There is something pathetic and expressive here, a suggestion of technological obsolescence, failure, and fragility.

Rebecca Horn, mentioned previously for her 1970s bodily extensions, captured a similar dynamic in her later painting machines, such as *The Little Painting School Performs a Waterfall* (1988). For this installation, three fan paintbrushes move on flexible arms, dipping themselves into cups of blue and green paint and spattering both canvases and the wall behind them, creating a floor-to-ceiling cascade of pigment. The architectural element is integral to Horn's *The Little Painting School*, as the whole height of the room becomes covered by paint, a casualty of the recklessness of the brushes as they blindly fill canvases. Long interested in kinetic sculpture and its analogues with the human body, Horn has noted the inevitable breakdown of any machine:

> My machines are not washing machines or cars. They have a human quality and they must change. They get nervous and must stop sometimes. If a machine stops, it doesn't mean it's broken. It's just tired. The tragic or melancholic aspect of machines is very important to me. I don't want them to run forever. It's part of their life that they must stop and faint.[7]

Horn's oeuvre has inspired a different use of a painting machine, albeit one that also raises questions about the role of chance and

authorship: fashion designer Alexander McQueen's *Dress No. 13* (1999). For the finale of his spring/summer collection, a white strapless muslin dress, belted around the chest, was sprayed by two industrial robotic painters as the model wearing the garment rotated on a mechanized platform embedded in the runway. (McQueen acknowledged that this look was inspired by a Horn artwork involving machine guns firing red paint at each other.[8]) Embellished, or perhaps assaulted, by black and yellow lines that resemble graffiti tags, the dress is transformed by this encounter with robots – invented and widely used in manufacturing to assure standardization and inhuman levels of polished perfection – into an impossible-to-replicate, one-of-a-kind piece that embodies McQueen's provocative flair. The machines seem to come to life as they work, bobbing up and down ferociously with their focused nozzles trained upon their target, and as he later commented, though they appear to spray capriciously, "it took a week to program the robots."[9] A human could have done the job in half an hour, of course, which points to the fact that artists and designers do not necessarily invent or deploy such machines as time-saving devices, but to create spectacle and upend convention.

Of course, not everyone is in a position to acquire industrial robots, even if only on loan for a one-time show. Some tooling

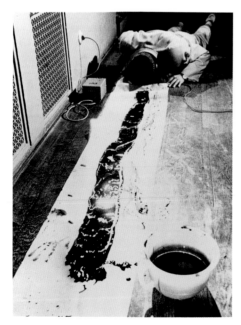

Nam June Paik performing La Monte Young's *Composition 1960 #10 to Bob Morris (Zen for Head)*, Wiesbaden, West Germany, 1962. Dimensions variable

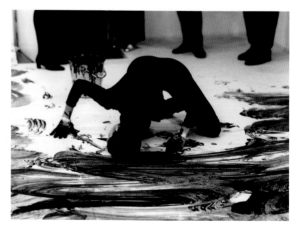

Janine Antoni, *Loving Care*, 1992. Performance with Loving Care Natural Black hair dye, at Anthony d'Offay Gallery, London, 1993, dimensions variable

up stems from artists realizing that their own bodies are the cheapest, and most readily available, material of all; with minimal adjustments, they can be put to new use. Why not turn the body itself into a tool? Some of the artists mentioned previously do just that, including video artist Nam June Paik, who in 1962 dipped his head into a bowl of paint and drew a long line on a roll of paper, face down, in *Zen for Head*. Janine Antoni also uses the head as a brush in her *Loving Care* (1992), a performance with feminist implications that recalls Shigeko Kubota's *Vagina Painting*. For this work, staged at the Anthony d'Offay Gallery in London, Antoni soaked her hair with hair dye and swabbed the gallery floor, pushing the viewers out of the door as they moved back to avoid the dark brown stain. The title refers to a popular brand of Clairol dye that was marketed toward women to cover their gray hair (it has since been discontinued), and the name of the color she used – "Natural Black"– is patently oxymoronic. Antoni's piece harks back to Paik's *Zen for Head*, but she inflects her work with gendered connotations of durational and domestic women's work as she "mops" the floor, dirtying rather than cleaning it.

Antoni has also been involved in fashioning tools that are integral to her more elaborate performance installations. In *Slumber* (1993–94), the artist sleeps in a gallery, hooked up to an electroencephalograph machine that records her rapid eye movements as she dreams. During the daylight waking hours, she sits at a loom of her own creation, weaving a long trailing blanket in which the strips of the nightgown are used as material to weave the REM pattern into the cloth. At night, the blanket covers her, closing the circuit of cloth, pattern, and labor. As Martha Buskirk has stated, "the blanket grows longer each time the work is exhibited, carrying from site to site traces of each past exhibition woven quite literally into the fabric of the work."[10]

Antoni is participating in a deep history of weavers who modify the looms on which they work, a tradition that continues today as makers create looms from upcycled goods like old picture frames or adjust and reconfigure pre-existing looms to accommodate unconventional materials. For their collaborative project *Sound Weave* (2003), Sachiyo Takahashi and Sidney Fels made weavings out of audio-cassette tapes on a loom that was altered for this purpose. Using their own supply of tapes as the warp, they invited audiences at the Heart of Prague Quadrennial Project to bring in their cassettes for the weft; these intermingled sound sources then flowed out into the exhibition space. Laurie

Sachiyo Takahashi and Sidney Fels, *Sound Weave*, 2003. Modified loom, used audio cassette tapes, 27 9/16 × 27 9/16 × 27 9/16 in. (70 × 70 × 70 cm)

Anderson used tape to reinvent the violin bow because that was the predominant audio recording technology of the moment; in the intervening years, cassettes have become obsolete, and Takahashi and Fels's use of audiotape is about outmodedness and nostalgia, salvaging tape, and memory, as it fades into history.

As examples like Antoni's *Slumber* and Takahashi and Fels's *Sound Weave* suggest, tinkering is not the exclusive purview of handy and efficient people, whiling away their time in the garage. Tooling up is – at least potentially – a political act. It permits individuals to express themselves more potently (or simply differently) than they otherwise could. Recently this idea has acquired a high-tech gloss, through the application of a new term: hacking. Originally, the word "hacker" referred narrowly to someone who intruded into computer security networks to gain unauthorized access to data. This usage is still in circulation, but has been vastly expanded to refer to nearly every aspect of fooling around with stuff, including shortcuts and tricks. Now you do not alter an old toy in your garage, you "hack" it. There is a whole website devoted to enthusiasts who engage in "IKEAhacking," by which the instructions of the home goods behemoth are altered and its mass-produced parts repurposed. There are even self-help guides about how to "lifehack" your productivity or retool your well-being. (If this usage sticks, it is further proof that the line between the hands-on and the virtual is ever dissolving.)

Glib overuse aside, the concept of hacking does capture the insurrectionary promise of tooling up. Every time an artist invents or repurposes a tool, they are at least tacitly expressing dissatisfaction with the status quo, taking matters into their own hands. It is striking how often artists working in an expressly politicized context have embraced the rhetorical power present in tooling up, particularly when reusing an ordinary object for an unintended use. David Hammons, for example, has indicated his rejection of conventional modes of drawing and his insistence that items dismissed as quotidian can be resignified as generative artistic tools, by dribbling a dirty basketball against clean white paper. The unexpectedly beautiful result is accompanied by a label giving the materials as "paper and Harlem earth."

Some artists invent tools intended for self-exploration. In the 1960s and 1970s, Lygia Clark's altered "sensorial masks," goggles, and invented outfits created new models for interpersonal exchange and heightened states of self-awareness in the context of her interest in therapeutic discourses. Her masks, meant to be worn rather than observed at a distance, might be embedded with scents, or be outfitted with mirrors so that the wearer's sense of sight is destabilized. Clark's explorations of facial extensions, which make us see, and sense, each other and ourselves differently, were made during her time in Paris as an exile, and have been understood

Judy Chicago, *Car Hood*, 1964. Sprayed acrylic on car hood,
42 ⁷/₈ × 49 ³/₁₆ × 4 ⁵/₁₆ in. (109 × 125 × 10.9 cm)

Judy Chicago installing *A Butterfly for Oakland* at Oakland Museum, California, 1974

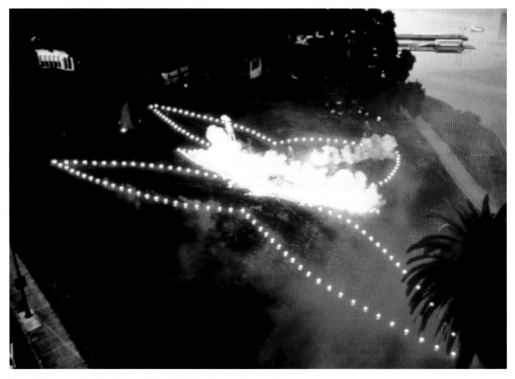

Judy Chicago, *A Butterfly for Oakland*, 1974. Fireworks and flares

as an oblique statement against the more rigid disciplining
of bodies during the military dictatorship in Brazil.[11]

It is striking, in fact, how often women artists such as Kubota,
Antoni, Horn, and Clark have employed tooling strategies as a
way in which to destabilize existing narratives based on gendered
power dynamics. Another woman working with and against our
assumptions about tools is Judy Chicago, known best for her central
role in the feminist art movement of the US. Chicago has been at
the forefront of seizing unexpected methods of making for her
artworks, using industrial procedures to create "finish fetish" works
like her *Car Hood* (1964). While a graduate student, Chicago bucked
the conventions of the day by enrolling in auto-body school to learn
about custom spray-painting. *Car Hood*, with its crisp lines and
smoothly even surface featuring a perfectly symmetrical design that
foreshadows her later turn to more explicitly vaginal iconography,
underscores that her lessons paid off.

Like Bontecou with her vacuum-formed fish, Chicago was
profoundly interested in pulling non-art methods into the art
world, and went on to produce works using fiberglass casting,
another typically masculine technique affiliated with surfboards
and boats. From 1969 to 1974, she also incorporated fireworks
into a series of site-specific outdoor installations in California;
these culminated in *A Butterfly for Oakland* (1974), a large
pyrotechnic performance on the shores of the city's Lake Merritt
that utilized fireworks and road flares in a great winged shape.
Photographs document her installing the work on the grass,
kneeling with a hammer. Most of the fireworks were "mechanically
lit while others were hand ignited" by Chicago, her pyrotechnical
expert, and a small team of volunteers.[12] (Though the artist had
officially requested a female pyrotechnic engineer, anecdote has
it that she was arrested at the airport on her journey to Oakland
for trying to bring fireworks on the plane: a reminder that some
tools are more sensitive, and more literally explosive, than others.[13])
The performance itself lasted for less than twenty minutes, creating
a fiery, smoky butterfly atmospheric "painting" that glittered on
the edge of the lake. Staged in close proximity to Oakland's
historic Chinatown, Chicago's piece merged earth art and feminist
iconography related to transformation, and triggered multiple
associations linked to the technology of fireworks.

One anthropological definition of a tool is an implement (often
held in the hand) used to accomplish a specific task. But as we have
seen, our tools are not necessarily external to ourselves, no longer

those threshold objects that mediate between the space of the personal and the outside world. Sometimes our bodies absorb or become our tools, and sometimes our tools reshape or reconfigure our bodies. In this chapter, we have considered tools as agents of making: a realm of invention at one remove from the finished work. With a couple of exceptions (McQueen's robotic sprayers and Chicago's elaborately planned fireworks), we have concentrated on small-scale, inexpensive tools. In this respect, the chapter has served to extend our examination of studio-based practice.

Yet there is another lens through which to look at this subject: tools are also a form of capital. In art, just like any arena of manufacture, one way to create more (or more valuable) products is to invest in the production system. In the ensuing two chapters, we will consider cases in which artists not only tool up, but do so ambitiously, securing highly skilled craftspeople, complex industrial machines, and even whole factories in order to produce their work. As we will see, the implications of such investment are not only practical and economic, but also involve aesthetic and ethical dimensions. An old saying goes, "Only poor workers blame their tools." When it comes to making critical assessments, however, it might be entirely right to judge an artist by the tools he or she has chosen.

Cashing In

Chapter 6

There is a wonderful (and possibly even true) story about the Japanese artist Ogata Kôrin, who lived in the city of Kyoto in the early seventeenth century. In those days, there were laws in Japan that placed strict limits on the ownership of precious materials. Gold was reserved for the aristocracy. As a successful artist, Kôrin had many clients among the elite class, and was himself comparatively wealthy. But he was obligated to abide by the dictates of these regulations. According to the legend, he invited several of his patrician clients to a riverside picnic. Each guest brought his own food, exquisitely prepared, carried in lavishly decorated lacquer boxes, and served on expensive ceramic dishes. Kôrin's own picnic set was studiously, appropriately plain. But when it came time for him to eat, he unwrapped each morsel from a bamboo leaf completely sheathed in gold. As he dined, he tossed the gilt leaves into the river one by one, letting them drift away on the current.

In this little tale, we have a perfect study of an artist's relationship to luxury. Kôrin was aware that gold had a nearly magical status in his culture (as it does in ours), and he exploited that for aesthetic effect. At the same time, he exhibited an ironic disregard for material wealth. It would be interesting to know whether the French artist Yves Klein (of "International Klein Blue" fame, discussed in Chapter 1, see p. 35) had heard the story before enacting his *Zones de Sensibilité Picturale Immatérielle* (1959). In this conceptual project, Klein sold empty spaces in Paris to collectors in exchange for a certain number of grams of gold, half of which he would then throw into the Seine, and half of which he kept as payment.[1] For him, gold was a material laden with associations: purity, immortality, alchemical transformation. Of course, a skeptical observer might also see, in his riverside ceremonies, the smooth operation of a con artist. Klein's concurrent series of paintings sheathed entirely in gold leaf, collectively entitled *L'Âge d'Or*, emblematize this ambivalent relationship to wealth. Was he genuinely transported by the

Cildo Meireles, *Money Tree*, 1969. 100 folded one-*cruzeiro* banknotes,
1 × 2 ¾ × 2 ⅜ in. (2.5 × 7 × 6 cm)

transcendent qualities of gold as a pure metal? Or was he
knowingly aiming at a clientele that already owned gold jewelry
and watches, and might want to have a painting to match?

The examples of Kôrin and Klein serve to introduce this
chapter, which addresses the use of precious substances in recent
art – luxury materials like gold, silver, and gemstones – and the
broader, problematic relationship between art and value. Our
discussion follows directly from, and is meant as a counterpoint
to, our discussion of performance, as here artists take up not the
most readily available – and free – of all resources (one's own body),
but the most high-end and inaccessible matter. Great art is often
said to be "priceless." What figure can one set on human creativity?
Yet objects by art market stars are bought and sold all the time,
and for increasingly stratospheric sums. Rhetorically, artists often
hold themselves at a lofty distance from commerce. Pragmatically,
however, art involves significant financial investment for those
who make it, as well as dealers, collectors, museums, and other
players in the business. The result is ongoing contradiction.
On the one hand, nothing damages an artist's reputation more than
the perception that they are making work primarily to sell. On the
other, artistic reputations are made by and in the market. The artists
who succeed financially are those who manage to have it both ways.

It would be interesting, as a means of exploring these issues, to
stage an exhibition of art made entirely out of money. If you were
to curate such a show, you might place, near the entrance, a wad of
fresh, folded currency on a pedestal. A little further on, there might

be a pile of gleaming copper pennies, or silver coins placed on the floor in the shape of a heart. The show might culminate in a pyramid of solid gold bars, guarded by a squadron of miniature matchstick men.

These are all real works in which artists have used various forms of money as a raw material. The first, called *Money Tree* (1969), is by the Brazilian conceptualist Cildo Meireles. When he first exhibited it, he listed the price of the artwork as twenty times that of the face value of the Brazilian *cruziero* notes used in the work. This was a dark joke, not only about the commodity status of art, but also an economic backdrop of extreme deprivation. Meireles quipped that "money was the cheapest material" in Brazil at the time, thanks to runaway inflation under the dictatorship, and he clearly intended *Money Tree* as a rebuke to the corrupt technocrats who ruled his country.[2]

Meireles was pitting money against itself, employing the apparatus of power as a means of critique. That same impulse can be found in the other works in our imaginary exhibition.

When Gerald Ferguson piled a million Canadian pennies in the center of a gallery, he was offering a deadpan imitation of post-Minimalist sculpture of the previous decade by artists like Robert Morris. The low denomination of the coinage means that, despite its monumental scale, there is only $10,000 worth of money in Ferguson's piece: it connotes dead weight as much as economic value. A parallel idea can be found in the art of the German artist Katharina Fritsch, who often masses small objects

Gerald Ferguson, *1,000,000 Pennies*, 1979.
One million Canadian pennies, variable dimensions

Chris Burden, *Tower of Power*, 1985. 100 32 oz (1 kilo) pure gold bricks, 20×18×18 in. (50.8×45.7×45.7 cm), matchsticks, pedestal (wood, marble, and glass), 70×30×30 in. (177.8×76.2×76.2 cm)

together to create an impression of overwhelming scale. Her arrangement of silvery coins (actually made of plastic) into the shape of a heart is one of many pieces in which she marshals the potential of kitsch materials to engender an almost spiritual experience for the viewer, albeit one whose affirmations are hollow.

At the conclusion of our imaginary exhibition is *Tower of Power* (1985) by the artist Chris Burden. He persuaded his gallery, Gagosian, to purchase $3,000,000 worth of solid gold bars, which he stacked into a ziggurat. Surrounding the pile, comically tiny figures protect the gold against unseen opponents. The piece mocks American obsessions with wealth, power, and military might, and suggests a paranoia with regard to globalization's competitive challenge, or the hoarding and stockpiling of resources in the face of imagined threats. When displayed in the artist's retrospective at the New Museum in 2013, it was positioned at the top of a narrow flight of stairs, with a (real) guard to protect it. Visitors lined up dutifully to see it, as if queuing at a store before opening time.

Leaving our exhibition, presumably through the gift shop, one might pause to consider its lessons. That art is a commodity? Certainly, but we knew that already. Back in the 1960s, Andy Warhol frankly acknowledged that his artworks were goods for sale, commodities among many others. He illuminated this theme in a manner both deadpan and scandalous, in the process opening up

a territory for experiment much as Marcel Duchamp had done decades earlier with his readymades. Yet Warhol addressed value in its symbolic, not its material, register. He silk-screened dollars onto canvas, rather than piling them up and setting them on display.

The artists in our exhibition, by contrast, literally make their work from currency (both fake and real, though one might ask whether money is still inherently valuable once it has been taken out of circulation and subsumed into an artwork). In so doing, they raise a different and perhaps more troubling issue than even Warhol considered: not the mere fact of art's commodity status, but rather the question of how much it should actually cost. When Meireles set a price for *Money Tree*, he did so arbitrarily: twenty times the face value of the notes, a completely random figure.

Andy Warhol, *80 Two Dollar Bills (Front and Rear)*, 1962. Silk screen ink on canvas, 82 $^{11}/_{16}$ × 37 $^{13}/_{16}$ in. (210 × 96 cm)

Cildo Meireles, *Zero Dollar*, 1978–84. Offset print on paper, 2 ¹¹⁄₁₆ × 6 ³⁄₁₆ in. (6.8×15.7 cm), unlimited editions

Is the art market as a whole all that different? One wonders what the artist would have made of the fact that another of his works, a screen-print entitled *Zero Dollar* (1978–84), sold in 2011 at Christie's for $3,000. Why not $300? Why not $300,000? Indeed, why not zero?

The real message of our imaginary exhibition, then, is that contemporary art's valuation is arbitrary at its core, sustained only through an elaborately circular system of self-reference. Meireles's work costs a certain amount because he says so, and the market sustains this claim, and then exerts counter-claims of its own. How? By positioning Meireles's claim of value in relation to those made by other artists. Is Meireles more or less "important" than, say, Warhol? That subjective ranking, rather than any condition inherent to the work, is what determines the price of his art.

This is a very different way of thinking from that which has prevailed through most of the history of art, when economic worth has been held to reside in objective factors: utility, scale, level of craftsmanship, and especially materials. Religious altarpieces in Europe, for example, were fashioned from hammered gold leaf and pigments containing crushed gemstones.[3] Chinese scroll paintings were made on luxurious silk with expensive inks.[4] In most places and times, the finest sculpture has been created from equally fine marble, silver or gold, jade, or exotic woods.

In the eighteenth and nineteenth centuries, there was a momentous shift away from this state of affairs. No longer was the value of a work of art determined principally by its physical qualities. Instead, the artist's "genius," an ideal that had gained ground since the European Renaissance, was increasingly held to be the most important factor in determining the selling price. Eventually this new attitude became the norm. In the cult of the bohemian artist, prevalent from the late nineteenth century onwards, financial impoverishment was taken as a sign of spiritual and expressive wealth. This was a stereotype founded in economic truth. Most artists have indeed been poor – at least at the beginning of their careers – and have struggled to afford the space, time, and materials required to make their work.

Not by coincidence, most of their materials have been very cheap. Oil paint began to be affordable in the 1840s, when the company Winsor & Newton introduced it in a prepared form and sold it in little tubes. Marble and bronze were still expensive, but sculptors could work in wood, clay, or plaster, and increasingly chose these materials. As the twentieth century progressed, the range of accepted artistic materials became broader still: concrete, machine parts, pixels. None of these come free, quite, but all are relatively affordable and accessible.

Today, the most expensive modern artworks in the world, such as paintings by Vincent van Gogh and Pablo Picasso, are typically of negligible inherent material value. Many sculptures are quite literally made from studio trash. Again, the price of such works is assigned according to the workings of the market, and it is the very unpredictability of art's value that makes it an ideal arena for financial speculation. Because the price of a painting or sculpture is unmoored from its materiality and function, it can balloon endlessly, reaching figures higher than any luxury goods.

Artists themselves are rarely the greatest beneficiaries of this process. When the collector Robert C. Scull auctioned his holdings

in 1973, he realized $84,000 on two works by Robert Rauschenberg, purchased originally for $900. The artist reportedly confronted Scull after the auction and shouted, "I've been working my ass off for you to make that profit!"[5] In the decades since, the market has remained buoyant, making Scull's then-astonishing selling prices look bargain-basement. Many have commented on the inflationary dynamics of this booming trade, and predicted that its end must be coming soon. So far, there are few signs of a crash. There is, however, another shift underway that suggests a widespread discomfort with the arbitrariness of art values. In recent years, materials like gold and silver, along with associated techniques of fine craftsmanship, are once again in common usage among contemporary artists. This appropriation of the precious directly challenges the presumption that the market price of a work of art should be divorced from its material value.

The most infamous example of this tendency is Damien Hirst's *For the Love of God* (2007), a platinum skull encrusted with

Damien Hirst, *For the Love of God*, 2007. Platinum, diamonds, and human teeth, 6 ¾ × 5 × 7 ½ in. (17.1×12.7×19 cm)

8,601 diamonds. The work was unveiled at the artist's gallery, White Cube, with a price tag of £50 million (the exhibition was, appropriately, entitled *Beyond Belief*). The skull subsequently did sell to a conglomerate of investors, including Hirst himself and his dealer, Jay Jopling of White Cube Gallery. Insofar as they retained a "controlling interest" in the object, their strategy resembled that of a company being floated on the stock market as an initial public offering.

As with much high-value art these days, it is difficult to obtain hard data about the production costs of the skull. The London jeweler that fabricated it, Bentley & Skinner of Bond Street, is under a non-disclosure agreement and will not make any public comment on the commission. But press reports suggest that about £22 million (less than half of the selling price) went into labor and materials, leaving about £28 million of the selling price unaccounted for. That, presumably, is the price of Hirst's creativity, or perhaps, we might say, his brand equity. Very few contemporary artists could have made this work, because they lacked the necessary capital.

Hirst is unapologetic about the dedication to materialism that was involved in making *For the Love of God*. "Everybody was encouraging me [to] save money," he has said. "They were asking, 'Do you want the diamonds to go inside the nose? Do you want them to go inside the roof of the mouth? And shall we use cheap diamonds underneath?' And I was answering, 'No, you can't. It's all a hundred per cent. All perfect.'"[6] It would be naive to accept Hirst's narrative at face value: as if he were only concerned with an aesthetic ideal, and simply crafting the economics of the work to fit. Every luxury business uses this same rhetorical sleight of hand. Overindulgence in production (only the best materials and the most skilled craftsmanship, whatever the cost) is what maintains the brand's position in the market. In the larger scheme of things, this can be extremely lucrative.

A last point about *For the Love of God* is that it makes people extremely angry. Many have protested that it is a form of wretched excess, from hostile art critics to members of the public to museum professionals. Ralph Rugoff, director of the Hayward Gallery in London, has argued that the artist and his gallery bought into the work only because it would not sell otherwise: they needed to save face.[7] Clearly, Hirst's taunting exposure of the mechanics of the market is one reason that it has become so controversial. He suggests that we could slip back (or perhaps already have)

into a more ancient conception of art, as a brute expression of wealth and power. Beyond the art world outrage regarding prices, Hirst's use of materials like diamonds, which are often mined and traded in murky or patently inhumane circumstances, also raises questions about the ethics of using so-called "conflict resources."

To the extent that contemporary art is joining hands with luxury, it is indeed edging away from the supposed basis of its valuation (which is meant to be on critical and expressive grounds) and subscribing to a different, more direct type of economic logic. It is no coincidence that some of the world's most powerful art collectors – François Pinault and his rival Bernard Arnault, for example – are titans of the luxury industry as well. When artists reflect on this fact, they tend to sidestep it with a self-parodizing tone. For example, Jeff Koons's celebrated installation at the Palace of Versailles in 2008 included several works owned by Pinault (who also helped to underwrite the exhibition, alongside other collector-lenders such as the Los Angeles real estate magnate Eli Broad). Concurrently, the artist began making enormous jewels that landed in public spaces, like the lost possessions of bling-laden

Model poses with a Takashi Murakami Louis Vuitton bag at a beauty shoot for *Madame Figaro* on January 30, 2003 in Paris

Sylvie Fleury, *Vuitton Keepall*, 2000. Chrome-plated bronze, 12 ½ × 18 × 7 ⅞ in. (32 × 46 × 20 cm)

Sylvie Fleury at *Icones* exhibition at Espace Louis Vuitton, Paris, 2006

giants. As is his usual practice, when Koons takes on luxury he does so in a literally outsized and unapologetic manner, celebrating conspicuous consumption as a source of human self-satisfaction.

There is, too, the phenomenon of brands commissioning "limited editions" from artists, building name recognition for both parties. In the process artists are selling out and growing up, realizing their strategic economic potential in a way that even Warhol could not have dreamed. Takashi Murakami, the most successful Japanese artist of the last twenty years, has plumbed the depths of these shallows to a greater degree than any of his competitors.[8] He has gained much of his notoriety through an ongoing partnership with the French accessories company Louis Vuitton. Beginning in 2003, he partnered with the firm's head designer Marc Jacobs to create handbags, scarves, luggage, shoes, and other fashion items, designing his own version of the company's logo as the primary insignia of the collaboration.

Eventually the artist went so far as to include an emporium for this product line in his own retrospective, © *Murakami*, at the Museum of Contemporary Art in Los Angeles in 2007 (the show traveled to the Brooklyn Museum of Art in the following year). He earned a backhanded compliment from Roberta Smith, senior art critic for the *New York Times*, who professed a preference for the commercial product over the real thing: "The bags, their shiny

brass fittings and the impeccable white-enamel display cases achieve an intensity of artifice, tactility and visual buzz that Mr. Murakami's higher art efforts don't always muster."[9]

Murakami is often described as a latter-day Pop Artist, whose tactics are the logical conclusion of those pioneered by Warhol.[10] Yet there is a crucial distinction between the two artists, just as there is a difference between Campbell's soup and Louis Vuitton. Warhol's cheerleader-like adoption of everyday consumer goods was carried out in a spirit of rough approximation, quite different from actual mass production. Murakami has mastered not only the visual tropes of luxury, but also the productive necessities it requires. His work is rendered in the same skill-intensive manner involved in making a high-end handbag.

The Swiss artist Sylvie Fleury is, if anything, even more deeply enmeshed in the luxury business than Murakami, though like him she shapes her production methods to mimic those of high-fashion brands, festooning the surfaces of her works with logos and making them gleam through the application of chrome and gold plate. Fleury often uses the imagery of cars, shoes, bags, and other fashion accessories, which she describes as "vehicles," meaning not only that they contain and carry, but also that they perform a service, for capitalist subjects, that spiritual "vehicles" like meditation might perform for Buddhists.[11] This comparison implies a very intimate relationship to luxury – the attitude of a connoisseur, not a critic – and, indeed, Fleury purposefully collapses the distance that normally exists between art and branding.[12] In 2000, for example, she recreated one of Louis Vuitton's best-selling handbags in chrome-plated bronze. The company made a copy in turn, imitating Fleury's imitation in reflective PVC. Reportedly, the artist completed the cycle by carrying the bag to an opening of her own work, which was underwritten by the company.[13]

In this scenario, one can feel contemporary art vanishing into a vortex of conspicuous consumption. Fleury's siren song is exemplified in her signature work *Ela 75K (Easy Breezy Beautiful)* (2000), an empty gold-plated shopping cart rotating endlessly on a turntable of mirrored Plexiglas. The piece could be read as an allegorical self-portrait: that of a person in thrall to the skin-deep. "Many artists," Fleury observes, "are basically seduced by their own work."[14] For her, art and luxury are ideal dancing partners, whirling about in an inexorable embrace.

Few artists are so sanguine about committing themselves to this romance. Consider the equal and opposite position taken

Sylvie Fleury, *Ela 75K (Easy Breezy Beautiful)*, 2000. Gold-plated shopping cart and Plexiglas bar, on turning mirror and aluminum pedestal, 50 × 43 5/16 × 43 5/16 in. (127 × 110 × 110 cm)

by Josephine Meckseper, a German-born conceptual artist who conceives her works "as provocations for destruction, [as] targets, like high-end shop windows being smashed during riots and protests."[15] Meckseper also adopts the display strategies of luxury retailers, such as logos, mannequins, Plexiglas boxes, and reflective plinths, but is a scathing critic of this system. A key difference between her work and that of Murakami and Fleury is that they both create visually resolved, cleanly composed work – easily photographed, and thereby consumed via print and online reproduction. Meckseper's works, by contrast, are densely

Josephine Meckseper, *Tout va bien*, 2005. Mixed media in display window, overall 38 × 98 ½ × 23 ⅝ in. (96.5 × 250.2 × 60 cm)

layered rebuses, hard to decode even when seen in person. Their complexity mimics the intensely competitive scenarios in which commodities are presented to the public, at shopping malls and car shows, and, of course, commercial art fairs. This blurring between retail and art world presentation styles ("somewhere between a department store display case and a museum vitrine," as one critic puts it) illustrates the degree to which art is itself a luxury product.[16]

This in itself is no particular revelation, and Meckseper has been criticized for making connections that were already "mind-numbingly obvious."[17] A rejoinder, however, would be that the mind-numbing effects of hyper-commodification are exactly what concern her. By recycling the cliché tropes of luxury display, she depicts contemporary art production as a hall of mirrors, held together through a fragile alliance of mutual recognition. That stance strikes right at the heart of artistic authorship, including her own: "a Chinese counterfeit designer," Meckseper claims, "could come up with very similar products and concepts."[18] In her world of visual overload everything is for sale, but true value is nowhere to be seen.

Meckseper's vision is hermetic and airless, expressing the idea of the art world as a closed circuit. Other artists critique the

art/luxury nexus from a broader standpoint. One is Fred Wilson, well known for installations that deconstruct the "master narratives" underpinning museums and other institutional authorities. In his seminal *Mining the Museum* (1992–93), Wilson rearranged objects in the Maryland Historical Society and relabeled them to insightful, and frequently devastating, effect: a set of silver vessels and a pair of slave shackles, for example, bear the legend *Metalwork 1793–1880*. This project addressed the troubled history of luxury production, pointing to its long and largely unacknowledged connections to racial domination: silver was mined mainly by South American slaves in the eighteenth and nineteenth centuries, and silver services were among the crowning glories of the cotton plantations of the antebellum South.

In recent years, Wilson has taken the perhaps unexpected step of creating his own luxury artifacts. He has worked with handmade glass, collaborating with skilled artisans both in Italy and America to realize sculptures like *To Die Upon A Kiss* (2011; the title quotes the final words of Shakespeare's Othello), a chandelier shading inexorably from white to black as if it has been dipped in ink. The sculpture exemplifies the way that Wilson shows blackness as overdetermined: referring not only to racial identity, but also "funerals, Goth and pirates, you can't just separate out

Fred Wilson, *Metalwork 1793–1880*, from *Mining the Museum: An Installation by Fred Wilson*, The Contemporary and Maryland Historical Society, Baltimore, 1992–93. Silver vessels in Baltimore Repoussé style, 1830–80, maker unknown; slave shackles, ca. 1793–1872, maker unknown, made in Baltimore

Fred Wilson, *To Die Upon A Kiss*, 2011.
Murano glass, 70 × 68 ½ × 68 ½ in.
(177.8 × 174 × 174 cm)

Fred Wilson, *Regina Atra* (detail), 2006. Silver and
black diamonds installed in wood and glass vitrine,
7 ½ in. (19 cm) diameter × 2 ¹⁵/₁₆ in. (7.5 cm) high,
overall installed 60 × 23 × 23 in. (152.4 × 58.4 × 58.4 cm)

one meaning."[19] The work's site of production, the island of
Murano off the coast of Venice, plays an important thematic
role. The location refers to Othello (the "Moor of Venice") as
well as to other black people who crisscrossed the Caribbean
in centuries past, without leaving much of a written or material
trace. Metaphorically speaking, the image of life draining
away echoes the erasure of these individuals from history.

A slightly earlier work by Wilson, *Regina Atra* (2006; the title
is Latin for "black queen"), is a copy of the Diamond Diadem, made
for King George IV in 1820 and worn by the monarchs of Britain
ever since, including Queen Elizabeth II as seen on Royal Mail
postage stamps. As in the chandelier, Wilson's transformative
intervention to a luxury item is through color. The silver in the
crown has been patinated black, and black pearls have been
substituted for white ones. He also sourced artificial "black
diamonds" for the piece, made by irradiating natural stones.
Wilson is incisive about what it means for an artist to make
an object of such lavishness. Like any process of significant
investment, he and his gallery had to begin by gathering
together the necessary capital. Once materials and production

were sourced, there remained the question of appropriate display (an exhibition entitled *Uncomfortable Truths* at the Victoria and Albert Museum in London, which marked the 200th anniversary of the abolition of slavery in the United Kingdom, provided one such context). Then the final hurdle: selling the work, so that the investment can be recouped.

At the time of writing, *Regina Atra* sits in a vault, awaiting a suitably ambitious buyer. Even prominent artists like Wilson, who can afford to work with luxury materials, take on significant risk when they do so. The high value of diamonds, gold, and other precious materials imposes significant constraints on the artistic process. Wilson puts it this way: "The idea that I would even be in a place where I could use that raw material freely and fluidly is itself problematic."

This self-conscious and self-critical position is akin to that adopted by Susan Collis, a British artist who has made a career of submerging the luxurious in the everyday. Collis has a particular interest in the preparatory labor necessary for the staging of art experiences. When her work is complete, it looks at first like an installation is just getting underway. But upon closer inspection, the detritus of the workspace proves to be extravagantly handmade. A drop cloth, apparently paint-spattered, is actually painstakingly embroidered with variously colored threads. What appears to be a stack of cheap lumber and MDF is fabricated from a range of expensive hardwoods – ebony, white holly, walnut, bird's-eye maple – further embellished with platinum nails and gold screws, and faux stains made of amber, topaz, and jasper.[20] She has also made a broom, a worktable, and a stepladder, all similarly inlaid with precious stones and mother-of-pearl.

At one level, Collis's sculptures continue the ancient tradition of *trompe-l'oeil*. The annals of decorative art in both Europe and Asia are littered with glass fruit, porcelain vegetables, and silk flowers. Yet Collis's frame of reference is specific to the contemporary situation. The luxury materials that she uses – gemstones and exotic woods – pay quiet tribute to painters and carpenters who work behind the scenes. Like Meckseper, she directs our attention to the contexts in which art is displayed; unlike Meckseper, she excavates under the glossy surfaces of presentation, revealing the unacknowledged labor that lies beneath. Paintings and sculpture become commodities only when they are released into the market, and Collis focuses her attention on that moment of transformation.

Susan Collis, *The oyster's our world*, 2004. Wooden
stepladder, mother-of-pearl, shell, coral, freshwater pearl,
cultured pearls, white opal, diamond, 32 × 14 $^{15}/_{16}$ × 22 $^{13}/_{16}$ in.
(81.3 × 38 × 58 cm)

At first glance, the prevalence of luxury materials in contemporary
art feels like a capitulation to an ever-escalating market: the logical
conclusion of art's increasing prominence as an arena of financial
speculation. No doubt this is true to an extent. But as this chapter
has shown, preciousness can be put in the service of a wide range of
emotional and political positions. One final example brings us full
circle to the gold leaves that Ogata Kôrin tossed into the current. On
two occasions in her career, Roni Horn has worked with gold of
astounding thinness, less than that of a human hair,
by annealing and then compression welding the metal. "I wanted
to put the gold out there, self-sufficient," she has said, "not as an
accompaniment to some other idea, but just in itself."[21]

In 1994–95, she created a version of this work that was dedicated
to the artist Felix Gonzalez-Torres and his partner Ross Laycock,

Susan Collis, *Gas Boys*, 2012. From left to right: cedar, mother-of-pearl, sterling
silver (hallmarked), oxidized silver (hallmarked), sonokeling rosewood, rosewood,
white holly veneer, ebony veneer, mother-of-pearl; walnut, crushed lapis lazuli in a
liquid medium, oxidized silver (hallmarked), beechwood, beech, pear and white holly
veneer, silver (hallmarked), smoky quartz, black diamonds, amber, hand-knitted
Japanese silk; sonokeling rosewood, white holly and padouk veneers, silver
(hallmarked), bronze (hallmarked), platinum (hallmarked); beechwood, beech and
white holly veneer, crushed lapis lazuli, silver (hallmarked), bronze (hallmarked),
cigar box cedar, white gold (hallmarked), smoky topaz, variable dimensions

shortly after Laycock's death from AIDS. The work could not be simpler: two sheets of gold, one laid atop the other, resting on the floor. Nor could it be more emotive. The two fragile rectangles of leaf touch one another gently, evoking a pair of lovers at rest. The form echoes a grave plot; gold death masks, common in ancient cultures from Egypt to Greece to Central America, may also come to mind. Horn's work is a reminder of what Kôrin knew well. For all the problems surrounding the intersection of art and luxury, the materials associated with preciousness have an abiding hold on our imagination. For her consummately loving gesture, a humble monument to the partnership of two dear friends, no other material would do.

Roni Horn, *Gold Mats, paired – For Ross and Felix*, 1994–95. Pure gold foil, 49 × 60 × $^{1}/_{1250}$ in. (124.5 × 152.4 × 0.002 cm)

Fabricating

Chapter 7

In 2010, Chinese artist Ai Weiwei spread 100 million porcelain sunflower seeds on the floor of the Turbine Hall at Tate Modern. This low-lying carpet of massed tiny objects was accompanied by a video that explained that these seeds, far from being identical units, had been individually handcrafted over the course of two years by some sixteen hundred skilled workers in a city, Jingdezhen, historically known for its ceramics industry. Many commentators on the *Sunflower Seeds* video, which was posted on YouTube, portrayed Ai as a tyrannical manager, an overseer whose art "factory" was no better than the worst corporation. As one such poster acidly wrote: "Mining and pulverising marbles [*sic*] produced a lot of fine dust particles which were inhaled by these poor Chinese peasants who will suffer long term health effects. Heartless Ai Wei Wei [*sic*] exploited these poor peasants like Union Carbide exploited the poor Indians of Bhopal." This comment, with its condescending tone that forces equivalences between the compensated artisanal workshops of Jingdezhen (who were paid above-average wages) and the sickened residents of Bhopal, encapsulates how the outside fabrication of art often triggers cries of exploitation or of a despoliation of the artistic process, which "should" be a more intimate, personal, and individual act.

Fabrication: this word has the potential to signify across a range of practices, from assembly-line manufacturing that plops out widgets, to a theatrical performance that has been carefully staged. It can mean both process (that is, the gestures, or motions, or systems that move toward a product) and concrete output. The term can also imply deception, the creation of a fictional scenario, which is often indeed the case when it comes to discussions of making in the realm of contemporary art. In the context of this book, however, we use fabrication to refer to the making of an artwork by someone who is not the authorial artist, but does have significant skills and knowledge that are invested in the final result.

The practice is controversial and not only when Chinese laborers are involved. Many members of the public and art world alike feel

strongly that artists should make their own work, despite the fact that, art historically, this has been the exception rather than the rule. From the Renaissance through the nineteenth century, the execution of sculpture and large-scale paintings was typically by subdivided labor. The lead sculptor in an atelier might make an initial model out of clay or plaster, which was enlarged by assistants into a more durable material such as marble or bronze through a series of translations. The lead sculptor might (or might not) then apply a final finish to the work. In painting, similarly, artists were often specialized in the execution of specific elements such as landscape backgrounds, hands, or drapery. The artist who nominally authored a portrait might only have painted the face. These standard practices did not begin to decline until the emergence of an individualistic, Romantic ideal of the artist; in sculpture they remained commonplace well into the twentieth century, as the workshop practices of Auguste Rodin show, for example.

In recent decades the idea that artists might direct the work of others, like factory floor managers, industrial designers, or scientists in a laboratory, is back with a vengeance.[1] The huge upsurge in the art fabrication industry – particularly in Europe and the US, where the prevailing conditions for intense capitalization have been present for the longest time – is due to a number of factors. Among them is the broader range of materials and forms that artists now adopt, often requiring unusual specialist knowledge, and the related fact that artists are less and less likely to have professional levels of skill in making. The sense that artists should be able to work with any medium or format they choose has militated against specialism of this kind. Furthermore, since the "theoretical turn" of the 1960s, art schools have been more likely to send their students to the library than the metal shop.[2]

But the most important factor in the rise of fabrication has been the context for the display of art. In the crowded and competitive environment of a biennial or commercial art fair, and in the gargantuan spaces of new public museums, production values have become increasingly important as a way of achieving distinction. Sheer size is the most obvious example. As Caroline Soyez-Petithomme writes, "the XXL format has now become a norm for midcareer and established artists," which "of course, obliterates any emancipation from architecture or the art market."[3] Ironically, many of the exhibition spaces in question are former factories and other commercial spaces (including Tate Modern's

Turbine Hall, a former power station; DIA Beacon, previously a Nabisco box-printing facility; MASS MoCA, whose building was at one time an electronics plant and, prior to that, used for textile printing; La Sucrière, an ex-sugar factory that hosts the Lyon Biennale; and several defunct factories in Stoke-on-Trent, in which the city's ceramic biennial now takes place). Through handicraft fabrication carried out offsite, art is literally occupying the space emptied out as a result of de-industrialization.

While the rise of the fabricator is a conspicuous phenomenon, it has a wide range of historical precedents, many of which tapped into existing microeconomies of exchange. As early as the 1920s, the Hungarian-born artist László Moholy-Nagy created a series of *Telephone Paintings* on steel featuring abstract forms so simple that they could be ordered from an enamel factory over the telephone. These conformed to the Constructivist aesthetic explored elsewhere in Moholy-Nagy's work, an aesthetic that became powerfully influential through his teaching at the Bauhaus and in Chicago. He dreamed of a completely populist art that could be industrially manufactured, like cars or airplanes.[4]

There is no proof, however, that fabricators actually made all of the *Telephone Paintings*. Moholy-Nagy most likely produced at least some of them in his own studio. One might be inclined to dismiss

La Sucrière, Lyon

this detail as irrelevant. The concept was clear enough; does it really matter if it was only hypothetical? It certainly does, for when it comes to outsourcing we are in the terrain of actual rather than notional "art work." Moholy-Nagy had hoped to equate his artistic labor with that of the proletariat. But the productive base is not always cooperative. When art fabrication did eventually move out of the studio and into the factory, something very nearly the opposite occurred. The Constructivist dream had been a level playing field, in which everyone was involved in the making of art.[5] Instead, outsourced production has become a high-end specialist industry capable of evermore complex and expensive forms of making, and hence progressively higher levels of stratification.

Sculptors had long relied on casting specialists both inside and outside their own studios, just as photographers and printmakers had used commercial print shops. Beginning in the 1930s, they increasingly turned to large-scale industrial fabricators in order to realize their art. When Alexander Calder wanted to make larger sculptures than his own studio would allow, for example, he first collaborated with shipbuilding companies and went on to employ highly skilled French welders who otherwise were occupied making nuclear power plants.[6] Eventually the fabricators began to seek out the artists. In the early 1960s, the Brooklyn metal fabrication shop Milgo Bufkin began to collaborate proactively with sculptors, though its main business remained architectural metalwork.[7] The first company to focus exclusively on making art to order, however, was founded by Donald Lippincott in Connecticut in 1966. Lippincott was not selling a defined service. His firm was more like

The Lippincott crew in front of *Love* by Robert Indiana, 1970

Barnett Newman, *Broken Obelisk*, 1963–67, on display in the field at Lippincott. Cor-Ten steel, 26 ft × 10 ft 6 in. × 10 ft 6 in. (7.93 × 3.2 × 3.2 m)

a bespoke craft shop; customization was the norm. The business also had a commercial sideline, selling large-scale sculptures directly on an artist's behalf and lending pieces to exhibitions. Already in its early days, then, the fabrication business was more than a contracting service: it was a node within a network.

Barnett Newman's *Broken Obelisk* (designed in 1963 and first fabricated in 1967) is perhaps the best-known production of Lippincott's early years, featuring heavily in the firm's own published history and on the cover of a 2007 special edition of *Artforum* about art and production.[8] Obelisks have been symbols of power since the first ones were erected in ancient Egypt, and for US audiences Newman's snapped-off version inevitably recalls a violated Washington Monument. Against the backdrop of political unrest in the late 1960s, it would have read clearly as an emblem of fractured and inverted authority. But the work also aptly represents the contradictions and possibilities of the fabrication business. Newman, of course, is mainly known as a painter. Most of his canvases consist of one or more vertical stripes ("zips," he called them) against a monochrome background. Conceptually, each zip functions as a "You are here" sign, a marker of the encounter between artist and viewer. The same is true of *Broken Obelisk*, which converges at a daringly small fulcrum where obelisk meets pyramid. The sheer scale and weight of the sculpture emphasize the effect: three tons of Cor-Ten steel meeting at one point along perfectly straight vectors, thanks

to the technical skill of Lippincott's team. No wonder the Museum of Modern Art in New York chose it as the centerpiece of its new building when it reopened in 2004.

Yet in the photograph of *Broken Obelisk* in Lippincott's yard, there are not one but *two* points of convergence. The effect is disorienting. Is this a twice-exposed photograph? No, these are the original casts of the sculpture, identical except for the snow clinging to their slopes. The image at once contradicts the singularity of the sculpture and suggests the power of the fabricator. If a form can be made twice, it can be made as an indefinite series. Indeed, two further *Broken Obelisks* would eventually be made at Lippincott for institutional clients, in 1969 and in 2005 (the latter long after Newman's death but with the permission of his estate). In theory, there could be more. Even for this most existential of artists, then, fabrication loosened the relation between the original authorial concept and the finished work, bringing them into alignment with the dictates of institutions and the market.

It is no coincidence that serial art fabrication flourished at the same time that the depersonalized aesthetics of Minimalism and Conceptualism held sway in the 1960s and 1970s. The Expressionist tendencies of the preceding generation had placed a great emphasis on individual action and gesture: aspects of the artistic process that cannot be left to others. But for the generation of the 1960s, personal touch was often expunged through careful planning. Donald Judd, for example, prioritized exact rendering of shapes and surfaces as a means to achieve an effect of forceful unity. He, too, spoke of ordering his sculptures over the telephone, but he and the other Minimalists were certainly not picking up where Moholy-Nagy left off. As the honed surfaces of Judd's metal and plastic sculptures make clear, outsourcing was not a way to democratize his work, but rather the contrary: a means of elevating production values.

To achieve the precise results that he wanted, Judd worked with several fabricators, including Milgo Bufkin, the metal shop Bernstein Brothers, and the carpenter Peter Ballantine, who became a particularly trusted partner for the artist. Often, seemingly crucial details were left unspoken. "Judd never stopped by," according to Ballantine:

> It wasn't because the shop wasn't close. My shop was a block and a half away from his studio. It was so close that you could walk over and discuss the new pieces that you were thinking

DATE: JULY 10, 1967

NAME: DONALD JUDD

ADDRESS: 53 East 19th Street NY/3

REF:

DATE: Dec 13, 1967.
INV. No.
JOB No.
CUST. O. N.
REQ.....

1 — Wall Mount Unit 2 75 — no change

To affect Bill 13/13/67.
Dw # 851
Job # 726 B — Item # 1 —

① GALV WALL UNIT (#24 GALV) 141½"
 11'-9"

27" 7" 7" 7"
2×3 BLUE
30"
30"

Tot wt 200 lbs.

2" 27" 3"
2×2×¹⁄₁₆ ×
#16×24" BRACKET #18 GALV 3"
1"×¼" BOLT
27"
2" 1"
30"

NOTCH AFTER ASS'Y

PITTS
PITTS

CUT
4 — 32 × 30⅛ 29⅝
4 — 60⅛ × 32
8 — 33¼ × 30½

NOTCH 3³⁄₈ × 3³⁄₈

Bernstein Bros., *Fabrication Drawing Job #44m*, 1967.
Pencil and pen on invoice note paper, 11 × 8 ½ in. (28 × 21.5 cm)

Anne Truitt working on a sculpture in her studio, Washington, DC, early 1970s

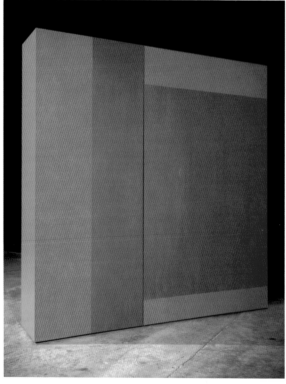

Anne Truitt, *Valley Forge*, 1963. Acrylic on wood,
60 ⅛ × 60 ⅜ × 12 in. (152.7 × 153.4 × 30.5 cm)

about in the rain without an umbrella. But you weren't running to ask, "Should I use a darker grain of plywood?" That kind of stuff – the type of plywood, where to cut the sheet, to a large extent the details of the joints – those were fabricator decisions. They were not Judd decisions.[9]

If fabrication as a mode of working (and its often attendant grandiose size) was commonplace for the male Minimalist artists, female artists who had affinities with this movement – such as Agnes Martin and Eva Hesse – have frequently been characterized as resistant to such methods and more inclined toward the hand wrought at bodily scale. Yet this opposition along gender lines breaks down at times; Anne Truitt, for instance, attained a high-polish look akin to Judd's on her simplified geometric forms, but achieved the surfaces through hand painting. When Truitt began her painted wooden sculptures, she did all the work herself, but as she became more successful she employed professional carpenters in order to concentrate her energies on the surfaces.[10]

The Minimalists' recourse to outside workshops was still unusual in the 1960s, but it had become run-of-the-mill by the mid-1970s. Only a few years after Lippincott opened his doors as a specialist art fabricator, he already had plenty of competition. In 1971, Peter Carlson began making sculptures for other artists near Los Angeles, in the San Fernando Valley. Until its recession-induced closure in 2010, Carlson & Company was the most heavily capitalized art-fabrication company in the world (it has since relaunched as Carlson Arts LCC, specializing in custom work). The workshop has memorably been described as "an art studio inside a paint shop inside a machine factory inside an airplane hangar inside a world-class museum" and "a sci-fi incubator for some kind of cyborg life form, only the aliens turn out to be artworks."[11] In its early years, Carlson made multiples for artists as various as Isamu Noguchi, Ellsworth Kelly, and Robert Rauschenberg. Latterly, the firm's best-known client was Jeff Koons, whose series of immaculate, immense, toy-like objects entitled *Celebration* is perhaps the most involved art-making project ever taken on by an outside contractor. Fittingly, the firm hired engineers from the Disney Corporation to get the job done. On the brink of closure, Carlson was in the thick of developing an even more prodigious (and, at the time of writing, still unrealized) project for Koons: a full-scale locomotive engine dangling from a crane, the fabrication costs of which have been estimated at $25 million.

Though specialists like Lippincott and Carlson have tended to dominate the fabrication scene, there are generalists in the business as well. Treitel-Gratz (now Gratz Industries) and the aforementioned Milgo Bufkin make sculpture alongside architectural elements, designer furniture, and the like. Both firms existed as metal shops in New York City prior to World War II and only later became involved in the art business. Yet they produced some of the most iconic postwar sculptures, such as Walter De Maria's seminal earthwork *Lightning Field*, for which Treitel-Gratz made the metal poles, and Robert Indiana's sculpture *LOVE*, several copies of which have been fabricated by Milgo Bufkin. Similarly, the Germany-based glass manufacturer Schott works within a bewildering range of industries, from defense and pharmaceuticals to solar power and scientific research. Were it not for its high-tech capabilities, Roni Horn could never have created a sculpture like *Pink Tons* (2008), whose title aptly conveys the impression made by the work: an update on Minimalism in which obdurate steel is exchanged for the magical but massive effects of solid optical glass.

The mixed economy of such companies points to an important fact: generally speaking, these shops have no "house style," no artistic predilections. Fabricators may well make major aesthetic contributions, helping to determine material selection, color, construction, scale, and finish. They are no doubt status-

Roni Horn, *Pink Tons*, 2008. Solid cast glass, 48 $^1\!/_{16}$ × 48 $^1\!/_{16}$ × 48 $^1\!/_{16}$ in. (122×122×122 cm)

conscious and not shy about revealing their associations with celebrity artists. But fabricators do not typically have the opportunity to pick and choose their clients, nor do they profess to be arbiters of what makes good or bad art. As production values have become increasingly central to the art scene, this professional neutrality has come to be a default mode of operation, which is arguably shared by curators, dealers, galleries, museums, fairs, and even some private collectors. As the challenges of fabricating and installing work mount ever higher – in keeping with the rising tide of financial investment that has buoyed contemporary art since the 1980s – nearly everyone in the art business has taken on something of the fabricator's ambitious and exacting, but fundamentally indiscriminate, approach.

These effects are enhanced by geographic proliferation. Wherever you find artists with financial means in large numbers today, there are also bound to be art fabricators. London alone is home to several major providers such as AB fine Art Foundry, MDM Props, and Mike Smith Studios. In most cases, artists do not simply outsource production to these firms, but remain actively involved throughout the process. This is one business where proximity still matters: no amount of digital renderings will replace a face-to-face consultation on the workshop floor. Marc Quinn, for example, is heavily involved in the modeling, finishing, and other artistic decisions involved in the creation of his neo-Neoclassical sculptures, such as his series depicting the supermodel Kate Moss twisted into the seemingly impossible yoga pose of a contortionist, inspired by ancient Chola bronzes from southern India. To realize these works, Quinn has collaborated with both art fabricators and foundries such as AB Fine Art, as well as specialist artisans at the goldsmithing firm Smith & Harris.

MDM Props – which also makes work for Quinn – was founded by the sculptor Nigel Schofield and carries out projects for commercial, theatrical, and museum clients, as well as art stars. To visit its studio in south London is to feel an odd equivalence between projects that will eventually be categorized very differently. In one corner of the shop, you might see a monumental bronze casting for a blue-chip artist; in another, props for a play or even display furniture for a shopping mall. A casual viewer may not know which is which. The range of work is enormous, and one of the company's primary concerns is simply sourcing and retaining sufficiently skilled artisans. The team can expand to meet the needs

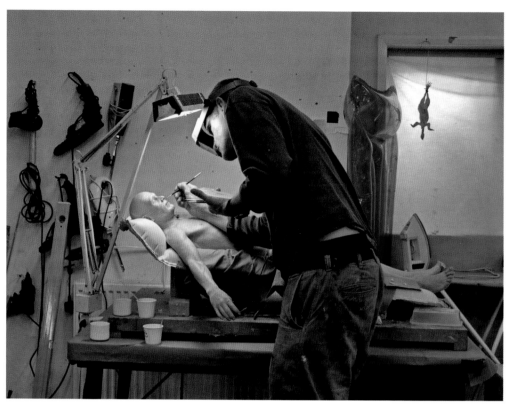

Ron Mueck at work in his studio, London, 2009. Photograph by Gautier Deblonde

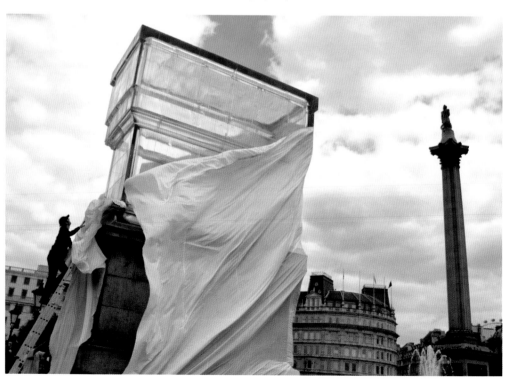

Unveiling of Rachel Whiteread's *Monument*, Trafalgar Square, London, June 4, 2001.
Resin and granite, 29 ft 6 5/16 in. × 16 ft 8 13/16 in. × 7 ft 10 ½ in. (9 × 5.1 × 2.4 m)

of a specific project, be it simple carpentry, carving and painting photorealistic figures, or modeling miniature landscapes.

Mega-fabricators like MDM can pool resources and talent from anywhere they like, without being overly concerned about their own identity or its implications for their clients. This raises a sensitive point: many of the artisans who work for fabrication companies are sculptors in their own right, who pursue an independent professional career when not "on the clock." Though the phenomenon is largely undocumented, save an important book by Michael Petry featuring interviews with fabricators, the boundary between fabricator and artist is a permeable one.[12] Figurative sculptor Ron Mueck, for example, has built upon and refined skills and techniques he learned in his early career as a model maker to create the high level of detail and finish seen in his minutely observed sculptures. Conversely, London's best-known fabricator, Mike Smith, started as one of the emergent stars of the Young British Artist generation. Though he had some success as an artist, he was also a consummate craftsman and frequently took on jobs for others, including Damien Hirst, for whom he made vitrines designed to hold hundreds of gallons of formaldehyde and sliced-up animals.

In 1995, Smith decided to concentrate solely on fabrication. He has gone on to make some of the most technically ambitious recent British artworks, including Rachel Whiteread's project for the Fourth Plinth in Trafalgar Square, entitled *Monument*: a direct copy of the existing plinth in transparent polyurethane resin, which was set upside down atop the original, creating a watery mirror image. This ghostly echo of imperial grandeur is powerfully poetic, but in press coverage it was often downplayed in favor of sheer physical magnitude: the sculpture weighed nearly twelve tons; the mold took four months to make; it cost £250,000; it was the largest resin object ever made. Ironically, given the sculpture's subtle critique of monumentality, these impressive statistics, as well as the Herculean efforts made by Smith and his team to overcome the difficulty of the making, became the principal discourse around the work.

Of the various issues that surround outsourced fabrication, this is undoubtedly one of the most contentious: that other people's making will take precedence over the artist's ideas and intent. Though he has always been crystal clear that he is the fabricator, not the author, of pieces made in his studio, Smith inadvertently touched that nerve in 2003 when he took

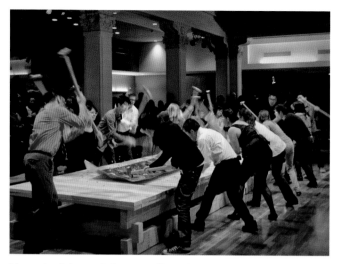

Margarita Cabrera, *Pulso y Martillo (Pulse and Hammer)*, 2011. Installation view at UCR Sweeney Art Gallery, University of California, Riverside

Margarita Cabrera, *Pulso y Martillo (Pulse and Hammer)*, 2011

the unprecedented step of publishing a monograph about his work.[13] (Even now, the only other fabrication firm to have published a book about its activities is Lippincott, and that is mainly about the early years, safely distant by a few decades.) While fabrication has become a less closely guarded secret in the decade since, it is still difficult to gain access to details of the process, much less the finances involved. Such inquiry raises questions about who exactly is doing the work, how such laborers are compensated, how their safety conditions are monitored, and who has the privilege to call the finished product theirs.

Some artists grapple explicitly with such questions of privilege, as a way to index economic injustice within the current manufacturing landscape. In her piece *Pulso y Martillo (Pulse and Hammer)* (2011), Margarita Cabrera, a Mexican-born, US-based artist who has continually engaged with issues of fabrication and the ethics of outsourcing, made a "production" out of production, that is, she theatricalized and made public one method of making. For this piece, a group of performers (mostly immigrant students in southern California) was enlisted to pound large copper sheets with sledgehammers. The resultant sound was resonant and percussive, reminiscent of noise music and the traditional procedures of handcrafted copper work, as well as of the assembly line. Cabrera was commenting on the often invisible labors of workers along the US–Mexico border, whose bodily efforts in *maquiladoras* (free-trade zone factory sites) are obscured by the processes of commodity

exchange. Instead of resulting in a materialized, tangible product, however, Cabrera utilizes what Claire Bishop has referred to as "delegated performance," in which others are asked to legibly embody their identities.[14]

Why does outsourced production – and performance – remain such a sensitive topic? Is it because of anxiety about a broader global economic condition, in which the shifting of manufacturing plants to developing nations has led to a widespread fear that all making will soon be outsourced, art included? Is it, more simply, that the public still expects work to be made by the artist him- or herself, and artists are reluctant to pull back the curtain? Certainly, that is suggested by the fascination that has attended revelations about the existence of a whole "painting village" in China, called Dafen, where there are thousands of painters who will make up canvases to order, based on pictures sent by email attachment.[15] The dynamics of this place are indeed startling. According to Winnie Wong, who has published a full-length book about art copying in China, the only artist who could be considered a "specialty" of Dafen painters is Vincent van Gogh, because "When unskilled painters first came from their villages to the

Painters work on copies of a painting at Dafen village in China's southern city of Shenzhen, June 21, 2007

The casting of *Secret Name*, a sculpture by Matthew Barney, at the Polich Tallix Fine Art Foundry, Rock Tavern, New York, July 26, 2011

city in the late '80s and early '90s to begin their training, they started with van Goghs because they were in high demand and because they were easy."[16]

A century after Duchamp, however, the idea that authorship and physical manufacture "should" in any sense be equated seems misplaced. Perhaps another concern is that the potency of fabrication has become so great that it trumps conception. This is potentially deeply troubling because, as Greg Hilty (curator at the Lisson Gallery in London) says, "it's still about the artist, for good or ill. The market needs a single figure, an artist's signature." We are a long way from a situation in which the authorship of art is apportioned out to all parties involved in the making of a work, with each credited in the manner of a Hollywood film. (Some artists do credit their fabricators, but this remains a personal choice, not an expectation.) Perhaps that day will never come. As Hilty puts it, despite the growth of the fabrication sector, "art isn't an industry like film is. It's very bespoke, very specific."[17]

It is this specificity – or perhaps a better word would be *specification* – that most defines success in the new world

of outsourced making. The artists who derive the greatest benefit are those who can fold the story of the making into the very substance of their work, even when they are not the makers. Figures like Hirst, Koons, and Quinn have, justly, been criticized for overindulging in production values. Each of them operates at the scale and budget of a Hollywood spectacular. But, so far, this has not resulted in an erosion of their artistic authorship. On the contrary, when Matthew Barney (who has actually produced several full-length films) had a retrospective at the Guggenheim in 2003, his artistic persona was hardly diluted. Rather, he seemed to absorb the museum itself as one more prop in his bizarre and byzantine narrative of sex, technology, art history, and Masonic symbolism. He is another example of an artist who has mastered outside fabrication as a medium in its own right, which can be manipulated as surely as paint or clay.

For artists, fabrication is fraught with political implications, as Ai Weiwei's *Sunflower Seeds* demonstrated beyond even his initial expectations. The work was originally meant to be interactive. Photographs taken by the public and posted on social media during the first week of the installation show how visitors enjoyed manipulating the seeds: raking them into patterns in the manner of a rock garden, burying each other underneath them as if at the beach. But the amount of dust kicked up by these activities was judged by museum officials to be hazardous to the staff. Tate took the controversial decision to close down the installation, instantly transforming it into a somber field of gray, reminiscent of an abandoned gravel pit rather than a scenic seashore. The subtext of the decision was the dramatic disparity between the workers who had made the seeds in China (who after all had spent two years inhaling the offending dust) and the workers who tended it in London. That Tate had a clear duty of care to one of these groups, and not the other, exemplified all too clearly the uncomfortable realities of global production systems: the very topic that the project had meant to address, albeit not so directly.

Much of contemporary art is premised on the idea that authorship can take any form, flowing unimpeded through new structures. But like the resistance in an electrical system, the realities of production impose friction on this process. Partly on purpose and partly by accident, this friction became the overwhelming subject of Ai Weiwei's *Sunflower Seeds*. In a way, he achieved what he set out to do, and more: the work exposed the asymmetrical realities of global production.

This is an unusual example, but it illustrates a general trend. The artists who most successfully navigate the new sea of possibilities afforded by fabrication are those who know exactly what they want, and manage to reflect on the process even as they exploit it. As the art system comes to rely on evermore sophisticated systems of outsourcing, we can expect the complexities of collaboration to come increasingly to the fore. For now, fabrication is a backstage activity. In retrospect, however, it may well become clear that it was the primary content of art in our time.

Digitizing

In 1995 four people, named Jeffrey Howington, Andrea Latvis, Peggy Soung, and Lisa Yurwit, drew lines on a wall using variously colored felt-tipped markers. Their instructions were as follows:

> *The first drafter has a black marker and makes*
> *an irregular horizontal line near the top of the wall.*
> *Then the second drafter tries to copy it*
> *(without touching it) using a red marker.*
> *The third drafter does the same, using a yellow marker.*
> *The fourth drafter does the same using a blue marker.*
> *Then the second drafter followed by the third and fourth copies*
> *the last line drawn until the bottom of the wall is reached.*

The result was a drawing that looks like a topographical map. As it drifts down the wall, the contours shift imperceptibly. As one might expect, the second line on the wall is very similar to the first, and the third is very similar to the second. But "similar" is not "the same." By the time the drafters reached the bottom of the wall, in spite of their best efforts to be precise, the shapes of the lines had become entirely different. The drawing is a kind of chart, which records our human inability to match a pre-existing model.

What Howington, Latvis, Soung, and Yurwit were making was *Wall Drawing 797* by the conceptual artist Sol LeWitt. Since the late 1960s, LeWitt had been putting his ideas into motion by writing instructions to be followed by others. He was not the first to use this hands-off strategy of art-making; it had been pioneered by artists in the Fluxus movement, who employed "event scores" that could be executed by anyone, according to their own interpretation. These bits of text were typically written in a very open, evocative, even poetic way. For example, the Fluxus artist Alison Knowles's *Color Music #2* (1963) reads as follows:

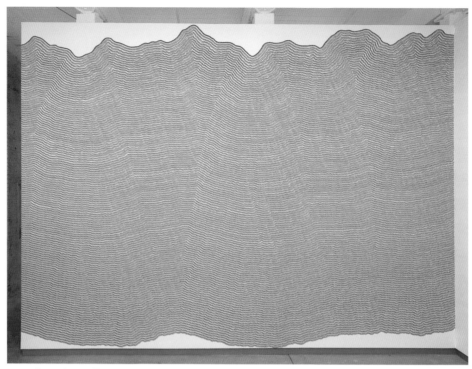

Sol LeWitt, *Wall Drawing 797*, October 1995. Black, red, yellow, and blue markers, variable dimensions

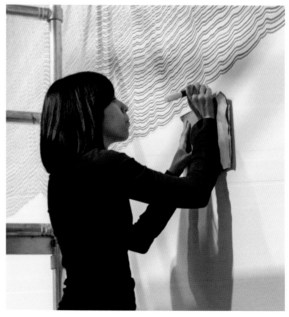

Milinda Hernandez drafting Sol LeWitt's *Wall Drawing 797*, February 2014. Installation view at the Blanton Museum of Art, University of Texas, Austin

Alison Knowles, *Color Music #2*, 1963. Executed by Glenn Adamson
in 2014, Brooklyn, New York

Print in the streets.
1st movement: orange
2nd movement: black
3rd movement: blue[1]

As the prospective enactor of this work, that short text is all you
get; the rest is up to you. Yet the simplicity of Knowles's writing
is deceptive. In only thirteen words, she manages to allude to
musical composition, public space, abstraction, and printmaking,
while also suggesting an activity that verges on protest (the term
"movement" implying not only part of a symphony, but also
a political action that happens in the streets).

 An infinite number of versions of *Color Music #2* are
possible: large and small, screen-printed or stamped, executed
by one or many. In contrast, while LeWitt's wall drawings
emphasize the individual handwork of his drafters, they are
relatively circumscribed. The material, position, personnel, and
form of the work are all stipulated in advance. Unlike Knowles's
event score, many of LeWitt's instructions will produce a similar
result every time. In fact, he was sufficiently concerned to achieve
consistency that, by the time he devised *Wall Drawing 797*, he
had started to employ a cadre of specialist drafters who were
able to render his instructions at a very high level of skill. As art
historian Beatrice Gross comments, "the fact that he delegated the
execution did not mean he was indifferent to it: the more careful
the execution, the more it served the 'optimum form' of the idea."[2]

In the previous chapter, we explored more fully the role of specialist fabricators in realizing artistic intention. Here, though, our concern is with how artists like Knowles and LeWitt have used different types of "code" to instigate (rather than execute) a form. Each of their works originates in a script, which produces a more or less predictable, more or less unique, result. In retrospect, their early experiments look astonishingly similar to the routines of a computer. They are the forerunners of digital art, not in the sense that they use technology, but because of the way in which they place production under the constraints of language. (They also both rely upon an older sense of digital: that which relates to the digits, or fingers, of the human hand.) What has changed, with the advent of computerized digital technology, is the nature of the script itself and the tools that it sets in motion. Instead of everyday language, artists now can use more powerful and abstract forms of logic to set their works in motion. As the artist Leo Villareal, known for spectacular displays of light that flow in complex patterns, puts it: "Code is the new pigment; control boards are the new palette."[3]

Compare the following text to the scripts by LeWitt and Knowles:

> *Photoshop CS: 110 by 72 inches, 300 DPI, RGB, square pixels, default gradient "Spectrum," mousedown y=16700 x=4350, mouseup y=27450 x=6350*

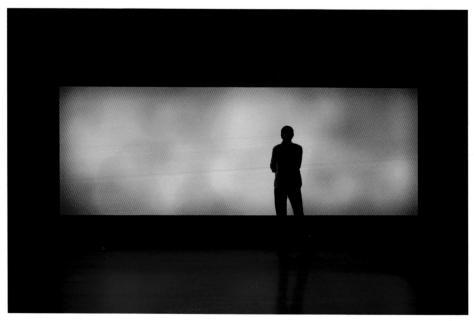

Leo Villareal, *Amanecer*, 2010. LEDs, diffusion material, custom software, and electrical hardware, 84×240×15 in. (213.4×609.6×38.1 cm)

This is the title of a work (2010) in Cory Arcangel's series *Photoshop Gradient Demonstrations*. It consists of a particular set of commands in the software program Photoshop.[4] Computer-savvy viewers will be able to repeat this protocol on their own device, producing an exact duplicate of the image. The anarchic anything-goes possibilities of Knowles's score and laborious handwork required to make one of LeWitt's wall drawings are both absent from Arcangel's point-and-click method. But this does not necessarily mean that Arcangel's work exists in a state of "dematerialization" (a commonly used, and heavily contested, term among conceptualists of LeWitt's generation). While anyone can create a new digital file inspired by one of Arcangel's works, few would have the means or know-how to print out the results at high resolution and enormous scale, up to nine feet (2.8 meters) tall, as he does.

This is an important point: the digital is not immaterial. New computer tools mark a significant departure from older analogue processes, above all with regard to distribution. An artwork that lives online can proliferate immediately and globally, in a way unprecedented by other forms of serial production. Yet digital tools have their physical limits and possibilities, too. We easily forget that the internet has a physical infrastructure: it requires servers to host it and devices to access it. "The cloud" is hardly vaporous: microchips need to be assembled, mainframe computers dusted, keystrokes entered, server farms maintained, broken links fixed, and so on. As media theorist Barbara Junge has put it, "It is clear that the much-nurtured and cherished differentiation between the virtual (the simulated) and the real is no longer valid. Digital information is becoming physically tangible."[5]

Cory Arcangel, *Photoshop CS: 110 by 72 inches, 300 DPI, RGB, square pixels, default gradient "Spectrum," mousedown y=16700 x=4350, mouseup y=27450 x=6350* from the *Photoshop Gradient Demonstrations* series, 2010. Chromogenic print, 110 × 72 in. (279.4 × 182.9 cm)

Furthermore, as anyone who has ever owned a five-year-old smartphone will attest, the physicality of the digital is abundantly evident in the speed with which it ages. Arcangel is attuned to this rapid obsolescence and even sees

Facebook's Luleå Data Center, Sweden

a melancholic dimension in it.[6] His elegiac stance is evident in an early project entitled *Super Mario Clouds* (2002–ongoing), a Nintendo game in which everything but the clouds and background has been erased. All that remains is a blue sky against which white clouds drift in a slow leftward movement. This effect was achieved not through digital manipulation, but rather a clever DIY adjustment of the actual game cartridge. (Arcangel, a believer in open-source culture, details the process in full on his website: "Next take some wire clippers and clip the legs of the PRG chip. I like to use the red clippers from Radioshack."[7]) Through these means, he draws attention to the particular aesthetic of Nintendo-era graphics – flat, blocky, and slightly jerky – and finds in them a kind of serene beauty.

In *Super Mario Clouds*, Arcangel returns to an earlier moment in the proliferation of digital media, when consoles and cartridges were standard means of transmission. The graphics of that era seem very dated now, but no more so than today's digital images will in ten or twenty years. Each stage in the development of this technology imparts a particular look, which is extremely specific to its moment and to the hardware that supports it. As Arcangel put it in 2008,

> those crappy compressed blocky images you need to squint your eyes to understand [are] all over the internet. And in case you haven't noticed, this look is everywhere else as well (ads, digital cameras, digital video, etc.). If the '80s gave us "hot" colors and "rad" graphics, and the '90s gave us slick vector design, then the '00s are giving us compressed blocky images.[8]

Today, according to commentator James Bridle, we have accidentally discovered a "new aesthetic" that is entirely technologically determined: endemic online motifs such as blur and pixelation, avatars, and visual glitches; the panoptic view of surveillance cameras and satellite maps; and formats like the

Cory Arcangel, *Super Mario Clouds*, 2002–ongoing.
Handmade hacked Super Mario Brothers cartridge
and Nintendo video game system, variable
dimensions

An internet "glitch" sourced by James Bridle
for his website on the "new aesthetic".
Image data: Google Earth

self-portraits ("selfies") made possible by smartphone cameras.[9]
In an era of widespread governmental monitoring, corporate data-
dredging, and debates about online privacy, this "new aesthetic"
has potent social significance as well.

Currently, the dominant portal to visual information online
is Google Images, in which any word or phrase can be translated
into a grid of low-quality "thumbnails." It is sobering to think that
the vast majority of contemporary encounters with visual art occur
via Google, and so involve only the most rudimentary indication
of the original's true appearance. On the other hand, the artist and
theorist Hito Steyerl wrote in 2009 in defense of such "poor images,"
casting them as a progressive counterpart to "rich" and saturated
higher-quality originals. For Steyerl, the low-resolution, debased,
and often unauthorized copy of an image or film constitutes a
political opportunity. Floating free past roadblocks of intellectual
property control, it can be claimed by anyone for any purpose.
"The poor image," she writes, "transforms quality into accessibility,
exhibition value into cult value, films into clips, contemplation into
distraction... it is a visual idea in its very becoming."[10]

Whether or not this narrative of liberation can be sustained,
Steyerl's idea that artists can lay individual claim to a "poor
image," and have their way with it, is certainly true. An example
is found in the *jpegs* series (2004–ongoing) by Thomas Ruff.
Trained at Düsseldorf Academy under the renowned conceptual
photographers Bernd and Hilla Becher, Ruff is one of a generation
of German artists (alongside Andreas Gursky and Thomas

Struth) to embrace digital production as a way of transforming photography. This group of artists treats their medium – normally understood as an indexical record of the real – as something akin to painting, in that the image field can be built up, layered, and distorted at will.[11]

Ruff's *jpegs* are enormous in scale, but they begin from tiny, low-resolution "thumbnails" found online. The imagery is uniquely troubling: "terrible yet beautiful pictures of destruction and disaster," the artist says, "that have found their way into the collective image archive: the Twin Towers after the attacks, the burning oil fields in Kuwait, the bombing of Baghdad."[12] An especially challenging series within the artist's body of work is *Nudes* (begun in 1999), where the source imagery is pornography. As in the *jpegs* works, the artist first downloads the image, then reduces it further in scale, then blows it up by several orders of magnification. Once he has a high-resolution file, he manipulates individual pixels, changing key details (for example, genitalia are sometimes erased) and producing an overall effect of blur that knowingly recalls the paintings of German artist Gerhard Richter. As Okwui Enwezor writes, the picture "migrates from a small digital file to a scaled up image meant specifically to disintegrate."[13]

Ruff's choice of subject matter makes the allusion to painting plain – as the nude, especially female nude, is the central subject matter of academic art – but the splayed bodies remind us of the proliferation of many types of pornography within contemporary culture, including so-called "ruin porn" or "war porn." What is most disturbing about them is not only the blurred naked bodies that hover uncomfortably between visual accessibility and

Thomas Ruff, *Nudes ma27*, 2001. Chromogenic print with Diasec, 44 ⅛ × 55 ⅛ in. (112 × 140 cm)

Claudia X. Valdes, *In the Dream of the Planet*, 2002.
Digital video, 7 minutes 40 seconds, installation, variable dimensions

inaccessibility, but also the sense that the sensual and the sexual have been colonized by a second- or third-order experience: these are not just pictures, but pictures of pictures. Ruff puts the point plainly: "for my generation the model for the photograph is probably not reality any more, but images we have of that reality."[14]

While Ruff draws from a wide range of searing images for his source material, including mushroom clouds from atomic blasts, artist Claudia X. Valdes has more narrowly honed in on precisely such images from the nuclear age to interrogate how they continue to circulate in popular culture. Her digital video, *In the Dream of the Planet* (2002), is an adaptation of the apocalyptic made-for-television movie *The Day After*, shown in the US in 1983 at the height of President Ronald Reagan's fear-mongering about the nuclear arms race. Condensed down from its original length of over two hours to short sequences of fifty-six seconds that replay in an endless loop, Valdes shows how images feed into the fear of imminent catastrophe, as well as shedding light on the endless manipulability of media representations and their haunting after-images.

Artists like Ruff, Valdes, and Steyerl share the presumption that digital means of production generate a worldview distinct from the perspective afforded by analogue media. This same instinct was anticipated many years ago by Nam Jun Paik, whom we discussed

185

Nam June Paik in collaboration with John J. Godfrey, *Global Groove*, 1973.
Still from single-channel videotape, 28 minutes 30 seconds, color, sound

earlier in our chapter on tool-making (see pp. 119–20, 127). In his
television-based works, such as the sprawling multi-screen *Global
Groove* (1973), he presents fragments of appropriated footage
that cut in and out, skitter and slide, and leap from one monitor
to another, in eerie prescience of today's hop-skip-and-jump
internet culture. Though they seem frictionless and automatic,
Paik's works in this vein were possible only through extensive
technical experiment, in collaboration with technologist Shunya
Abe. Together they invented a video synthesizer that allowed
them to change colors, mix footage, and layer images, for the
first time treating moving images as artists had once collaged
bits of newspaper and paint.[15]

Paik's embrace of these techniques had a gleeful energy, born
not only of the rudimentary technology at his disposal but also
the excitement of fresh discovery; he has been hailed as the
heroic "prophet" of what Martha Rosler calls, with appropriate
criticality, video's "utopian moment."[16] Today, given that digital
image manipulation is present throughout media and advertising
culture, artists necessarily approach these techniques from
an entirely different vantage point, often laced with suspicion.
The artist Paul Pfeiffer frankly declares, "I am using the tools
of the enemy... the same tools used by advertising agencies and
blockbuster moviemakers."[17] He alters existing video footage,

often of sports, in such a way as to expose the unspoken, underlying racialized dynamics of pop culture.

In the mesmerizing video work *John 3:16* (2000; the title is based on the biblical verse often seen on signs at sporting events), many shots of athletes playing basketball are cut together in such a way that the ball seems to float, spinning but stationary, while hands grasp desperately at it in an endless loop. Though a simple work, it has a rich range of reference, from the myth of Tantalus to Jeff Koons's basketball-in-a-tank sculptures. The video conveys the sense that, in media spectacles like professional sports, pleasure is always deferred, held teasingly before us but beyond our grasp. "A special relationship exists between black bodies and spectacle," Pfeiffer notes, commenting on the charged bodily absences at the center of this video. "It's almost as though the spectacle could not exist without them."[18]

It is easy to forget, looking at Pfeiffer's works, how laborious they are to make. To achieve the effect of immobility in *John 3:16*, for example, he manually refocused and edited huge amounts of existing footage: a demonstration of the way that working in digital media can require just as much "hand work" as do traditional techniques. The same can be said of *Morning After the Deluge* (2003), for which Pfeiffer recorded a sunset and a sunrise and then flipped one atop the other. As curator Stefano Basilico explains,

> the horizons met and became one. By motion-tracking the sun and keeping it centered in the frame our traditional frames of references – the landscape and the horizon – are eliminated. The sun neither sets nor rises... the sun remains fixed in place,

Paul Pfeiffer, *John 3:16*, 2000. Installation view, digital video loop, 2 minutes 7 seconds, metal armature, LCD monitor, 5 ½ × 6 ½ × 36 in. (14 × 16.5 × 91.4 cm), DVD player

Paul Pfeiffer, *Morning After the Deluge*, 2003. Still from projected video installation, 20-minute loop

while the world circles around it: which is, of course,
the way it actually is.[19]

Though here his subject is much more general (our place in
nature), there is a continuity with Pfeiffer's sociopolitical concerns.
Figuratively speaking, there is nowhere to stand in this video.
Just as the basketball floats free in *John 3:16*, here it is we who
are dislodged from space and time. No wonder that Pfeiffer has
described the work as "a study of the human figure: its place in
the history of western art, and its disintegration at the dawn of
the digital age."[20]

Morning After the Deluge is always shown on a large
screen, the better to engulf the viewer in color. But in most
of his works, Pfeiffer employs distinctively small monitors in
which the technological support systems are clearly seen: wires,
power supply, armatures. This approach, which he describes as
"calculatedly unspectacular,"[21] is commonly seen in contemporary
art, not only because it feels honest and direct, but also because
it is a great deal easier than installing the relevant wiring behind
a seamless wall. Expediency aside, when taken to its logical
extreme the naked presentation of such means of production
can become a sculptural genre in its own right.

Haroon Mirza exemplifies this approach. Though he now
practices entirely as a visual artist, he was previously active as
a composer and DJ, and one navigates his spry, wiry installations
with the ears as well as the eyes.[22] Mirza frequently returns to
the technology of the recent past, and cites Paik as a major
influence. He freely blends analogue and digital electronic devices,
often setting them in motion. The result is typically a technological

Haroon Mirza, *Cross section of a revolution*, 2011. Mixed media, variable dimensions

Renée Green, *The Digital Import/Export Funk Office*,
1996. Booklet

mash-up. A turntable, lights, a radio, amplifiers, and a light bulb
might all combine to create an acoustic environment rich with
hisses, pops, and feedback. Sometimes he is more arcane in his
instrumentation: ants crawling on a copperplate, or an electronic
keyboard whose circuitry is activated by a jet of water inside a
metal dustbin. Responding to composer Edgar Varèse's observation
that "all music is organized noise," Mirza muses, "[that] is like saying
all sculpture is organized materials. I guess I combine the two."[23]

The interface of sculpture and music (that is, space and sound)
using digital technology has also been explored by Renée Green in
the CD-ROM version (1996) of one of her best-known installations,
Import/Export Funk Office. The original work, from 1992, was a
library-like collection of artifacts related to the global exchange of
cultural products: in this case, objects related to hip-hop music as it
was produced by African diasporic musicians and made its way to
sometimes unexpected locations around the world. The process of
moving from a physical set of objects to a collection of digitized
information as *The Digital Import/Export Funk Office* was for Green
an exercise in translation that mirrored the project itself and
was transformational:

> the disk is a new work. The possibility of actually having
> a form (location) which is compact, yet can store quite a lot,
> allowed me to move into another level of thinking about the

work and how the work can exist beyond its spatial presentation in a gallery or in a museum.[24]

We mentioned earlier the material repercussions wrought by digital technologies, not least corporate and governmental networks of surveillance that have the potential to monitor our every email or text message. US artist Julia Scher was an early provocateur in the field of surveillance art, creating projects using security cameras to comment on ever-ubiquitous regimes of control. In her 1995 *Securityland*, Scher asserted that we were all in the process of moving into a single, shared house, linked by a vast network of public and private cameras. Scher is a true dystopian, but her vision is no less prescient for that. "At least you can see actual space," she notes. As Scher elaborates:

> Virtual space is another ruse, because our virtual identities have to be created before we can pass through a virtual space. What kinds of hierarchies are going to be employed to keep us in or out of those virtual spaces? I can penetrate those walls without being a physical presence. I'm interested in the extremity of this battleground.[25]

Julia Scher, *Securityland*, 1995. Website

Natalie Jeremijenko, *BIT Plane*, 1997. Stills from camera-equipped remote control plane

Hasan Elahi, *Tracking Transience*, 2002–ongoing. Interdisciplinary self-surveillance project

In 1997, Natalie Jeremijenko and the Bureau of Inverse Technology took up a project parallel to Scher's called *BIT Plane*, an effort of counter-surveillance to conduct aerial reconnaissance of one of the major centers of digital innovation, California's Silicon Valley. Using a small, radio-operated spy plane outfitted with a micro-video camera that transmitted data digitally back to its operators, Jeremijenko conducted flyovers of high-tech corporate campuses including Apple, Lockheed, and Hewlett Packard (which often ban cameras and conduct their business in a shroud of secrecy). In the

wake of 9/11 and the heightened national security that ensued, this culture of surveillance has become of even greater concern, and many artists have followed Jeremijenko's lead. Bangladeshi-American artist Hasan Elahi, after being erroneously placed on a US governmental "terrorist watch list" and being asked to account for his frequent travels, decided to make his movements totally transparent to anyone who cared to look, and now documents his every step using GPS tracking. Elahi's *Tracking Transience* includes a map pinpointing his whereabouts every second of every day, in real time, on his website. Underscoring the infringements of privacy that these new technologies have fostered, Elahi has created an overwhelming data set that emphasizes how non-white individuals in the US, as racialized "outsiders," are more frequently scrutinized and monitored than others.

Because it is a long-standing misapprehension that the digital realm does not substantially exist, but rather hovers as an ephemeral system of invisible wireless signals, it must be reiterated that digital technology is not immaterial, nor is it detached from social structure. Men predominate in roles as programmers and digital artists alike. Yet, as with any mode of production, issues of gender are vital to consider within the realm of digital making. Cyberfeminist artist Faith Wilding has explored a range of high-tech feminized labors. Writing about home-based "telework" that is often the domain of women and probing our gendered assumptions about the tech industry, she says:

> We must rethink the contexts in which computers are used, and question the particular needs and relations of women to computer technology. We must try to understand the mechanisms by which women get allocated to lower-paid occupations or industries, and make visible the gender-tracking that obtains in scientific fields of work.[26]

Wilding is part of the feminist collective subRosa, whose projects have sought to illuminate connections between gendered bodies and technology, such as *Cell Track* (2004), an installation and website that examine the

subRosa, *Cell Track*, 2004. Website

Cao Fei, *Yanny at Home*, from the *Cosplayers* series, 2004. C-print, 29 ½ × 39 ⅜ in. (75×100 cm)

ethics of human embryonic stem-cell research. The site offers a map of the human body with information (legal and otherwise) about patenting and privatizing of genomes that have been sequenced digitally, one code (DNA) meeting another.

subRosa's cyberfeminist work highlights the real-world applications of bio-technology. Yet the creation of online digital universes has also allowed for novel kinds of fantasies to flourish. The immersive environments of multiplayer games and other online platforms have let some people fashion entirely new identities and inhabit fictitious spaces. The invented digital world and the supposed "real world" are bracingly juxtaposed in Cao Fei's *Cosplayers* series (2004), in which people dressed incongruously as avatars from video games enact some of the unrealistic moves from the games (swordfighting, martial arts) in actual spaces. Commenting on the disconnection felt by youths who spend most of their time playing video games, her series transports them, in full costume, from the idealized screen to actual streets and landscapes, showing their lack of interaction in sites like public transportation or while eating dinner at home in front of the television.

With deft humor, Fei begins to suggest the implications of a life lived entirely online. It is an idea that many other artists are trying to chart too, including by rigidly formal means. What does the world look like, in purely visual terms, from a digital point of view? One possible answer is provided in *Colors* (2006), another work by Cory Arcangel. *Colors* is based on the film of that name directed by Dennis Hopper in 1988, a drama about the policing of gangs in Los Angeles, yet the content of the movie, with its racial tensions between different "colors," is hardly the point. To make his adaptation, in which the entire movie is broken down into its smallest visual units, Arcangel wrote a program that would sample every single line of pixels, making innumerable horizontal cross sections. Each of these infinitesimally thin color slices is then stretched to fill an entire screen. Arcangel's version of the film is considerably more beautiful than Hopper's original, and also much, much slower. It takes thirty-three days to run through the

Cory Arcangel, *Colors*, 2006. Single-channel video, artist software, computer, 33 days. Installation view, Power Points, DHC/ART Montreal, Canada, June–November 2013

Gerhard Richter, *Strip*, 2011. Digital print on paper between Alu Dibond and Perspex (Diasec), 86 ⅝ × 86 ⅝ in. (220 × 220 cm)

David Hockney, *Untitled, 19 June 2009, No. 4*, 2009.
iPhone drawing

whole piece, more than enough time for the viewer to get the point: an apparently seamless cinematic image is actually made up of physical matter, which can be cut up and manipulated just like any other medium.[27]

The method is remarkably similar to a recent series by Gerhard Richter, who has treated his own abstract paintings to a similar process of atomization. The original painting, with its dragged and layered pigments, is divided into small units, manipulated, and then digitally stretched out into horizontal stripes. A hostile reviewer, trying to express the "antiseptic" quality of the prints, described them as looking remarkably like touch screens, and there is something to this.[28] Arcangel and Richter alike are pushing fine art closer to the material condition of our everyday digital culture.

This conversation can go both ways. British painter David Hockney enthusiastically adopted his iPhone (specifically,

the application "Brushes") as an art-making tool, at the age
of seventy-two. He explained his attraction as follows:

> It's always there in my pocket, there's no thrashing
> about, scrambling for the right color. One can set to work
> immediately, there's this wonderful impromptu quality, this
> freshness, to the activity; and when it's over, best of all, there's
> no mess, no clean-up. You just turn off the machine. Or, even
> better, you hit Send, and your little cohort of friends around
> the world gets to experience a similar immediacy. There's
> something, finally, very intimate about the whole process.[29]

Hockney's commentary is a reminder that, for most artists, as
with any other type of production, the sheer practicality of digital
making is the primary consideration. When he speaks about his
iPhone drawings he emphasizes portability, cleanliness, and speed,
the same things that attract anyone else to use such a device, rather
than conceptual issues to do with intangibility or network culture.
The images that Hockney produces on his phone subscribe to the
most traditional artistic genres of landscape, portrait, and still life.
It is a reminder that, as potentially disruptive as this technology
may be, we should not forget that the digital is, after all, just
another way of making art.

Crowdsourcing

Chapter 9

In response to Marcel Duchamp's urinal being rejected from an ostensibly unjuried exhibition held by the Society of Independent Artists in 1917, an unsigned letter appeared in a New York paper, defending the artistic ideals put forth by Duchamp's alias, R. Mutt: "Whether Mr. Mutt with his own hands made the fountain or not has no importance. He CHOSE it. He took an ordinary article of life, placed it so that its useful significance disappeared under the new title and point of view – created a new thought for that object."[1] Duchamp's *Fountain* has been understood as inaugurating a shift in the definition of art itself. Rather than something that must be made or created, art could be anything that an artist decided to choose or select. However radical, this new definition nonetheless kept in place the status of the *artist* as the authorial guarantor of meaning, value, and significance.

We have considered how the multiple legacies of Duchamp's readymade from the early twentieth century continue to have ramifications for contemporary issues of production, from media that are usually generated by a single person, such as painting, to massive manufacturing endeavors involving many fabricators. In this chapter, we consider what happens when the idea of the artist as the producer of art is renounced, or at the very least contested. That is, we examine the gray areas around authorship and originality that arise when artists relinquish their special role as makers and selectors, and instead seek (sometimes successfully, sometimes less so) to spread authorial status around, to as many people as possible.

In Chapter 7, we noted that outsourcing art to teams of skilled workers using specialized instructions has become a widespread mode of artistic production. "Crowdsourcing" – a neologism created by combining "crowd" and "outsourcing" – is a somewhat different matter. Coined in 2006 by *Wired* magazine editor Jeff Howe, the term refers to soliciting an undefined, general public, often online using social media, to complete a task. As Howe writes, "Remember outsourcing? Sending jobs to India and China is so 2003. The new

pool of cheap labor: everyday people using their spare cycles to create content, solve problems, even do corporate R & D."[2] Physical commodity production via outsourcing has by no means disappeared, nor has it been replaced by the largely "content"-oriented tasks that are generally performed via crowdsourcing. But the word has been taken to signal the emergence of a new paradigm for some forms of popular, volunteer participation. Since its appearance, crowdsourcing has spawned other parallel activities and terminology, including crowdfunding and crowdvoting.

When viewers of television shows are recruited to make their own video clips and submit them for broadcast, or when amateurs are encouraged to produce home-grown advertisements for a cola's promotional website, these are examples of corporate crowdsourcing. As these instances suggest, it has become a popular business model because it saves money: no staff writers to employ, no celebrities to manage, and no major overhead costs save those of culling submissions and uploading (though these efforts should not be dismissed, as they too can be an onerous form of labor). Sometimes tasks such as making video clips are remunerated, but people also often complete them for free in acts of mass volunteer cooperation, as is the case with the crowdsourced online encyclopedia Wikipedia, to which people contribute not for personal gain or recognition, but in order to enhance the pool of publicly available knowledge.

Some artists turn to crowdsourcing as a way to intentionally undermine their own claims to authorship, yielding decisions about their work to a group of collaborators. Duchamp's assertion that the job of the artist is to beget "a new thought" in relation to an existing object is challenged by artists who mine others for their ideas. Such projects raise key ethical questions about authorship in the age of open-source creativity. One of the most famous quotes in recent art is Joseph Beuys's exhortation that "everyone is an artist," a sentiment borrowed from the eighteenth-century Romantic writer Novalis. Against this utopian premise, curator Bill Arning has retorted, "Sure, everyone might be an artist... but only one artist gets to be the guy who says that everyone else is an artist."[3] In an era saturated by corporate crowdsourcing, Beuys's call for an infinitely expanded field of authorship is no longer necessarily a revolutionary call to arms.

There are several major strands of artistic crowdsourcing: one in which artists allow others to make certain decisions about their making for them; one in which virtually anything made by

anyone is nominated as art; and one in which the artist provides directions for others to carry out. None of these strands is especially novel. Though we associate crowdsourcing with the internet era, it has precedents that go back decades, just like the script-driven forms of creativity that we considered in our discussion of digital art-making in the previous chapter. As we saw in Chapter 5, artists of the 1960s, inspired by the repeatable scores and chance operations of John Cage, were interested in turning art into a series of directives, such as Yoko Ono's conceptual, poetic wish that viewers might take to the air in *FLY* (1964), part of her larger body of instruction paintings.

FLY
小野 洋子
場所: 内科画廊
時: 4月25日（土）8. P.M.

飛ぶ用意をして来る事。

Yoko Ono, *FLY*, 1964. Announcement for the event at the Naiqua Gallery, Tokyo, April 25, 1964. Yoko Ono did not attend

These strategies were consciously updated in the 1993 exhibition *do it*, curated by Hans-Ulrich Obrist, which traveled to venues throughout the world and was hosted virtually in a "home edition" by e-flux. *do it* featured instructions by dozens of internationally prominent artists that could be reinterpreted by museums or individuals. As Obrist noted in his introduction,

> It is important to bear in mind that *do it* is less concerned with copies, images, or reproductions of artworks, than with human interpretation. No artworks are shipped to the venues, instead everyday actions and materials serve as the starting point for the artworks to be recreated at each "performance site" according to the artists' written instructions. Each realization of *do it* occurs as an activity in time and space. The essential nature of this activity is imprecise and can be located somewhere between permutation and negotiation within a field of tension described by repetition and difference. Meaning is multiplied as the various interpretations of the texts accumulate in venue after venue. No two interpretations of the same instructions are ever identical.[4]

The instructions in the show included domestic how-to guides, such as Mona Hatoum's suggestions for how to turn an ordinary kitchen colander into an electrical appliance, and Rirkrit Tiravanija's recipe

for a spicy Thai chili paste (a recipe is, after all, one of the most classic and familiar forms of instruction, widely understood not as marching orders but open to be interpreted, modified, and personalized). Hatoum's instruction, *How to Turn Your Ordinary Kitchen Utensils into Modern Electrical Appliances*, bears a visual

Mona Hatoum, *Home*, 1999. Wood, steel, electric wire, 3 light bulbs, computerized dimmer device, amplifier and two speakers, variable dimensions

relationship to her artwork *Home* (1999), an elaborate, and sinister, installation in which the potentially lethal electrical current crackles as it feeds the lighted, metal kitchen goods. Unlike the *do it* instruction, this artwork explicitly demands that the audience does not touch or meddle.

As these examples illustrate, *do it* contained directions for museum personnel or "the community at large" to follow the instructions of well-known artists, including one by Felix Gonzalez-Torres – "Get 180 lbs of local wrapped candy and drop in a corner." The result of that action resembled some of his iconic works manifested with candy. Those familiar with the artist's signature works may be startled by the notion that any mound of candy might constitute a recreation of one of Gonzalez-Torres's artworks. Of course, this is not at all the case – the products of *do it* instructions are, emphatically, not a creation of a work by the artist, and as such are not listed as a work in his catalogue raisonné. For owners of Gonzalez-Torres's art, including museums, questions of physical "genuineness" are ever-present. Certificates of Authenticity and Ownership, which are issued for some of Gonzalez-Torres's works, are not, naturally, issued with the piles of candy that might be generated out of the *do it* instructions. For artists like

Felix Gonzalez-Torres, *"Untitled" (Portrait of Ross in L.A.)*, 1991. Candies individually wrapped in multicolored cellophane, endless supply. Overall dimensions vary with installation. Ideal weight: 175 lbs (79.4 kg). Installation view of *Feast: Radical Hospitality and Contemporary Art*, Smart Museum at the University of Chicago, Chicago, IL, 16 February – 10 May 2012

Gonzalez-Torres, certificates become increasingly important when the work consists of ordinary objects easily procured (though it would take some effort for any one person to purchase, or carry, that much candy). The idea that anyone with the means to do so could make an object that resembles a Gonzalez-Torres piece – though it might look identical, it would always be ersatz – challenges art's fragile systems of valuation.

But there is a more subtle way in which the original work is speculatively undermined by the potential of a *do it* recreation. Note that the weight stipulated in the instructions, 180 lbs, is very close to the weight of one of Gonzalez-Torres's "candy spill" artworks, *"Untitled" (Portrait of Ross in L.A.)*, from 1991, the "ideal weight" of which is 175 lbs. Though the work of course has multiple reference points, this particular spill, with its parenthetical indication of a portrait, has been widely understood as a queer reference to Gonzalez-Torres's lover, Ross Laycock, who died of AIDS in 1991.[5] When *"Untitled" (Portrait of Ross in L.A.)* was placed in a corner by the artist or an owner or authorized exhibitor of the work, the invitation to the audience to take the candy, thereby reducing the pile, implicates the viewer in an act that some have interpreted as recalling the fluctuations of Laycock's body. (Roni Horn's tribute to the Gonzalez-Torres and Laycock partnership formed the concluding example to Chapter 6; see p. 154.)

Understood as a kind of bodily incorporation, this act of symbolic substitution suggested by a conceptual "portrait" (candy stands in for body, offered up to be ingested) is provocative, moving, and a bit painful. Does the same emotional charge apply to any imagined

do it version? Taking the thought experiment further, could any pile of candy be considered Gonzalez-Torres's? Or are we presented with something more like the postcard of a painting, a representation or derivative of the original, forceful gesture? Does the attribution of authorship here still matter in the context of Obrist's *do it* project, given the already extreme readymade character of the actual artwork? Indeed, this example captures in microcosm a broader dynamic, in which the dispersal of the artistic gesture across an indeterminate number of people extends but also perhaps dissipates the force of artistic gestures as such.

When we turn to contemporary examples of crowdsourced art, it is worth keeping these questions in mind, as they may help us to assess in more detail some individual works. Take, for example, the contrast between two online web projects, Sam Brown's *explodingdog*, and Miranda July and Harrell Fletcher's *Learning to Love You More*. Brown (the pseudonym of Adam Culbert) makes stick-figure pictures based on titles emailed to him by strangers through his website. In a drawing entitled *Moving Day* (2014), one character holding up a huge boulder asks another, "Where do you want it?" This question thematizes the underlying premise of Brown's enterprise – he executes someone else's directive, in effect putting things where others want them – yet the artist always maintains his distinctively cartoonish brand of drawing, retaining control of his aesthetic choices. The content that he gleans from the submissions emailed to him are suggestions, not commands. *Explodingdog* is, then, a very mild version of crowdsourced art, in which the basic idea for an image (but by no means its final look) is collected through social media and then transformed.

Sam Brown, *Moving Day*, 2014.
Pencil on paper, Photoshop

Learning to Love You More, which was live from 2002 to 2009, operated on a directly opposite premise. On this website, the founders laid out a series of instructions – called "assignments" – and invited participants to complete them and then post them

Miranda July and Harrell Fletcher, *Learning to Love You More*, 2002–9. Website

online in a series of "reports." Here the artists asked the public to realize the work. "Sometimes it's a relief to be told what to do," explain July and Fletcher.

> We are two artists who are trying to come up with new ideas every day. But our most joyful and even profound experiences often come when we are following other people's instructions. When we are making crepes from a recipe, attempting to do a handstand in yoga class, or singing someone else's song.[6]

Over the course of seventy assignments, thousands of people uploaded documentation of themselves engaging with *Learning to Love You More*, ranging from somewhat quotidian instructions, like "take a picture of the sun" or "braid someone's hair," to more extraordinary demands, such as "interview someone who has experienced war" or "curate an artist's retrospective in a public place." The resulting reports tended to have an earnest, often hand-spun appeal, as in the poster created by Stephanie M. Lucas for the assignment "Make an Educational Public Plaque,"

which she affixed on a busy street in Scottsdale, Arizona, to raise awareness of coyotes and promote peaceful cohabitation between humans and non-domesticated animals.

Learning to Love You More was conceived, in part, as a way to use the internet, in a pointed and knowing paradox, to foster the world of *analogue* or "offline" relationships and activities. The instructions typically require people to leave the computer and do something in their neighborhood ("grow a garden in an unexpected spot"), relate with friends and family ("take a picture of your parents kissing"), or dwell in the solitary, reflective field of their own emotions ("write down a recent argument"). The website of reports was not edited or cherry-picked for quality – every submission was posted – and many of the assignments asked participants to, in essence, deploy artistic or creative skills: taking photographs, making outfits, drawing pictures, sculpting busts, illustrating scenes, recreating posters, performing phone calls, etc. In effect, July and Fletcher nominated the contributors as co-creators. The logical conclusion of the project was reached in an assignment that asked people to create a new assignment, thereby relinquishing the last remaining creative role of the artists.

Curator Andrea Grover has theorized that part of the impetus for becoming involved with *Learning to Love You More* was that it nurtured a feeling of being connected to a wider group, as well as the sense that one would not be judged for one's individual contribution but, rather, that the whole effort would be assessed collectively.[7] Overall, this open structure yields a much greater potential to activate a community than that offered by *explodingdog*. Still, projects like *Learning to Love You More* often come under fire for what some critics have seen as a confessional "voyeur/ exhibitionist" dynamic, as well as an "infantilization and sentimentalization" of participants via detailed instructions that leave little interpretive room.[8] Clearly, though it is one of the most vaunted concepts in contemporary art, participation is also a lightning rod for debate, and as a mode of practice it has been heavily critiqued.[9] Because of complicated, charged negotiations around agency and distributed authorship, crowdsourcing inevitably raises the specter of power and its inequities around uneven valuations of artistic attribution.

Of course, not all contemporary crowdsourced projects involve digital platforms. Others are communitarian exercises conducted in public space, which seek to position art in non-elite contexts outside of the museum/gallery nexus. The *Heidelberg Project*, begun

Obstruction of Justice House, Heidelberg Project Archives, 1986–ongoing. Detroit, Michigan

by Tyree Guyton in 1986, is a celebrated example. The setting is a few blocks of vacant houses and empty lots in an African-American neighborhood of Detroit's East Side. Using a combination of castaway found objects, urban detritus, hand-lettered signs, bicycles, stuffed animals, and colorful paint, Guyton worked with neighborhood youth to transform trees, houses, and cars into a vivid sculptural environment. An urban area marked by poverty and systematic disenfranchisement gradually became a destination for art tourists. Like much crowdsourced art, this move has not been without its controversies, and even though the *Heidelberg Project* has sponsored street festivals and public programs for children in the area, it has been targeted by the city of Detroit (which has twice attempted to demolish it in its entirety) and more recently by unknown arsonists. In addition, those who live in the area have not always embraced the piece, and according to one scholar, some "object to the daily sea of faces peering out from the safety of locked automobiles moving slowly down the street; these residents resent having become part of the spectacle on the street and the attendant loss of privacy."[10]

Thus, despite its pointed intention to intervene in an open social space, and its intense level of democratic involvement – Guyton's

marshaling of many hands to paint, gather materials, and assist in creation at every level – the *Heidelberg Project* is nonetheless implicated in questions of institutional power. This leads us to another issue that attends crowdsourcing: when museums and other art institutions embrace the idea, are they attempting to expand the realm of authorship, or engaging in a marketing exercise? A 2007 exhibit at the Musée de l'Elysée Lausanne in Switzerland called *We Are All Photographers Now!* featured a rotating selection of photographs uploaded by the general public from around the world, taken on devices from professional cameras to cell phones. The project predated crowdsourced image sites such as Instagram by a few years, but it anticipated one dynamic of such social media, in which individual creativity is molded to the dictates of a centralized authority. Other museums have used citizen photography or crowdsourcing to explicitly promote their conventionally defined art stars, as when the Los Angeles County Museum of Art (LACMA) partnered with Flickr to host visitors' photographs of Chris Burden's sculpture of vintage streetlamps, *Urban Light*, installed in 2008. The uploaded images were featured in a digital exhibition, and one was chosen for the cover of a print-on-demand book, entitled *Celebrating Urban Light*, which featured a selection of the many submissions.[11]

The Musée de l'Elysée Lausanne exhibit, and the flood of often repetitive photographs of Burden's piece posted on Flickr, demonstrated that the populist impulse to crowdsource content has a further, troubled corollary: if everyone is an artist, then everything is already art. This sounds liberating enough, until we realize that when art loses its status as a special category, its value can collapse into banality. At some level, crowdsourcing must inevitably deal with questions about criticality. If there is no editing process, curation, or critical framing, then the deluge of images produced is no different from the constant image-stream of everyday visual culture. Sometimes the purported "wisdom of crowds," to quote a bestselling book by James Surowiecki, appears to lose its way.[12] Deferring to a mass population and averaging out the results is democratic, but it may not prove to be the most effective approach to making compelling art.

Take, as another example, the works produced by the automatic website SwarmSketch, designed by Peter Edmunds, in which viewers can contribute small lines to a collectively made drawing and also vote on the relative "quality" of other people's

Musée de l'Elysée Lausanne, *We Are All Photographers Now!*, 2007

Chris Burden, *Urban Light*, 2008. Installation views as uploaded by museum visitors Mark Dienger and Mr. Littlehand onto Flickr

lines. Every sketch has a designated theme, and the SwarmSketch site explains how the topics are selected:

> Each week it [SwarmSketch] randomly chooses a popular search term which becomes the sketch subject for the week. In this way, the collective is sketching what the collective thought was important each week. A new sketch begins after one week, or after the previous sketch reaches one thousand lines, whichever comes first.

The results of all this activity are disappointingly similar, and in the main visually uninteresting. They look pretty much like what they are: not especially adept computer-assisted, freehand doodles, where the lines sometimes coalesce into recognizable subjects. What these drawings *as drawings* might tell us about the state of collective consciousness, or how to envision popular search terms, is not entirely clear.

 This suggests that not all kinds of crowdsourcing are equally successful. If this is the case, then the authorial role of the artist

210

Faces of Meth, 2005. 1,200 individual lines contributed by approximately 1,200 anonymous participants on www.swarmsketch.com over a period of 3 hours

Mount Everest, 2005. 1,000 individual lines contributed by approximately 1,000 anonymous participants on www.swarmsketch.com over a period of 8 hours

Python Eating Alligator, 2005. 1,000 individual lines contributed by approximately 1,000 anonymous participants on www.swarmsketch.com over a period of 17 hours

Unclaimed Baggage, 2005. 1,000 individual lines contributed by approximately 1,000 anonymous participants on www.swarmsketch.com over a period of 2 days

is not so much dissolved as displaced. Just as some artists excel in managing outsourced fabrication, others design particularly ingenious and insightful crowdsourcing structures. Interestingly, the projects that often resonate most are those in which a form of group authorship that already exists as a popular practice is further transformed, as a means of commenting on the dynamics that were present in the original. For instance, the commonplace internet activity of the fan mash-up, in which people re-edit short clips from their favorite movies and post them online, is reimagined and greatly exaggerated in scale in Christian Marclay's *The Clock* (2010). Here, short film segments in which the exact time is visible – numerals on a digital wristwatch reading 3:24, hands on a clock tower showing a few minutes before midnight – are arranged into a constant 24-hour loop, which is played to match the actual, local time. (Viewers know precisely when to leave the screening to make their dinner reservations.) This extraordinarily laborious feat of editing was possible only through the contributions of many paid assistants, who painstakingly reviewed footage in search of usable examples. The usual dynamic of an online mash-up, in which familiar material is recycled with whimsical abandon, is inverted: the logic of the piece imposed on Marclay and his helpers a crushingly rigorous task, which could not be completed until the last precious bits of footage – times in the wee hours of the morning, which rarely make it into films – were tracked down.

Another "meta-version" of a popular crowdsourcing practice can be seen in the work of the French artist JR, who emulates digital social networks like Instagram, but applies their logic in a way that is hands-on and distinctly local in its address. JR calls his method "Pervasive Art," signaling his intent to permeate streets around the globe. In his *Inside Out Project*, begun in 2011, he facilitates from afar the production of large photographic portraits of residents, who then wheat-paste those portraits in various public locations, such as walls or the sides of buildings, creating monumental murals of individuals in the places where they live. "Now the communities aren't just involved, they are the creators," proclaims a video about the work (even though the artist sets many of the parameters of these creations, including material and scale). Some of these murals focus on a selected population chosen to draw attention to political issues, such as the persecution of ethnic minorities, sexual inequality, and immigrant rights. One such mural (2012), located in Caracas, Venezuela, which featured 220 portraits of women who had lost children due to violence. Key

Christian Marclay, *The Clock*, 2010. Single-channel video,
duration 24 hours

to this project is the fact that these are self-portraits, created by the women themselves. Though at the end of the day it is marketed, indeed branded, as a JR initiative, and JR's studio facilitates all aspects of the production, there is nonetheless an opportunity here for otherwise marginalized people to assume a visible public presence.

In conclusion, we would like to focus on one of the most popular strains of artistic crowdsourcing in recent years, in which traditional hand-making techniques are married to distributed forms of authorship. In such practices, which we might term "craftsourcing," we come full circle, returning to traditional, physical art-making methods like those we considered in the early chapters of this book, but now set into a conceptual framework that is conditioned by life online. Feminist craftsourcing further places issues of gendered production at the heart of crowdsourcing, and asks questions about how populist organizing and activism, in which people are recruited to join together for a larger cause, might be considered a different origin moment to today's crowdsourcing. Though they are far too numerous

JR, *Inside Out Project* in Caracas, Venezuela, 2012. Global participatory project

We Work in a Fragile Material, *You Can Do It!*, 2004. Workshop at the Tensta Konsthall, Stockholm

We Work in a Fragile Material, *You Can Do It!*, 2004.
Workshop at the craft cooperative Blås & Knåda, Stockholm

and diverse to list, craftsourcing practices generally ask the public to pitch in on a large-scale making project, sometimes using the internet to issue an open call, and at other times inviting people to join a hands-on workshop with materials on site.

In 2004, the Swedish design collective We Work in a Fragile Material was invited by Oda Projesi to participate in a show at the Konsthall in Tensta, a suburb of Stockholm. During the course of the ten-day exhibit, for a piece they called *You Can Do It!* (a coincidental echo of Obrist's show of a decade earlier), they brought in tons of Play-Doh clay for visitors to use as they wished. As with many other crowdsourced projects, the output was not particularly inspired, with a proliferation of lumpy little figurines or crooked pinch-pots, each tagged with the name given to it by its creator. After the ten days were over, We Work in a Fragile Material moved the clay objects to a crafts cooperative to institutionally reframe them and, as they write, "Here the question

was raised; what happens when the contemporary art workshop moves to the crafts gallery? And is it possible to exhibit a workshop or is it in the end just a mess of clay?"[13] Contemporary art institutions are structured by the theoretical and logistical process of curation – that is, selection, choosing, and editing out – yet, perhaps because of crowdsourcing, they are more open to this sort of display than are craft galleries, who are still keen to maintain quality and fight against long-standing prejudices about the dilution of handmade work via "arts and crafts" school projects.

Stephanie Syjuco, *The Counterfeit Crochet Project (Critique of a Political Economy)*, 2006–ongoing. Collected images courtesy of project participants

Some craftsourcing artists tap into the energies of hobby makers, drawing on the resurgence of interest in the so-called women's work of knitting, sewing, and crocheting to create polemical messages. In her *Counterfeit Crochet Project (Critique of a Political Economy)*, commenced in 2006, Stephanie Syjuco creates and posts online patterns for brand-name luxury handbags, inviting crocheters from around the world to make replicas complete with Gucci, Chanel, or Prada logos. Syjuco explains:

> I am also interested in how this project can be similar to contemporary manufacturing and distribution channels. As a collaboration it parallels the idea of "outsourcing" labor, but also adds a democratic and perhaps anarchic level of creativity – within the basic framework, participants have taken liberties with their translations, changing colors, adding materials (cardboard, hot glue, etc.) to suit their needs.[14]

Syjuco's craftsourced project shines a spotlight on the privileged world of global consumption that is subtended by poor working conditions endemic to contemporary mass manufacturing, in which a minuscule portion of a bag's purchase price goes to compensate those who crafted it.

Some craftsourced projects are hybrid art pieces as well as activist interventions. Cat Mazza is at the forefront of political craftsourcing, notably with her *Nike Petition Blanket*, which she initiated in 2003 as a way to protest against Nike's alleged labor abuses. In this piece, which takes the form of a 15-foot-long (4.6-meter) bright orange banner depicting a blocky Nike swoosh, Mazza and her project microRevolt reached out to knitters and anti-sweatshop activists on the internet and invited them to knit small squares, each of which functions as a "signature" on this blanket-cum-petition to advocate fair labor practices for garment workers. In her piece *Stitch for Senate* (2007–8), Mazza asked volunteer knitters in all fifty US states to knit military helmet liners, which were sent to every senator in the nation in a message against US involvement in the wars in Iraq and Afghanistan. This is a reminder that some of what we now think of as crowdsourcing used to be called grassroots organizing, or simply pitching in. Mazza's work shows that textile craft – which historically has been seen as a method that lends itself to communal making, as in women's quilting bees and sewing circles – can be particularly potent in conjunction with crowdsourcing.

Chapter 9

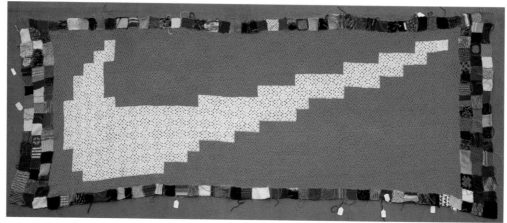

Cat Mazza, *Nike Petition Blanket*, 2003–8. Synthetic and wool yarns, 15 × 6 ft (4.57 × 1.83 m)

Like Mazza, Anne Wilson has used craftsourcing to comment on protocols of manufacturing and the history of textile production. Her installation *Local Industry* (2010) was created for the Knoxville Museum of Art, in Tennessee, a region that was once a vibrant hub of industry in the USA.[15] Commenting on the loss of jobs related to mill closures in the area, as well as on the sustained presence of local weavers, Wilson filled a room with participatory workstations – what she termed a makeshift "textile factory" – at which visitors to the museum were asked to thread bobbins on hand-cranked bobbin winders. The bobbins were then used by over seventy experienced weavers from the region as they worked in shifts to produce a single, striped bolt of cloth. In Wilson's work, craftsourcing, in the form of volunteer hands that wound bobbins, was but one part of the overall project; importantly she also drew from a reservoir of

218

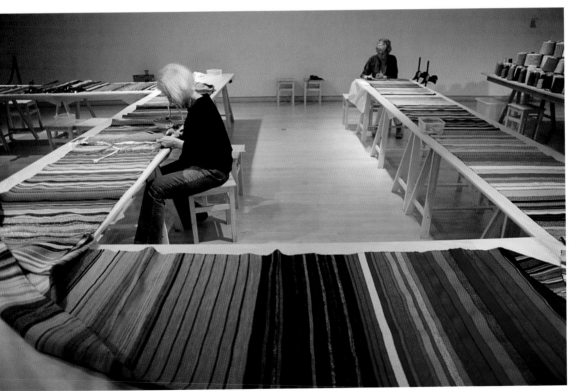

Anne Wilson, *Local Industry*, 2010. Installation view,
Knoxville Museum of Art, Tennessee

skilled craftspeople to help turn the raw material into a finished object (all the weavers were named and credited). In addition, Wilson herself had predetermined much about the consistency of the cloth bolt, including the use of stripes; the finished cloth is satisfying at an aesthetic level because of, not in spite of, her authorial decisions. With Wilson's example, which collapses distinctions between hands-on and conceptual, we are brought back to our discussions of pigment that launched this book. *Local Industry*, with its acknowledgment of a fading textile industry woven into the making of the piece, also forcefully illustrates one of the main arguments of this book, namely that all production is political.

Ultimately, crowdsourced and craftsourced artistic practices that seek to marshal the surplus time of participants and to harness "collective wisdom" do so to varying effect. Some reflect on the process of production itself; others turn into an unedited, unstructured free-for-all. What about the "crowd" that has been "sourced"? Have the individuals been exploited? Rendered invisible? Or have these new methods of working helped give them new platforms for recognition? Duchamp's 1917 assertion that an artist is someone who *chooses* might be all the more relevant today, as many crowdsourcing artists attempt to *redirect*, or selectively edit, the intense image flow that characterizes contemporary visual culture, rather than generate the images themselves. It is up to those in the crowd to decide if – and how – they might want to participate.

Conclusion

This book has ranged widely across time, space, and topic. While we have been concerned with narratives of making throughout, our seemingly simple theme has taken us in many directions, from the concrete to the digital, the monumental to the ephemeral, the handcrafted to the industrial, the economical to the extravagant. Yet there is one subject that has been present throughout: "distributed authorship." By this term, we refer to means of production that involve more than one person. This condition is pervasive in contemporary art. Even works that may initially seem to have been made by a single person, such as paintings, are revealed upon closer consideration to involve store-bought materials and tools (paint and brushes), and commissioned elements (stretchers and frames), as well as an extensive infrastructure of institutional support. The most extreme, self-denying performances turn out to depend on the contributions of an intimate friend. Many artists engage in much more elaborate systems of making than these, which can involve tens, hundreds, or even thousands of people.

Given these realities of art production, we have argued for an expanded framework of analysis. We have considered making as a social – not just a technical – process. Here, in conclusion, we would like to contemplate the broader implications of this approach. Despite the fact that contemporary art is a group enterprise, the concept of single authorship still attaches itself powerfully to individual works. We might contrast this situation to other industries such as film, where multiple people are acknowledged for their role in production (including the "producer") and credits roll at the end. Artists are no more autonomous than movie directors, but they do not usually give recognition in this way. Even in this book, we have for the sake

of convenience embraced a logic in which works are ascribed to individuals: a work is "by" Santiago Sierra or Rachel Whiteread, no matter who helped them to make it and how.

It might be worth saying here that our book is itself a work of distributed authorship. In addition to the many dependencies we have incurred along the way to our publisher, printer, research assistants, designer, and distributor (not to mention the artists we consulted and our partners who are named in the Acknowledgments), we wrote the book in a literally distributed fashion. At no time during the period of collaborative writing did we live any closer than 3,000 miles (4,800 kilometers) or three time zones apart. We were variously based in London, New York City, and Oakland. (Julia received a fellowship in London partly to facilitate the writing process, but by the time she arrived Glenn had moved away to take a job in New York City.) The book would certainly not exist without the digital apparatus of attachments and file-sharing services. But there is a more important point: every line of the book was first drafted by one of us, edited by the other, and then revised again, moved around, cut out, reinstated. We checked in with endless phone calls, texts, and emails as we swapped texts back and forth. When glitches did emerge (synching problems, inevitable minor confusions regarding multiple drafts), a flurry of messages would ensue until they were resolved.

No book is easy to write. Co-authoring can, instead of halving the amount of work involved, compound it by introducing levels of logistical and psychological intricacy to an already complicated process. We had to negotiate not only our physical distance and disjunctive schedules, but also our own egos, to relinquish ingrained feelings of possessive "ownership" over ideas and words. At times, cherished paragraphs or pages written by one were completely excised by the other: we were merciless with each other's first drafts. In the end, we would be hard-pressed to pick out the phrases each of us wrote, nor would we want to. It was an emotionally challenging process, but the rewards of thinking together far outweighed any sense of misgiving. We were also equally encouraging of each other. Much more prominent than the little hiccups were the shared feelings of relief and excitement when the other would smooth over a clunky sentence or introduce a pertinent example. We built on each other's insights, and feel it is a stronger book as a result.

Both of us had professional pressures to consider as we embarked on this project. Within the realm of the university,

Julia found that a jointly authored book is still somewhat exceptional for humanities research (though it has long been the norm within the sciences). In some academic disciplines, collaborative scholarship is viewed with some suspicion and "counts less" than does single-authored work, even though it may take the equivalent, if not more, intellectual energy for all parties. For Glenn, a museum director, meanwhile, the clear priorities are management, institutional strategy, and fundraising. Writing a book "on the side" is hardly standard operating procedure. With this book, we hope to affirm the value of collective writing as a way to push against all these limits, both theoretical and practical.

Though it seems risky to offer our own working method as a model, it strikes us that, if we can share authorship of a book in this way, people involved in the making of art might be able to do the same. There are certainly examples of this, notably in collectives that efface individual authorship entirely, such as Assume Vivid Astro Focus, Raqs Media Collective, or Otabenga Jones and Associates. In other cases, artists conceive their efforts as a primer to further collective authorship. Paris-based duo James Thornhill and Fulvia Carnevale work under the name Claire Fontaine (taking their moniker from a brand of notebooks), a female-gendered self-declared "readymade artist" who "grows up among the ruins of the notion of authorship, experimenting with collective protocols of production, *détournements*, and the production of various devices for the sharing of intellectual and private property."[1] In much of her work, Claire Fontaine thrusts issues of commodification,

Claire Fontaine, *This Neon Was Made By Felice Lo Conte for the Remuneration of One Thousand, Nine Hundred and Fifty Euros*, 2009. Neon, transformers, cabling, 2 × 134 5/8 × 16 9/16 in. (5 × 342 × 42 cm)

225

Sam Durant, *White, Unique Mono-Block Resin Chair.*
Built at Jiao Zhi Studio, Xiamen, China. Produced
by Ye Xing You with Craftspeople Xu Fu Fa and
Chen Zhong Liang. Kang Youteng, Project manager
and Liaison., 2006. Glazed porcelain, 18 × 18 × 30 in.
(45.7 × 45.7 × 76.2 cm)

worth, and making into visibility, as in the piece *This Neon Was Made by Felice Lo Conte for the Remuneration of One Thousand, Nine Hundred and Fifty Euros* (2009), a neon sign that says just that. This attempt at demystification was not always embraced by the technicians themselves, and "some of them in fact refused to make the work because they didn't like to have their name next to the amount of money they had received."[2]

Much would be gained if there were greater transparency about methods of making in contemporary art. For the most part artists must contend with more pragmatic questions when it comes to the politics of production. Should they simply credit everyone that was involved in the making of a work? This was Sam Durant's approach in 2006 when he asked a Chinese porcelain manufactory to make copies of nine plastic chairs, working by eye and hand rather than using a mold. The title of each chair is an exact description of its making, including the name of every worker involved, for example: *White, Unique Mono-Block Resin Chair. Built at Jiao Zhi Studio, Xiamen, China. Produced by Ye Xing You with Craftspeople Xu Fu Fa and Chen Zhong Liang. Kang Youteng, Project Manager and Liaison.* Durant's decision to credit the Chinese artisans who made the chairs – "to ensure that this information will never disappear as they circulate in the art world,"[3] as he put it – was a tacit inversion of the usual anonymity of Chinese workers, such as the ones involved in making the ubiquitous monobloc chairs that served as the model for the piece. Of course, the decision is still entirely Durant's. It remains "his" artwork.

Installation view of the Acknowledgment Panels from Judy Chicago's *The Dinner Party*, at the Hammer Museum, UCLA, Los Angeles, 1996

The same problem arose in an earlier instance of an artist attempting to generously give credit: Judy Chicago's wall of acknowledgments listing those who helped realize her feminist installation *The Dinner Party* (1974–79) did not stop some from decrying the fact that she alone received the glory.[4] The critique is not necessarily a fair one: Chicago was doing more than countless men had before her to recognize those who helped in this massive project (Robert Smithson, for instance, did not publicly display the names of those who drove earth-moving machines to make his *Spiral Jetty* of 1970), and she *was* the work's main driving force, conceptualizing and designing the piece as well as corralling the volunteers.

How much does crediting help, in any case? Parsing attributions can feel tedious for the artist and the viewer alike. There is also the matter of how far out to draw the circle of inclusion: the art handlers who uncrated the objects, the construction crew that helped build the space, the gallery assistant who printed out the

price list, the workers who assembled the printer, the logger who cut down the trees for the paper, etc. At every moment artists (along with everyone else) are interwoven into vast networks of reliance on other people's labor.

Hence a model of distributed authorship in which all those involved with the bringing about of a work are acknowledged for their contributions in a way that feels equitable still remains elusive. The answer, it seems to us, is not simply to pressure artists to recognize their collaborators more often, with long lists of assistants or manufacturers accompanying every wall text. Even in the case of Durant's well-meaning project, we learn little about Ye Xing You, Xu Fu Fa, Chen Zhong Liang, and Kang Youteng beyond their names and the bare facts of their jobs. To make matters worse, despite Durant's best efforts to cement the artisans into every account of these objects as they are bought and sold, when the chairs have gone on the market at auction, their titles have been radically shortened. The detailed list of makers enumerated above becomes *White, Unique Mono-Block Resin Chair*, as the names of those involved, so carefully included by Durant, are excised by the auction house.

Ultimately, artists themselves only have so much control over the way their work is presented and received. For this reason too, crediting, while certainly welcome, is not necessarily the answer. Rather, as we have tried to demonstrate throughout this book, it is imperative that art-making be approached by its audiences – from casual visitors to museum curators to students to scholars – in a contextual way. Our relations to any artwork are deepened when we pause to think about where the materials in it came from, and which hands, minds, and resources were involved in its creation. Conversely, every time we circumscribe the production narrative of a work, whether through confidentiality agreements or sheer inattention, we are effacing part of its meaning. It is of course important to take seriously the images and ideas that contemporary art presents to the world. But to really understand what is happening, to grasp completely the critical as well as the practical aspects of art, we must attend to matters of production.

3. Michael Rush, "Code as Medium," in Jo Anne Northrup, ed., *Leo Villareal* (Ostfildern: Hatje Cantz, 2010), p. 40.

4. Colin Herd, "Technological Expressionism: Cory Arcangel," *Aesthetica* 41 (June/July, 2011), pp. 30–32: 32. See also the artist's website: http://www.coryarcangel.com/things-i-made/2010-046-photoshop-cs#sthash.hbsA9AOn.dpuf.

5. Barbara Junge, *The Digital Turn* (Zürich: Park Books, 2012), p. 11.

6. Andrea Scott, "Futurism: Cory Arcangel plays around with technology," *New Yorker* (May 30, 2011), pp. 30–34: 30.

7. http://www.coryarcangel.com/things-i-made/SuperMarioClouds#sthash.Qo5ZyHiO.dpuf.

8. Cory Arcangel, "On Compression," in Steven Bode, ed., *A Couple Thousand Short Films About Glenn Gould* (London: Film and Video Umbrella, 2008), pp. 221–22.

9. http://new-aesthetic.tumblr.com/about.

10. Hito Steyerl, "In Defense of the Poor Image," *e-flux* 10 (November 2009), http://www.e-flux.com/journal/in-defense-of-the-poor-image/.

11. Thomas Weski, "The Privileged View," in *Andreas Gursky* (Cologne: Snoeck, 2007); Paul Erik Tojner, "Seeing Without Looking. Looking Without Seeing," in Michael Holm, ed., *Andreas Gursky* (Louisiana, Denmark: Hatje Cantz, 2012), p. 107.

12. Quoted in Thomas Weski, "The Scientific Artist," in *Thomas Ruff Works 1979–2011* (Munich: Schirmer/Mosel, 2012), pp. 16–17.

13. Okwui Enwezor, "The Conditions of Spectrality and Spectatorship in Thomas Ruff's Photography," in *ibid.*, p. 15.

14. Quoted in Matthias Winzen, *Thomas Ruff: Photography 1979 to the Present* (New York: DAP, 2001), p. 150.

15. John G. Hanhardt and Ken Hakuta, *Nam June Paik: Global Visionary* (Washington, DC: Smithsonian American Art Museum, 2012), p. 63.

16. Martha Rosler, "Video: Shedding the Utopian Moment [1986]," reprinted in Rosler, *Decoys and Disruptions: Selected Writings 1975–2001* (Cambridge, MA: MIT Press, 2004), p. 73.

17. Thomas Ruff and Paul Pfeiffer in conversation, *Paul Pfeiffer* (Ostfildern: Hatje Cantz, 2004), pp. 72–74.

18. Jennifer González, "Paul Pfeiffer," *BOMB* 83 (Spring 2003), p. 24

19. Stefano Basilico, "Disturbing Vision," in *Paul Pfeiffer* (Ostfildern-Ruit: Hatje Cantz, 2004), p. 25. See also Jane Farver, "Morning after the Deluge," in *Paul Pfeiffer* (New York/Chicago: DAP/Museum of Contemporary Art, 2003), p. 43.

20. Paul Pfeiffer and John Baldessari in conversation, in *ibid.*, p. 38.

21. *Ibid.*, p. 39.

22. Haroon Mirza, Helen Legg, and Marie-Anne Quay, "A Conversation Around an Exhibiton," in Helen Legg, ed., */1/1/1/1/1/1/1/1 A User's Manual* (Bristol: Spike Island, 2012), p. 7.

23. Haroon Mirza, interview with Elizabeth Neilson, *A Bulletin* 4 (Liverpool: A Foundation, 2009), p. 3.

24. Renée Green, "The Digital Import/Export Funk Office," in *Other Planes of There: Selected Writings* (Durham, NC: Duke University Press, 2014), p. 355.

25. Julia Scher, "Artist Statement," in "Julia Scher: Predictive Engineering2 – New Work," *SFMOMA*, http://www.sfmoma.org/exhib_events/exhibitions/details/espace_scher.

26. Faith Wilding, "Duration Performance: The Economy of Feminized Maintenance Work," artist's website, http://faithwilding.refugia.net/durationperformance.pdf, p. 10.

27. Ann Tempkin, *Color Chart: Reinventing Color 1950 to Today* (New York: MoMA, 2008), p. 228.

28. Karen Rosenberg, "Gerhard Richter: Painting 2012," art review, *New York Times* (September 20, 2012).

29. Lawrence Wechsler, "David Hockney's iPhone Passion," *New York Review of Books* (October 22, 2009), p. 35.

Chapter 9: Crowdsourcing

1. Though its authorship is not fully known, the piece was likely co-authored by Duchamp, Pierre Roche, and Beatrice Wood; "The Richard Mutt Case," *The Blind Man* 2 (May 1917), p. 5.

2. Jeff Howe, "The Rise of Crowdsourcing," *Wired* 14/6 (June 2006), pp. 1–4.

3. Bill Arning, "Sure, everyone might be an artist... but only one artist gets to be the guy who says that everyone else is an artist," in Ted Purves, ed., *What We Want is Free: Generosity and Exchange in Recent Art* (Stony Brook: SUNY Press, 2005), pp. 11–16.

4. Hans Ulrich Obrist, "Introduction," *do it* (2002), http://www.e-flux.com/projects/do_it/itinerary/itinerary.html. See also Ulrich, *do it: The Compendium* (New York: Independent Curators International, 2013).

5. See, for instance, Jonathan D. Katz and David C. Ward, *Hide/Seek: Difference and Desire in American Portraiture* (Washington, DC: Smithsonian National Portrait Gallery, 2010), p. 55.

6. Miranda July and Harrell Fletcher, *Learning to Love You More* (Munich/New York: Prestel, 2007), p. 1.

7. Andrea Grover, *Phantom Captain: Art and Crowdsourcing* (New York: Apexart, 2006), published in conjunction with the exhibition of the same name, shown at Apexart, New York.

8. Anna Dezeuze, "Express Yourself!," *Variant* 31 (Spring 2008), p. 4.

9. Debates about participation in recent art are too numerous to elaborate, but one prominent skeptical text is Claire Bishop, *Artificial Hells: Participatory Art and the Politics of Spectatorship* (London and New York: Verso, 2012).

10. Bradley L. Taylor, "Negotiating the Power of Art: Tyree Guyton's the Heidelberg Project and its Communities," in Viv Golding and Wayne Modest, eds., *Museums and Communities: Curators, Collections and Collaboration* (London: Bloomsbury, 2013), p. 51.

11. *Celebrating Urban Light*, with a preface by curator Charlotte Cotton (Los Angeles: Los Angeles County Museum of Art, 2009).

12. James Surowiecki, *The Wisdom of Crowds: Why the Many are Smarter than the Few and How Collective Wisdom Shapes Business, Economics, Societies, and Nations* (New York: Doubleday, 2004).

13. http://weworkinafragilematerial.com/Fragglarna/project06/04 _06 _ blasOchknada.htm.

14. Stephanie Syjuco website, http://www.stephaniesyjuco.com/p_counterfeit_crochet.html.

15. For more on this project, see Anne Wilson and Chris Molinski, *Wind/Rewind/Weave* (Knoxville, TN: Knoxville Museum of Art, 2011), which includes essays by Glenn Adamson, Julia Bryan-Wilson, and Jenni Sorkin.

Conclusion

1. Claire Fontaine website, http://www.clairefontaine.ws/bio.html.

2. Correspondence with Claire Fontaine, July 2014.

3. Sam Durant, Artist's Statement, 2006, http://samdurant.net/index.php?/projects/porcelain-chairs/.

4. For one account of some of this controversy, see Gail Levin, "Art Meets Politics: How Judy Chicago's *The Dinner Party* Came to Brooklyn," *Dissent* 54/2 (Spring 2007), pp. 87–92.

The Judith Rothschild Foundation. The Museum of Modern Art, New York / Scala, Florence. Courtesy Sean Kelly, New York. © Los Carpinteros.

p. 65 Los Carpinteros, *Globe*, 2015. 3D rendering. Commission for the Victoria and Albert Museum, London, 2015. Courtesy Sean Kelly, New York. © Los Carpinteros.

p. 70 Zaha Hadid Architects, digital render of Abu Dhabi Performing Arts Centre, 2008. Courtesy Zaha Hadid Architects.

p. 71 Anthony Caro, *Midday*, 1960. Painted steel, 7 ft 8 ³/₄ in. × 37 ⁷/₈ in. × 12 ft 9 in. (235.6 × 96.2 × 388.6 cm). Photo John Riddy. Courtesy Barford Sculptures Limited.

p. 73 Alice Aycock, *Maze*, 1972 and Carl Andre, *Cuts*, 1967, as illustrated in Rosalind Krauss, "Sculpture in the Expanded Field," *October*, Vol. 8. (Spring, 1979), p. 40, The MIT Press. Courtesy Alice Aycock. © Carl Andre / VAGA, New York / DACS, London 2016.

p. 74 Theaster Gates, *Dorchester Projects*, Chicago, 2013. *Archive House Past* (2009) and *Present* (2013). Courtesy White Cube, London. Photos Sara Pooley. © Theaster Gates.

p. 76 left Theaster Gates, *12 Ballads for Huguenot House*, 2012, Documenta 13, Kassel, Germany. Courtesy Documenta 13, Kassel and White Cube, London. Photo Tanja Jürgensen. © Theaster Gates.

p. 76 right Santiago Cirugeda, *Skips*, *S.C.*, 1997. Occupation license, steel beams and sheets, wooden boards, paint, variable dimensions. Courtesy Santiago Cirugeda.

p. 77 Teddy Cruz, rendering for *Manufactured Sites*, 2008. Courtesy Estudio Teddy Cruz.

p. 78 left Abraham Cruzvillegas, *La Invencible* (*The Invincible*), 2002. Rock, feathers, and mixed media, 18 × 15 × 4 ¹/₂ in. (45.7 × 38.1 × 11.4 cm). Courtesy the artist, Thomas Dane Gallery, London and kurimanzutto, Mexico City.

p. 78 right Abraham Cruzvillegas, *autodestrucción4: demolición The Call Up*, 2014. Bone, wood, concrete, and mixed media, 76 ³/₄ × 70 ⁷/₈ × 19 ³/₄ in. (195 × 180 × 50 cm). Photo Todd White. Courtesy the artist, Thomas Dane Gallery, London and kurimanzutto, Mexico City.

p. 79 Maya Lin, *74° West Meridian*, 2013. Vermont Danby marble, 9 in. × 168 ¹/₄ in. × 5 ¹/₂ in. (22.9 × 427.4 × 14 cm), edition of 3. Courtesy Pace Gallery. Photo Kerry Ryan McFate. © Maya Lin Studio.

p. 80 Isa Genzken, *Marcel*, 1987. Concrete, steel, 79 ¹/₂ × 21 ¹/₄ × 18 ¹/₈ in. (202 × 54 × 46 cm). Städtische Galerie im Lenbachhaus, Munich. Courtesy Galerie Buchholz, Berlin/Cologne.

p. 81 Rachel Whiteread, *House*, 1993. Photo Richard Glover / Corbis. Courtesy Gagosian Gallery. © Rachel Whiteread.

p. 83 above Oscar Tuazon, *Bend It Till It Breaks*, 2009. Wood, steel, and concrete. Centre International d'Art et du Paysage, Vassivière. Courtesy Balice Hertling, Paris. © Oscar Tuazon.

p. 83 below Oscar Tuazon, *I use my body for something, I use it to make something, I make something with my body, whatever that is. I make something and I pay for it and I get paid for it*, 2010. Concrete, reinforcing bar, mesh, approximately 30 ⁵/₁₆ × 177 ³/₁₆ × 161 ⁷/₁₆ in. (77 × 450 × 410 cm). Sammlung Migros Museum für Gegenwartskunst. Photo Stefan Altenburger Photography, Zurich. © Oscar Tuazon.

p. 84 Santiago Sierra, *Cubes of 100 cm On Each Side Moved 700 cm*, 2002. Perfomance at Kunsthalle Sankt Gallen. Sankt Gallen, Switzerland, April 2002. © DACS 2016. p. 85 above Shinique Smith, *No dust, no stain*, 2006. Mixed-media installation. Madison Museum of Contemporary Art, Madison, Wisconsin. Courtesy James Cohan Gallery, New York and Shanghai. Photo Steven Brooke. © Shinique Smith.

p. 85 below Shinique Smith, *Bale Variant No. 0020*, 2011. Clothing, fabric, twine and wood, 72 × 28 × 28 in. (182.9 × 71.1 × 71.1 cm). Courtesy James Cohan Gallery, New York and Shanghai. Photo Christian Patterson. © Shinique Smith.

p. 86 Artifacts chosen by curators out of the wreckage from the World Trade Center stored temporarily at JFK airport. Photo Julie Dermansky / Corbis.

p. 87 left Miya Ando, *After 9/11*, 2011. One piece of World Trade Center steel, 28 × 10 ft (8.53 × 3.05 m). Courtesy 9/11 London Project Foundation.

p. 87 right Isa Genzken, *Hospital (Ground Zero)*, 2008. Artificial flowers, plastic, metal, glass, acrylic paint, fabric, spray paint, mirror foil, fiberboard, casters, 122 ⁷/₈ × 24 ³/₄ × 29 ⁷/₈ in. (312 × 63 × 76 cm). Courtesy Galerie Buchholz, Berlin/Cologne and Hauser & Wirth, Zürich/London.

p. 91 Tehching Hsieh, *One Year Performance 1978–1979*, 1978–79. Life image. Photograph by Cheng Wei Kuong. Courtesy the artist and Sean Kelly Gallery, New York. © 1979 Tehching Hsieh.

p. 92 Tehching Hsieh, *One Year Performance 1978–1979*, 1978–79. 365 daily scratches. Courtesy the artist and Sean Kelly Gallery, New York. Photo Cheng Wei Kuong. © 1979 Tehching Hsieh.

p. 93 Tehching Hsieh, *One Year Performance 1978–1979*, 1978–79. Statement. Courtesy the artist and Sean Kelly Gallery, New York. © 1979 Tehching Hsieh.

p. 94 left Zhang Huan, *12m²*, 1994. Performance, Beijing. Courtesy Zhang Huan Studio.

p. 94 right Zhang Huan, *My New York*, 2002. Performance, Whitney Museum of American Art, New York. Courtesy Zhang Huan Studio.

p. 97 Adrian Piper, *Food for the Spirit*, 1971 (photographic reprints 1997). Detail, photograph number 1 of 14. 14 silver gelatin prints and original book pages of a paperback edition of Immanuel Kant's *Critique of Pure Reason*, torn out and annotated by Adrian Piper. 15 × 14 ¹/₂ in. (38.1 × 36.8 cm).

Collection Thomas Erben.
© APRA Foundation Berlin.

p. 98 Eleanor Antin, *The Last Seven Days* from *Carving: A Traditional Sculpture*, 1972. 28 black-and-white photographs, each 7 × 5 in. (17.8 × 12.7 cm), seven date labels, 148 black-and-white photographs in the complete piece. Courtesy Ronald Feldman Fine Arts, New York.

p. 99 Heather Cassils, *Day 1 of Time Lapse (Front)*, 2011, and *Day 161 of Time Lapse (Front)*, 2011. Archival pigment prints. Courtesy Ronald Feldman Fine Arts, New York.

p. 100 above Liz Cohen, *Air Gun*, 2005. C-print, 50 × 60 in. (127 × 152 cm), edition of 5, 2 APs. Courtesy the artist and Salon 94, New York.

p. 100 below Liz Cohen, *Bodywork Hood*, 2006. C-print, 50 × 60 in. (127 × 152 cm). Courtesy the artist and Salon 94, New York.

p. 101 Guillermo Gómez-Peña, *The Loneliness of the Immigrant*, 1979. Color print, 11 × 14 in. (27.9 × 35.6 cm). Courtesy the artist.

p. 102 Regina José Galindo, *We Don't Lose Anything By Being Born*, 2000. Performance at the municipal landfill, Guatemala. Lambda print on Forex, 70 7/8 × 45 11/16 in. (180 × 116 cm). Photo Belia de Vico. Courtesy Prometeogallery di Ida Pisani, Milan.

p. 103 Regina José Galindo, *We Don't Lose Anything By Being Born*, 2000, shown at La Caja Blanca, Palma de Mallorca, 2012. Photo courtesy Julian Stallabrass. Courtesy Prometeogallery di Ida Pisani, Milan.

p. 105 damali ayo, rent-a-negro. com, 2003–12. Website. Courtesy damali ayo.

p. 106 above Keith Townsend Obadike, *Keith Obadike's Blackness for Sale*, 2001. Website. Courtesy the artist.

p. 106 below Nunu Kong, *Crowds of Clouds*, 2010. Performance. Photo TL Pettersen. Courtesy the artist.

p. 108 Marina Abramović, *The Artist is Present*, 2012. Performance. Photo Bennett Raglin / Getty Images. © DACS 2016. © Marina Abramović.

Courtesy Marina Abramović and Sean Kelly Gallery, New York. DACS 2016.

p. 110 Tehching Hsieh, *Performance 1: Tehching Hsieh*, The Museum of Modern Art, New York, 2009. Photo Aaron Webb. © Tehching Hsieh.

p. 114 Shigeko Kubota, *Vagina Painting*, 1965. Performed during the *Perpetual Fluxus Festival*, New York. Courtesy Gilbert and Lila Silverman Fluxus Collection, Detroit. Photo George Maciunas. © Shigeko Kubota / DACS, London / VAGA, New York 2016.

p. 116 left John Cage preparing a piano, ca. 1960. Photo Ross Welser. Courtesy the John Cage Trust.

p. 116 right John Cage, *Table of Preparations*, from *Sonatas and Interludes*, 1946–48. Printed page, 9 × 12 in. (22.9 × 30.5 cm). Courtesy the John Cage Trust. © Henmar Press / Peters Editions.

p. 117 Allora & Calzadilla, *Stop, Repair, Prepare: Variations on "Ode to Joy" for a Prepared Piano*, 2008. Prepared Bechstein piano, pianist (Amir Khosrowpour, depicted), 40 × 67 × 84 in. (101.5 × 107.2 × 213.4 cm). Courtesy Gladstone Gallery, New York and Brussels. Photo David Regen. © Allora & Calzadilla.

p. 118 Joe Jones, *Cage Music*, ca. 1965. Metal birdcage containing painted plastic violin and battery-powered motor with striker, 15 3/4 × 13 × 13 in. (40 × 33 × 33 cm). The Gilbert and Lila Silverman Fluxus Collection Gift FC1899. The Museum of Modern Art, New York / Scala, Florence.

p. 119 Nam June Paik and Jud Yalkut, *TV Cello Premiere*, 1971. 7:25 minutes, color, silent, 16 mm film on video. Courtesy Electronic Arts Intermix (EAI), New York. © Nam June Paik.

p. 120 Rebecca Horn, *Finger Gloves*, 1972. Performance, fabric, balsa wood, length 35 1/2 in. (90 cm). Tate, London, with the help of the Tate Members, 2002. Courtesy the artist and Sean Kelly, New York. Photo Achim Thode. © Rebecca Horn / VG Bild-Kunst, 2016.

p. 121 above Laurie Anderson, *Tape-bow violin diagram*, 1977. Courtesy the artist.

p. 121 below Laurie Anderson, *Talking Stick* used in *Moby-Dick*, 1999. Performance. Courtesy the artist.

p. 122 David Byrne, *Playing the Building*, 2005–12. Installation view, Battery Maritime Building, New York, 2008. Photo Justin Ouellette. Courtesy the artist.

p. 123 left Jean Tinguely, *Méta-matic no. 8*, 1974. Felt-tip pen drawing on light board, 11 7/8 × 7 3/8 in. (30.1 × 18.8 cm). © ADAGP, Paris and DACS, London 2016.

p. 123 right Tim Hawkinson, *Signature Chair*, 1993. School desk, paper, wood, metal, motorized, 37 × 28 × 24 in. (94 × 71.1 × 61 cm). Courtesy the artist and Pace Gallery. © Tim Hawkinson.

p. 124 above Rebecca Horn, *The Little Painting School Performs a Waterfall*, 1988. Metal rods, aluminum, sable brushes, electric motor, acrylic on canvas, 19 ft × 11 ft 11 in. × 7 ft 11 in. (5.79 × 3.63 × 2.41 m). Collection Walker Art Center, Minneapolis, T.B. Walker Acquisition Fund, 1989. Courtesy the artist and Sean Kelly, New York. © Rebecca Horn / VG Bild-Kunst 2016.

p. 124 below Model Shalom Harlow in a fashion performance staged by Alexander McQueen, 1999. Standard / Rex Shutterstock.

p. 126 left Nam June Paik performing La Monte Young's *Composition 1960 #10 to Bob Morris (Zen for Head)*, Wiesbaden, West Germany, 1962. Photo © dpa. © Nam June Paik.

p. 126 right Janine Antoni, *Loving Care*, 1992. Performance with Loving Care Natural Black hair dye, variable dimensions. Photo Prudence Cuming Associates Ltd at Anthony d'Offay Gallery, London, 1993. Courtesy the artist and Luhring Augustine, New York. © Janine Antoni.

p. 128 Sachiyo Takahashi and Sidney Fels, *Sound Weave*, 2003. Modified loom, used audio cassette

p. 194 below Gerhard Richter, *Strip*, 2011. Digital print on paper between Alu Dibond and Perspex (Diasec), 86 ⅝ × 86 ⅝ in. (220 × 220 cm). Catalogue raisonné 919. © Gerhard Richter, 2016.

p. 195 David Hockney, *Untitled, 19 June 2009, No. 4*, 2009. iPhone drawing. © David Hockney.

p. 201 Yoko Ono, *FLY*, 1964. Announcement for the event at the Naiqua Gallery, Tokyo, April 25, 1964. Yoko Ono did not attend. © Yoko Ono.

p. 202 Mona Hatoum, *Home*, 1999. Wood, steel, electric wire, 3 light bulbs, computerized dimmer device, amplifier and two speakers, variable dimensions. Courtesy Galerie Max Hetzler and White Cube. Photo Jörg von Bruchhausen. © Mona Hatoum.

p. 203 Felix Gonzalez-Torres, *"Untitled" (Portrait of Ross in L.A.)*, 1991. Candies individually wrapped in multicolored cellophane, endless supply. Overall dimensions vary with installation. Ideal weight: 175 lbs (79.4 kg). Installation view of *Feast: Radical Hospitality and Contemporary Art*. Smart Museum at the University of Chicago, Chicago, IL. 16 February – 10 May 2012. Cur. Stephanie Smith. Catalogue. Courtesy Andrea Rosen Gallery, New York. © The Felix Gonzalez-Torres Foundation.

p. 204 Sam Brown, *Moving Day*, 2014. Pencil on paper, Photoshop. Explodingdog.tumblr.com.

p. 205 Miranda July and Harrell Fletcher, *Learning to Love You More*, 2002–9. Website. Courtesy the artists.

p. 207 *Obstruction of Justice House*, *Heidelberg Project* Archives. Photo Jeff Nyveen.

p. 209 Musée de l'Elysée Lausanne, *We Are All Photographers Now!*, 2007. Installation views, with photographs by Steve Bridger, Mich de Mey, Bart, Shane Forster and Ange.

p. 210 Chris Burden, *Urban Light*, 2008. Installation views. Photos by Mark Dienger, Mr. Littlehand. Courtesy the artist and Gagosian Gallery. © Chris Burden.

p. 211 *Faces of Meth* (2005), 1,200 individual lines contributed by approximately 1,200 anonymous participants on www.swarmsketch.com over a period of 3 hours; *Mount Everest* (2005), 1,000 individual lines contributed by approximately 1,000 anonymous participants on www.swarmsketch.com over a period of 8 hours; *Python Eating Alligator* (2005), 1,000 individual lines contributed by approximately 1,000 anonymous participants on www.swarmsketch.com over a period of 17 hours; *Unclaimed Baggage* (2005), 1000 individual lines contributed by approximately 1,000 anonymous participants on www.swarmsketch.com over a period of 2 days. Courtesy Peter Edmunds.

p. 213 Christian Marclay, *The Clock*, 2010. Single-channel video, duration 24 hours. Courtesy White Cube, London and Paula Cooper Gallery, New York.

p. 214 JR, *Inside Out Project* in Caracas, Venezuela, 2012. Global participatory project. © JR.

p. 215 above We Work in a Fragile Material, *You Can Do It!*, 2004. Workshop at the Tensta Konsthall, Stockholm. Courtesy Wwiafm.

p. 215 below We Work in a Fragile Material, *You Can Do It!*, 2004. Workshop at the craft cooperative Blås & Knåda, Stockholm. Courtesy Wwiafm.

p. 216 Stephanie Syjuco, *The Counterfeit Crochet Project (Critique of a Political Economy)*, 2006–ongoing. Collected images courtesy of project participants. Courtesy the artist and Catharine Clark Gallery, San Francisco.

p. 218 Cat Mazza, *Nike Petition Blanket*, 2003–8. Synthetic and wool yarns, 15 × 6 ft (4.57 × 1.83 m). Courtesy the artist.

p. 219 Anne Wilson, *Local Industry*, 2010. Installation view, Knoxville Museum of Art, Tennessee. Courtesy the artist.

p. 225 Claire Fontaine, *This Neon Was Made By Felice Lo Conte for the Remuneration of One Thousand, Nine Hundred and Fifty Euros*, 2009.

Neon, transformers, cabling, 2 × 134 ⅝ × 16 ⁹⁄₁₆ in. (5 × 342 × 42 cm). Courtesy the artist and Metro Pictures, New York.

p. 226 Sam Durant, White, *Unique Mono-Block Resin Chair*, 2006. Glazed porcelain, 18 × 18 × 30 in. (45.7 × 45.7 × 76.2 cm). Courtesy Paula Cooper Gallery, New York. © Sam Durant.

p. 227 Installation view of the Acknowledgment Panels from Judy Chicago's *The Dinner Party*, at the Hammer Museum, UCLA, Los Angeles, 1996. Photo © Donald Woodman. © Judy Chicago. ARS, NY and DACS, London 2016.

p. 248 Alice Aycock at Artpark, working on '*The Beginnings of a Complex…': Excerpt Shaft #4/five Walls*, 1977. Wood, 28 × 8 ft (8.53 × 2.44 m). Courtesy the artist.

Acknowledgments

We are very grateful to Jacky Klein for being our initial champion at Thames & Hudson, and for her enthusiasm and faith in the project. We thank all the people affiliated with the press who took part in making this book, including Sarah Hull, Linda Schofield, Sophy Thompson, Roger Thorp, Jo Walton, Celia White, and our designers Fraser Muggeridge, Constanze Hein, and Jules Estèves. Matters of production are clearly still sensitive for some. Though we requested images for almost every artwork mentioned in this text, several artists refused to grant permission outright. However, they were in the minority. We consulted and queried many artists and makers during the writing process, and they generously shared with us their wisdom and their knowledge. Sarah Cowan did excellent research work for us in California with her signature grace and intelligence, and Eleanor Davies provided additional research support in London, bringing many ideas and artists to our attention.

Glenn Adamson thanks Nicola Stephanie for being her inspiring, creative, and caring self. Julia Bryan-Wilson thanks Mel Y. Chen for constant encouragement, insight, humor, and love.

Lastly, we would like to acknowledge and express our gratitude toward everyone who had a hand in producing and printing this book, including those whose names we do not know.

About the Authors

Glenn Adamson is the Nanette L. Laitman Director of the Museum of Arts and Design in New York City. He was, until Autumn 2013, Head of Research at the V&A, where he was active as a curator, historian, and theorist. His publications include *Thinking Through Craft* (2007), *The Craft Reader* (2010), *Invention of Craft* (2013), and *Postmodernism: Style and Subversion 1970 to 1990* (2011). He is also the co-founder and editor of the triannual *Journal of Modern Craft*. Adamson holds a PhD from Yale University (2001), and he has taught and lectured widely at universities and art schools including the Royal College of Art, University of Wisconsin, RISD, California College of the Arts, and Cranbrook Academy of Art.

Julia Bryan-Wilson is Associate Professor of contemporary art at the University of California, Berkeley. She is the author of *Art Workers: Radical Practice in the Vietnam War Era* (2009), and the editor of *October files: Robert Morris* (2013). A scholar and critic, Bryan-Wilson has written about Laylah Ali, Ida Applebroog, Simone Forti, Ana Mendieta, Yvonne Rainer, Yoko Ono, Harmony Hammond, and Sharon Hayes among other artists, for publications including *Art Bulletin*, *Artforum*, *Grey Room*, *The Textiles Reader*, *October*, and the *Journal of Modern Craft*, as well as many exhibition catalogs.

Index

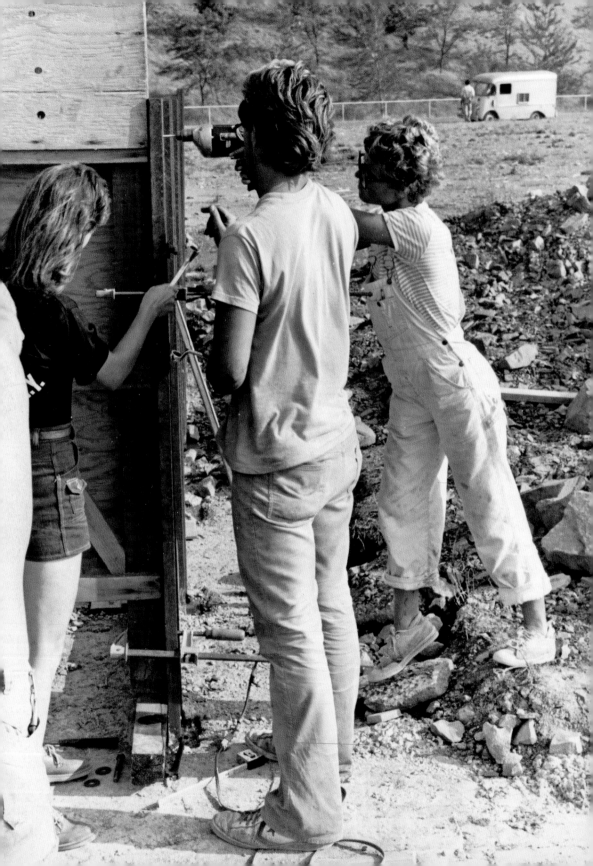